THE

AFFECTIONS

OF THE

HEART

IN

ART

A WRESTLING FOR THE FULL PLEASURES IN ART

JASON HARMS

CREED PRESS

The Affections of the Heart in Art
The Land of the Fear of Men

Copyright © Jason Harms 2007, 2009

www.jasonharms.com

Artwork: Adrian Johnston / kmov.org
Design: CREED PRESS

CREED PRESS
Minneapolis, Minnesota, USA
www.creedpress.com

ISBN: 978-0-9824065-0-2 (hardcover)
ISBN: 978-0-9824065-1-9 (paperback)
ISBN: 978-0-9824065-2-6 (ebook)

CREED PRESS

MINNEAPOLIS, MINNESOTA

YOU ARE NOT RESTRICTED BY US,

BUT YOU ARE RESTRICTED

IN YOUR OWN

AFFECTIONS.

II CORINTHIANS 6:12 (ESV)

ARE OUR PLEASURES IN ART OUR PLEASURE IN GOD?
WHERE THEY ARE NOT, I BELIEVE WE FORFEIT THE FULL PLEASURES
THAT GOD ORDAINS FOR OUR ENJOYMENT IN ART,
NAMELY,
OUR ENJOYMENT OF
GOD HIMSELF.

THIS IS A WRESTLING TO PURSUE AND ENJOY
THE FULLEST PLEASURES IN ARTISTIC EXPRESSION.

THE AFFECTIONS OF THE HEART IN ART

Table of Contents

Preface

What does an artist delight in as he labors in his art? What should an artist delight in? Do I run after the praises of man or the praise of God in my artistic endeavors? Do I hope in man or in God for my satisfaction to be realized in the arts? Are my artistic endeavors about giving or receiving? What motivates a work? What motivates me? Is my heart enslaved by the fear of man or is it free in the fear of God? Do I seek God or the market for inspiration? Am I or art or God the end in a work of art? These questions, and many others, are not unique to artists. If you can breathe and reason, then put your life's labor in the question and meditate on the Bible for a while, the whole Bible.

But artists in particular, with all of our creating and expressing, need to take a serious look at our own heart's affections, and I'm the first in need of a disciplined, exhorting analysis. Greed, pride, impatience, covetousness, envy, arrogance, immaturity, slothfulness, self-seeking, judgmental attitudes have all robbed artists from experiencing the full measure of pleasures that God has for us through artistic expression. Instead, they've bred a motive for creating and displaying art, namely, to experience the superficial (and ultimately unsatisfying) pleasures of self-exalting, observer-dependant, titillating expression. Of course, that's a generalization, but only in its degree of accuracy for each individual.

We probably started drawing or making music in innocent pleasure when we were young, but it didn't take long for our hearts to begin to

perform for men (understanding here a difference between "performance" as in a concert or presentation, and "performing" as a motive of seeking various forms of praise). There is a polar difference in motive between performing for the praises of others as opposed to artistically sharing or giving or testifying or blessing others with what you have been enjoying in the arts. When, in the arts, we stop giving and sharing and blessing, that is when we really stop receiving full and complete joy and satisfaction in our artistic labors.

If you have a heart, you will be tempted to find your satisfaction in your artistic labors in the praises of men, and you will find a measure of satisfaction, but it will not quench your desires. If you continue on that path, you will forever be an artistic, nomadic mess. But God is able to change a heart from stone to living flesh (Ezekiel 36:26). God is able to tune our ears to His praises and align our motives to His motives. He is more than able to give us inspiration beyond what we are able to artistically handle. And when He does, we begin to experience the full beauties and pleasures and joys to be found through artistic expression as He intended, in His loving-kindness, for our enjoyment. "For who can eat and who can have enjoyment without Him?" (Ecclesiastes 2:25).

We consistently fail to experience the fullness of enjoyment that God has for us in artistic expression because we do not understand how our pleasures relate to the pleasure to be had in God (Ecclesiastes 2:24-25, I Timothy 6:17). Or, we want to ultimately ascribe the glory of an artistic work to man the creature, rather than to God, the Creator of that genius artist (Romans 1:25). We forfeit so much joy to be had in art when we make man or art, and not God, the end of art.

Artists, I want to encourage you to ask your own heart questions like these and look to the Bible for counsel and answers. But don't mainly, or even first, search the Bible for art; search for heart. All art comes from a heart. If a spring is polluted, it will only yield dirty water. So it is with our

heart. A polluted heart, meaning a heart that is infested with all sorts of evil motives, is not able to either experience or express the fullest beauty and pleasure that God has intended for our enjoyment in art. For our own greatest joy, we must clean the wellspring called the heart. "Search me, O God, and know my heart; try me and know my anxious thoughts and see if there be any harmful way in me, and lead me in the everlasting way" (Psalm 139:22-24).

So that's the exercise that I am engaged in here. I am wrestling for a greater knowledge of the truth so that I can experience truth's fullest beauty as it manifests itself in artistic expression. There is such a thing as absolute truth, don't be fooled – consider the dead (Luke 16:19-31). We must grow in the knowledge of what is absolutely true, so that whether we view art or engage in creating art, we can discern and enjoy in full the pleasures to be had. Ignorance of the truth will only rob us of pleasure. Ignorance deprives us from seeing all that is to be seen, or from hearing all that is to be heard. In our ignorance, we've been deceived and have embraced the first luring pleasure that engages our senses, only to find it not ultimately satisfying in the end. In ignorance, we have built many fences that have proven to only redirect our blindness and thereby we continue to forfeit the pleasure of what is truly beautiful. We should, rather, be securing a superior foundation by which to better see beauty in every way that she presents herself.

I need to hear the Bible. I must care for the state of my own soul. Humanly speaking, no one has as much at stake in the outcome of my soul as I do, which is why Paul exhorts us to "work out [our] salvation with fear and trembling." And here is his encouragement, "for it is God who is at work in you, both to will and to work for His good pleasure" (Philippians 2:12b,13).

A wrestling through the Word of God will not be disappointing, nor is it for the fainthearted. But as you well know, no artwork of great beauty was ever fashioned by a slothful hand. So, put on the farmer's

endurance and patience, Harms. Get a little bruised and worn out behind the strength of the Word of God, and enjoy a farmer's harvest! "Where no oxen are, the manger is clean, but much increase comes by the strength of the ox" (Proverbs 14:4).

Find the supremacy of God in the arts, and see what pleasures He might have for you and others through faithfulness to Him in the artistic labors that He has given you for your enjoyment; your enjoyment in Him through His Son, Jesus Christ.

Fear and enjoy the Lord,

Jason Harms

THE GAIUS PROJECT

Prerequisite

It is hard for me to hear truth when my heart is distracted. In order to effectively discern the truth, I must take command of my heart's affections. But there is a danger in giving my mind control of my heart because I am very capable of deceiving myself with logic or theory or philosophy or emotion. I need God to control my heart, to lead my mind in the right and true way, to go before me and behind me and all around me, and to make my footsteps firm so that I can see and enjoy artistic expression as God has intended it for my enjoyment in Himself.

So I must humble myself before the Lord and ask Him to lead me into paths of righteousness for His name's sake and for my joy. I must yield my heart and my mind to the Lord for His probing so that I may learn what harmful ways exist in me. And so, to set our bearings straight, let's first yield to a washing with the Word of God and meditate on some exhortations from the Bible as we wrestle to discern the affections of our heart in art. Don't be tempted to rush through these verses. Pray through them, meditate on them, push on them, dissect them, consider them, "for the Lord will give you understanding in everything" (II Timothy 2:7b). Where they convict, repent and be free! Where they encourage, embrace and put them on as your shield and sword in this fight of faith in the arts arena. And where they illuminate, enjoy God for the depths of the riches of His wisdom and knowledge and beauty. Enjoy the Word of God more than thousands of gold and silver pieces!

There is nothing better for a man
Than to eat
And drink
And tell himself that his labor is good.
This also I have seen
That it is from the hand of God.
For who can eat
And who can have enjoyment
Without Him?

- Ecclesiastes 2:24-25

Prerequisite

For who regards you as superior?
What do you have that you did not receive?
And if you did receive it,
Why do you boast as if you had not received it?

- I Corinthians 4:7

Know that the Lord Himself is God;
It is He who has made us,
And not we ourselves.

- Psalm 100:3a

Prerequisite

All flesh is grass,
And all its loveliness is like the flower of the field.
The grass withers,
The flower fades,
When the breath of the Lord blows upon it.
Surely the people are grass.
The grass withers,
The flower fades,
But the word of the Lord stands forever.

- Isaiah 40:6b-8

To this one I will look,

To him who is humble

And contrite of spirit,

And who trembles at My word.

- Isaiah 66:2b

...If you continue in My word,
Then you are truly disciples of Mine;
And you will know the truth,
And the truth will make you free.

- John 8:31b-32

Prerequisite

For I delight in loyalty
Rather than sacrifice,
And in the knowledge of God
Rather than burnt offerings.

- Hosea 6:6

Prerequisite

When you pray,
You are not to be like the hypocrites;
For they love to stand and pray in the synagogues
And on the street corners
So that they may be seen by men.
Truly I say to you,
They have their reward in full.

- Matthew 6:5

Prerequisite

Do not look at his appearance
Or at the height of his stature,
Because I have rejected him;
For God sees not as man sees,
For man looks at the outward appearance,
But the Lord looks at the heart.

- I Samuel 16:7

Prerequisite

For the mouth speaks
Out of that which fills the heart.

- Matthew 12:34b

This people honors Me with their lips,
But their heart is far away from Me.
But in vain do they worship Me,
Teaching as doctrines
The precepts of men.

- Matthew 15:8-9

Prerequisite

And without faith
It is impossible to please Him….

- Hebrews 11:6a

...Whatever is not from faith
Is sin.

- Romans 14:23b

...Do not go on passing judgment
Before the time,
But wait until the Lord comes
Who will both bring to light the things hidden in the darkness
And disclose the motives of men's hearts;
And then each man's praise will come to him
From God.

- I Corinthians 4:5

Prerequisite

For am I now seeking the favor of men,
Or of God?
Or am I striving to please men?
If I were still trying to please men,
I would not be a bond-servant of Christ.

- Galatians 1:10

Prerequisite

Let a man regard us in this manner,
As servants of Christ
And stewards of the mysteries of God.
In this case,
Moreover,
It is required of stewards
That one be found trustworthy.

- I Corinthians 4:1-2

"The Lord will judge His people."
It is a fearful thing
To fall into the hands
Of the living God.

- Hebrews 10:30b-31

Prerequisite

Now,
Gird up your loins and arise,
And speak to them all which I command you.
Do not be dismayed before them,
Or I will dismay you before them.

- Jeremiah 1:17

These things I have spoken to you,
That My joy
May be in you,
And that your joy
May be full.

- John 15:11

Prerequisite

That which we have seen and heard
We proclaim also to you,
So that you may have fellowship with us;
And indeed
Our fellowship is with the Father
And with His Son Jesus Christ.
And we are writing these things
So that our joy may be complete.

- I John 1: 3-4

Introduction

For from Him and through Him and to Him are all things.
To Him be the glory forever. Amen. (Romans 11:36)

The greatest pleasures in all things pleasurable will only be enjoyed when our enjoyment of those things culminates and terminates in our pleasure in God Himself. The greatest pleasures to be enjoyed in the pleasures of artistic expression will never be enjoyed where man, art, or some artsy idea is the end of the affections of our heart in art. God did not make any created pleasure to be an end pleasure in itself. All pleasures flow from their source pleasure, namely, God Himself. And yet our heart hardly recognizes this truth.

When we suppress the truth of God by exchanging His glory in all that He has made for the glory of what He has made, we forfeit a pleasure that God has intended for us to enjoy. The glory of what God has made is only a partial emanation of the full glory of God Himself. All things pleasurable are so because of God's intention that they be so (I am not talking here about how we take pleasure in sinning with what God has made pleasurable. That theme will be wrestled with later.). I mean to affirm that God exercises Authorial intent in what He has made pleasurable. Honey is sweet because God designed it to be sweet. Honey

is sweet to our tongues because God designed them with buds to enjoy honey's sweetness. Both honey and the tongue are creations of God. He is their Author. Both honey and the tongue evidence a measure of the genius of their Creator. But when, either from ignorance or defiance, we terminate the affections of our heart on the pleasures of the created (as if the created is the beginning or the end of itself) rather than on the pleasure of the Creator and His pleasure in creating the created pleasurable, we will not enjoy, in full, the vast range of pleasures that God intends for our enjoyment. "For from Him and through Him and to Him are all things. To Him be the glory forever. Amen." (Romans 11:36).

We leave pleasure on the table all the time in the arts: the pleasures in serving, the pleasures in humility, the pleasures in freedom from the fear and praises of men, the pleasures of the extra portions that the Lord gives to the one who fears Him alone, the pleasures of fellowship with the Author of all things when enjoying all that He has made, the pleasures of artistic strength when God's strength is the well from which we draw rather than drawing from our own cisterns, the pleasures of purity, the pleasures in exhortation, the pleasures in edification, the pleasures in struggling to articulate Him who is unsearchable, the pleasures in giving of oneself for the health of others. There are so many pleasures to be had in the arts, and to be had much more richly, when we die to the pride of our hearts and embrace the glory of God in every work of His hand. "Whatever the Lord pleases, He does…" (Psalm 135:6). So, I intend to push on the affections of my heart in my pleasures in art to see where I am forfeiting pleasure, as God has revealed a bit of Himself for my enjoyment through all that He has made.

Artists, whose pleasure would it be to push on this theme with me? We will need wisdom, and the fear of the Lord is the beginning of it (Proverbs 9:10). God, grant us this fear that our joy would be full!

To fear the Lord is not a burdensome thing. It is the joyful acknowledgement and embracing of the truth that absolutely everything is His. I am His creation. Artistic expression is His creation. "The earth is the Lord's, and all it contains, the world, and those who dwell in it" (Psalm 24:1). "For all things come from You, and from Your hand we have given You" (I Chronicles 29:14b). "All things came into being through Him, and apart from Him nothing came into being that has come into being" (John 1:3). To own this reality is the beginning of our freedom to enjoy all that God is and all that He has given to us for our enjoyment in Him. "There is nothing better for a man than to eat and drink and tell himself that his labor is good. This also I have seen, that it is from the hand of God. For who can eat and who can have enjoyment without Him?" (Ecclesiastes 2:24-25).

All of mankind should be running after God in all of life. What does God make known about Himself in His creation of the ocean? What is God saying about Himself when He makes man in His image? What was God evidencing about Himself when He conceived of artistic expression and then carved man in such a way that man would be able to express his heart and mind artistically, and even take enjoyment in it? We should seek to find out so that we can begin to experience the full portion of pleasure that God takes in those things. God is leading us to Himself as we take enjoyment in all that He has made enjoyable, but do we ever see God, or do we only see what He has made? Are our hearts foolish and darkened? Are we suppressing the truth?

Where we can only see what God has made, and not recognize or delight in it as being from and of God, we will consider the pleasures in the created above the pleasures of the Creator and misplace or misappropriate our affections for the created. We will err in thinking that art or emotion is the end of our art-working, rather than God and God's purposes for giving us artistic expression and emotion. We will err in thinking that the ocean and its place in the life cycle is its own end, rather than God and

God's purposes in creating the ocean. We will err in thinking that a tree or a habitat is its own end, rather than God and God's purposes for creating trees and habitats. We will err in thinking that man is the end of man, rather than God being the end of His creature, man. Since God is the beginning of all things, He is therefore the end of all things, including His design in crafting man to be able to take pleasure in expressing himself artistically. "For from Him and through Him and to Him are all things. To Him be the glory forever. Amen." (Romans 11:36).

In God's emanation of at least a portion of the breadth of His creative ability, He took pleasure in creating man with great variation. While God designed some people to evidence and know a measure of His glory through being unusually fast or strong, He designed others to evidence and know a measure of His glory through being artistically skilled.

When I say, "to evidence God's glory," I mean this: We are His creatures (James 1:18). We are God's workmanship, created in His image (Ephesians. 2:10). It is God who has made us, and not we ourselves (Psalm 100:3). We all have the same Author who exercises Authorial intent in all that He creates. We would do well to study such an Author by studying all of His works. What do His works evidence of Him?

And when I say, "to know God's glory," I mean this: As God has created each of us with our own unique character and set of abilities, we each have a personally unique theater of life in which we could experience personalized fellowship with God, our Creator, as He unpacks Himself to us through the life and frame that He has given us. It is in that theater that God often specially articulates a portion of His glory to us. Of course it is not the only theater, it is just a more focused theater.

As we grow in the knowledge of God, we should consequently be growing in our response to what we have learned and enjoyed of God with a genuine affection of our heart towards such a peerless Author. The

word, in church vernacular, for this response of affection from our heart is worship. In the theater of art, our affections for what we find artistically enjoyable should be maturing towards our enjoyment of (our worship of) God Himself, as He is the Author of all things. We should be seeking to understand what God is saying about Himself in this pleasure we call art, since God made man with the desire and ability to artistically express his heart.

When I use the words art and worship together, I am not first or even mainly thinking here about a church "worship" time. We think too small if we only understand the word "worship" as describing the time of singing before the preaching at church, or a section of the store where a certain style of music is shelved. When I do use the words art and worship together, I am mainly thinking about the worship of God (the One who should be the end of my affections) in all of life's involvement and pleasure in art. It is really quite simple to determine what it is that you worship. Find where your affections terminate, and there you will find what you worship.

Whether I am studying, practicing, listening, viewing, creating, or displaying art, I will always have the opportunity, and a desire, to be worshiping something. This is a reality of our human nature. The question is, am I worshiping (terminating my affections on) God as I enjoy art, or am I worshiping art, or a work of art, or an artist, or a lifestyle, or a cause, or some freedom of expression, or myself, or something else? This is a very important question, because not only does the answer reveal where I may have exchanged the glory of the Creator for the glory of what He created (Romans 1:25), it will also inform me whether or not I am enjoying the full pleasures to be had in a work of art, as God has intended the pleasures of artistic expression for my enjoyment, my enjoyment in Him (Genesis 2:8-9).

Praise God that He is not constrained by man as He displays a

measure of His glory through man, His creature! (John 9:3). We have all seen beautiful evidences of God's genius displayed through human artistic creativity where the author totally disregards God. Anything that man does that is beautiful is only beautiful because it has drawn from and reflected, in some degree, what God has already established as being beautiful. Make no mistake, the Author and Definer of beauty is God! (Genesis 1, Ezekiel 16:13-14, John 1:3, 14, John 3:16, Ephesians 2, Colossians 1, Hebrews 1, Revelation 22).

When we think of art, do we think of God? When we think of worship, do we think of our life in the arts? When we "worship" God, are we really mainly thinking about the artistic expression of our "worship" affection? We need to learn what affections God delights in so that our acts of "worship" won't be in vain. "This people honors Me with their lips, but their heart is far away from Me. But in vain do they worship Me teaching as doctrines the precepts of men" (Matthew 15:8-9).

God has arranged everyone in the body of Christ just as He desired (I Corinthians 12:18). We see that God has made all kinds of artists. Are we as artists being faithful to God and to the body with our artistic abilities and charge? Are we both individually and corporately realizing the full potential of pleasure or reward to be had in our artistic expressions, or are we in want, maybe unknowingly, due to unfaithfulness or ignorance?

Let's hear what Jesus says in Matthew 6:5-6 about the relationship between an unfaithful motive and its corresponding reward:

> And when you pray, you must not be like the hypocrites; for they love to stand and pray in the synagogues and at the street corners that they may be seen by others. Truly I say to you, they have received their reward. But when you pray, go into your room and shut the door and pray to your Father who is in secret. And your Father who sees in secret will

reward you (ESV).

When I engage in prayer from the motive of "I want to be seen by others as one who can really pray" (which means that I am actually seeking my value or pleasure or identity from the praises of men rather than the praises of God), Jesus does not say that I will experience no measure of reward. If I utter a beautiful prayer, people may befriend me in some way. They may invite me for dinner. I may find myself accepted now with their group of friends. There is a measure or kind of pleasure that is experienced when we are embraced or praised by other people. Jesus does not deny this. Jesus acknowledges that I will experience a measure of reward even when my motive in calling out to God is to be seen by men. But man's reward will be all the reward that I will know. I will not know the fullness of pleasures to be known and enjoyed when my prayers are the flowers of foul affections. Pride is a joy thief. Pride will cede me just enough joy to deceive me into thinking that "I have found the joy that I was looking for" while it redirects my compass away from the Joy of all joys. But, I can know the fullness of joy, the full reward, if my motives are aligned to my Father's desires. His reward so easily out-values any reward from man. God's reward is Himself.

In the arts, we experience the temptation to be unfaithful to God in so many ways. We are tempted to look to man for the praise of our work, rather than to God. We are tempted to look to art for the hope of satisfying our soul's longings, rather than look to God to satisfy us with Himself (which He often does, and with great delight, through the means of another's artistic expression). It is not that praying or engaging in artistry is evil. It is our hearts that are evil and full of deceit (Genesis 8:21). Unfaithfulness to God is one way we miss the full portion of pleasure to be had in the pleasures in art.

Regarding ignorance, consider this analogy for a moment. Let's

say that we all took great pleasure in the thrill of moving fast. So we all ran around as fast as we could to experience a measure of "speed" pleasure. But we lived in a society that had not known anything faster than the fastest man. Our society had never seen a horse. Then one day, a herd of horses runs past our homes and we see that they can move much faster than we can. All of a sudden, the measure of speed pleasure we knew when we were running fast has just been put into perspective against the potential pleasure to be had if we could move as fast as the horse. So we capture a horse and ride him and find that there is a greater measure of speed pleasure to be had on the horse. And how great it is! Due to our ignorance of the existence of horses, we thought that we had known the full portion of speed pleasure to be experienced as we ran around so fast amongst ourselves.

Then one day, as we are out in full gallop on the horse, the horse takes us to a country previously unknown to us where a motorcycle speeds by. Well, now the speed pleasure experienced while on the horse is put into perspective against the motorcycle, and we see that there is even more speed pleasure to be had on the cycle. And then an airplane buzzes the cycle, and we see that it could take us even faster and further than the cycle. And then we see a rocket....

Now at this point in the analogy, we seem to be in the actual society in which we live regarding the potential for "speed" pleasure. The fastest way to move that we know of would be to strap ourselves onto some kind of rocket. Or is that the fastest? Do you remember the account of Philip and the eunuch and the Spirit of the Lord in Acts 8? Would that not be an eerie pleasure to find ourselves immediately in another town as Philip did?

My point in this analogy is that, due to our ignorance, we thought we were realizing the greatest measure of speed pleasure to be experienced when we ran, because nobody in our society ever pressed the local wisdom to find out if there was something faster than us. Our measure of

speed pleasure experienced in running is a pleasure indeed! But now we understand the value of its pleasure more accurately due to our increased knowledge of speed potential.

As we think then about artistic pleasures, the question is this: are we experiencing all the pleasure that is to be experienced in art when the artwork or the artist is the end of our affections, or is our society ignorant of (and thereby missing out on) the full pleasures to be known through art as God has designed artistic expression for our enjoyment in Him? I would say that we live in ignorance, and thereby forfeit pleasure, as long as we do not understand how God is, and enjoy Him to be, the end of all the pleasures He has made.

AN EXHORTATION TO PURSUE FAITHFULNESS

To my fellow artists: I am looking at this wrestling with the affections of the heart in art first from the perspective of my relationship to my Author (what I call my Sphere One), and then His part for me in the world (my Sphere Two). God looks "to him who is humble and contrite of spirit, and who trembles at [His] word" (Isaiah 66:2b).

I find singing, playing, writing, and listening to music to be so very pleasurable, and I want to know and enjoy the fullest possible measure of pleasure that God has for me through all the arts. I do not want to be ignorant. I do not want to strive after wind. If art is the end of my artistic endeavors, then my artistic labors and pleasures will be in vain because all works of art will eventually see their end (II Peter 3:10-12). But God is everlasting and He has given us artistic expression for our enjoyment with Himself as its end. Solomon says of men:

> I perceived that there is nothing better for them than to be
> joyful and to do good as long as they live; also that everyone

should eat and drink and take pleasure in all his toil – this is God's gift to man. I perceived that whatever God does endures forever; nothing can be added to it, nor anything taken from it. God has done it, so that people fear before Him (Ecclesiastes 3:12-14 ESV).

To all who are affected by artistic expression: While the artists play a part in the function of the body for us, we also play a part in the function of the body for them. No one is unnecessary. Both are in need of each other. All need to be faithful (I Corinthians 12).

We must not fail to recognize the scope and effects that the arts have on the greater body, nor fail to recognize that the body itself consists of artists. We must teach the body to see what God is revealing of Himself in an artist's skill and work, where He is indeed in it. We need to exhort the artists to run after God's praises rather than man's praises. We need to help all discern what is true, and not deceitful, in what is found to be pleasing. And we all must heed the Lord's words to Jeremiah to be faithful with what He is charging and commanding us, and not suckered by what the market is demanding of us.

...I will pronounce My judgments on them concerning all their wickedness, whereby they have forsaken Me and have offered sacrifices to other gods, and worshiped the works of their own hands. Now, gird up your loins, and arise, and speak to them all which I command you. Do not be dismayed before them, lest I dismay you before them (Jeremiah 1:16-17).

Artistic expression is very pleasurable and very powerful by God's design. We must be careful how we engage with art if we are going to know the full pleasures to be had through art. So let's exhort the mouths

(the artists) to fear the Lord. And on our part, we should better join with the mouths of the body who express the truth as Gaius joined with the brothers who went out for the truth. "For they went out for the sake of the name [of Jesus], accepting nothing from the Gentiles. Therefore we ought to support such men, that we may be fellow workers with the truth" (III John 7, 8).

If we can understand how to enjoy artistic expression with God Himself as the end pleasure, then our labors in art will not have been a striving after wind once the work is consumed or destroyed since THE ART WAS NOT THE END, but a pleasurable means of knowing and enjoying and expressing a portion of what God has already known, enjoyed, and expressed of Himself. Artistic expression is a pleasure for us from the hand of God. The fragrance (art) is not the flower (God). The fragrance is of the flower and from the flower, but it is not the flower. So let's enjoy the pleasures of the fragrances in full, and let them lead us to the fullness of pleasure found in the Flower.

In the artistic expression of Johann Frank's affections:

Jesus, priceless treasure,
Source of purest pleasure,
Truest friend to me,[1]

What I Call the
TWO-SPHERES CHASSIS

...that which we have seen and heard we proclaim also to you, so that you too may have fellowship with us; and indeed our fellowship is with the Father and with his Son Jesus Christ. And we are writing these things so that our joy may be complete. (I John 1:3-4 ESV)

Abide in Me, and I in you. As the branch cannot bear fruit of itself unless it abides in the vine, so neither can you unless you abide in Me. I am the vine, you are the branches; he who abides in Me and I in him, he bears much fruit, for apart from Me you can do nothing. (John 15:4-5)

To help sort through and better understand the many emotions and affections connected with the pleasures in artistic expression, as they mingle together and spread over so many catagories of life, I find it helpful, fruitful, to think from this TWO-SPHERES CHASSIS: my relationship to God, and my relationship to all else that God has made. These spheres do not sit next to each other like bulbs of an hour glass that I can run back and forth through, they relate to each other more like the yolk and white of an egg, with Sphere One being the yolk and Sphere

Two being the white.

An embyo must abide in the yolk sphere if it is to grow, as the yolk is the core. No yolk, no growing embryo (often called a "wind" egg). And so I, like the embryo, need to dwell inside Sphere One and feed on the nourishment of the yolk (fellowship with God) if I am to actually grow and mature. If I, as an embryo, tried to live outside the yolk in the white, I would not mature. I must abide in the yolk, and from there I will eventually grow out into the white and partake of its purpose in the development process.

There seems to be two spheres of affections brewing in the process of creating a poem, song, painting, film, or dance. The first sphere represents the personal fellowship between that person's soul and God (or another object or idea or self if God is not the end of his affections). The second sphere represents all those who are receivers of the expression of the fellowship of the first sphere. In the second sphere, others may begin their own new first sphere fellowship with God (or something else) as they benefit from what is being brewed in the first sphere of another.

The reason I use this chassis is because it helps me stay focused on the state and nurture of my own heart's affections, my Sphere One. It forces me to discern the root and object of my affections, which will help me know if I am headed toward the fullest potential pleasures. What is my heart really running after in the pleasures in art? Do my affections terminate on God or man or art?

When I am in fellowship with God, it is no labor to let Him spill over (Sphere Two) so that others might benefit from our communion (my Sphere One). But where I am first concentrating on Sphere Two (thinking: what is everyone else thinking about this?) rather than tending first to my own fellowship with God, I find that my labors in artistic expression are not nearly as fruitful or satisfying. It is God who does the effectual heart work in a person. I should let Him. I don't mean to imply that I never

What I Call the TWO-SPHERES CHASSIS

think about Sphere Two. A Sphere One relationship with God demands that I do (Matthew 5:16). Sphere One is often not complete or fully consummated until it expresses itself outwardly into Sphere Two. But the way I should approach the encouragement of Sphere Two edification is through the nurturing of my Sphere One fellowship with God.

Let's say that the Lord has just shown His faithfulness to me and my heart is enjoying the fresh power or grace of God, to the degree that a song is born from that enjoyment. The fellowship between my heart and the Lord would be this First Sphere. Later, I share my joy in the Lord with my wife (my Sphere Two) and I play her the song. My wife's observance I would call my Second Sphere as it relates to my enjoyment of the Lord. This Second Sphere is more like cell division because now my wife has (or at least has the potential for) her own First Sphere enjoyment of God for His faithfulness to me.

In the body of Christ, there is much and necessary room for testifying to each other of God and what He has done for us. All over the Bible God testifies of Himself to us (God's Sphere Two) which births worship to God in the people (their Sphere One) and produces the spreading of His praise before others (their Sphere Two). I think of Hannah's song to the Lord in I Samuel 2:1-10, and David's song to the Lord in II Samuel 22:2-51, and Habakkuk's prayer in Habakkuk 3, and Mary's Magnificat in Luke 1:46-55, and Zacharias's prophesying in Luke 1:68-79, and Simeon's blessing to God in Luke 2:29-32. In all of these examples, they are leading me (their Sphere Two) in worship to the Lord through their own souls' expressions to (affections for) the Lord (their Sphere One). Their outward enjoyment of God is of benefit to the body of Christ. God must think so since He included their praise to Him in the Bible for our edification.

Here are some more evidences that this Sphere Two testifying should happen and that it is a pleasure to do. In Psalm 40:3, 9-10 David

says:

> And He put a new song in my mouth, a song of praise
> to our God; many will see and fear, and will trust in the
> Lord…. I have proclaimed glad tidings of righteousness in
> the great congregation; behold I will not restrain my lips, O
> Lord, Thou knowest. I have not hidden Thy righteousness
> within my heart, I have spoken of Thy faithfulness and Thy
> salvation; I have not concealed Thy lovingkindness and Thy
> truth from the great congregation.

And in Psalm 111:1-2, "Praise the Lord! I will give thanks to the Lord with all my heart, in the company of the upright and in the assembly. Great are the works of the Lord; they are studied by all who delight in them." Psalm 145:4 says, "One generation shall praise Thy works to another, and shall declare Thy mighty acts."

Notice how this testifying is the outcome or result of what has been known in the personal fellowship first. God acts upon them, they see, and they respond to Him with praise for what they have seen of His righteousness, omniscience, faithfulness, salvation, lovingkindness, truth, His works, His mighty acts, etc… and they are overjoyed to tell others what they have just experienced of God. We find that we must share the joy we've known, and further find that we experience more joy as we share it with others.

The urge to respond to something truly beautiful is under pressure and must be released for our potential joy to be fully enjoyed. When we don't share our joy, we miss out on joy. How many greedy people do you see that are full of joy? John says, "…that which we have seen and heard we proclaim also to you, so that you too may have fellowship with us; and indeed our fellowship is with the Father and with His Son Jesus Christ. And we are writing these things so that our joy may be complete" (I John

1:3-4).

People with artistic inclinations often express their pleasure in God artistically. People with great resources might express their pleasure in the Lord with great financial generosity, proving that their pleasure and hope is not in their resources, but in the Resourcer. However, just because a song or artwork is birthed from a response of pleasure in God does not mean that it will be of benefit to anyone else. I cannot assume that it will. My artistic expression of my pleasures may only hold a valuable meaning between God and me. No one else may benefit from it, and that is fine. Is that fine with you, artist? A sweet, intimate fellowship between just you and God! A special communion intended for your heart alone. We don't have to yield to the temptation to despair if no one else is blessed by what we found pleasure in. Whose praises can match God's praises? Whose love can even approach God's love? Artists, let God be the end of your artistry, and entrust Him with deciding who else or how many others may be blessed through the artistic expression of your fellowship with Him.

Nevertheless, let's not be shy. We should "Let [our] light shine before men in such a way that they may see [our] good works, and glorify [our] Father who is in heaven" (Matthew 5:16). Jesus tells us to shine it! That is Sphere Two talk. He also knows that we are very susceptible to the arrows of pride, so He gives us counsel with the "in such a way" clause, warning us of that joy thief "Faithless." We have no greatness within ourselves except that which God has put in us (I Corinthians 4:7). Our charge is to work in such a way as to awaken and encourage the enjoyment of God in our enjoyment of the "light" He has put in us.

So, by His grace, I am responsible for cultivating my own heart's affections for God (Sphere One) and for the testifying of what I have seen of God (Sphere Two). But I cannot bring about these affections in another person. Only God can cause that growth (I Corinthians 3:7). I

am only able, and charged, to testify of what I have seen and enjoyed of God. If another responds to my enjoyment with their own enjoyment of God, then my testifying (Sphere Two) of what is happening in my soul (Sphere One) has birthed, by God's grace, another's Sphere One affection for God. That is the aim of Sphere Two: a new Sphere One. So then, I should focus on my own heart's affections for God, for the benefit and pleasure of all.

Is that that your aim, artist? Is your aim in sharing your artistry to share with others that which you have taken pleasure in? And do those pleasures terminate in your pleasure in God? There is no greater pleasure than fellowship with the Author of all pleasures known and yet to be known! This is why I have to work from this TWO-SPHERES CHASSIS. Because if I attempt to find the satisfying end for my affections by searching among other artists, or audiences, or works of art, I will roam around forever in Sphere Two, never mature, and produce no lasting fruit. I will be an artistic "wind" egg. I must, we must, abide in Sphere One. "...Abide in Me, and I in you. As the branch cannot bear fruit by itself, unless it abides in the vine, neither can you, unless you abide in Me..." (John 15:1-11).

I think of Jesus and Simon and the woman in Luke 7:36-49. The woman learned that Jesus was at Simon's house. She brought an alabaster vial of perfume and kept wiping Jesus' feet with her tears and anointing them with the perfume. Simon's thoughts, however, were not in the direction of the woman's or Jesus' thoughts. He does not recognize this as beautiful. He says to himself, "If this man were a prophet, He would know who and what sort of person this woman is who is touching Him, that she is a sinner" (Luke 7:39). Jesus said to Simon:

Do you see this woman? I entered your house; you gave
Me no water for My feet, but she has wet My feet with her

tears, and wiped them with her hair. You gave Me no kiss; but she, since the time I came in, has not ceased to kiss My feet. You did not anoint My head with oil, but she anointed My feet with perfume. For this reason I say to you, her sins which are many, have been forgiven, for she loved much; but he who is forgiven little, loves little (Luke 7:44-47).

The Sphere One affections are happening between the woman and Jesus. Jesus is seen by the woman to be beautiful, to be holy, to be worthy of her praise. She praises him with tears and perfume, using her hair as a rag, and finds the pleasures of fellowship with Jesus. The woman was leading as she enjoyed Jesus while among others, but no one was following her.

Notice that the woman was seeking fellowship with Jesus, and not the praises of Simon and the other men (which she didn't receive). Jesus warns us that if our affections for God are really motivated by our hopes to be "honored by men; truly I say to you, [you] have [your] reward in full" (Matthew 6:2b). The woman's motives were acceptable to Jesus. Jesus knew the affections of her heart. He knows when we have authentic affections for Him, and when we are putting on an act to build ourselves up in the eyes of others. Affections which long for God as their end please God, and those which long for man or anything else as their end, do not please God. God will not give His glory to another (Isaiah 42:8). And where God is not pleased with us, how could we ever enjoy the fullness of pleasure to be had in what God has made pleasurable?

How many times a day do we react first with judgment as Simon did because we are not walking in fellowship with God and seeing as He sees? We look at the outward appearance, we recall the history, we think of our circles of friends we are standing with and what they might be thinking (fearing man) as we take in someone's artistic expression of

genuine affection for God, and we end up missing all the beauty because we don't know how to see the way God sees. Simon could have joined with the woman, and wept with her, enjoying God's pleasure in granting mercy, but Simon didn't know this God who came to seek and save the lost. He didn't know God's pleasures, and so he missed the blessing while he stared it down with judgment. Simon missed the joy that the woman knew! We should learn from Simon's mistake to be quick to listen and slow to speak and slow to become angry or judgmental, particularly when affections for God are expressed in a way that is different from our preference or from that which we are accustomed to. We just might learn something about God.

Try this TWO-SPHERES CHASSIS as you engage with your pleasures in art, and see if it will not prove to bear a load of greater pleasures.

The Creation of the World As a Model for Artists

Whatever the Lord pleases, He does, in heaven and in earth, in the seas and all the deeps. (Psalm 135:6)

And [Christ] is the image of the invisible God, the first-born of all creation. For by Him all things were created, both in the heavens and on earth, visible and invisible, whether thrones or dominions or rulers or authorities – all things have been created by Him and for Him. And He is before all things, and in Him all things hold together. ...He is the beginning, the firstborn from the dead, that in everything He might be preeminent. (Colossians 1:15-18)

God is the Creator. Every creator/artist from the lineage of men is at best a failing pupil in comparison and would do well to sit at the feet of his Creator to learn how and why God creates as He does since "from Him and through Him and to Him are all things" (Romans 11:36a). Specifically, I mean this, "For since the creation of the world [God's] invisible attributes, His eternal power and divine nature, have been clearly seen, being understood through what has been made..." (Romans 1:20).

Everything that God has created tells us something about God. The songs that Duke Ellington wrote (all 2000 of them) tell us something about Duke Ellington. If I study Duke's charts, the works of his hands, I will grow in a better knowledge of Duke. And if I study the works of God's hands, of which Duke Ellington is one, I will grow in a better knowledge of God. In fact, isn't that the point of creating: to make known, to make tangible, that which the author knows and enjoys already (even if it is making known the pleasure found in the process of exploration)? Duke hears a conversation in his mind and feels an emotion in his soul that he takes pleasure in, and he works to articulate what he is knowing and enjoying by writing a song. The listener hears Duke's expression (the song) and has the opportunity then to know and enjoy what Duke knew and enjoyed.

Now, do we understand, and not deny, that Duke Ellington is a creation of God? So what is God saying about Himself in that He made Duke Ellington and made him with the abilities, skill, temperament, skin tone, swing, etc... that He did? Aren't we missing out on the knowledge and pleasure of God when we don't ask these questions of God about the works of His hands? Since the artist is a creation of God, and since God articulates a portion of what He has already known and enjoyed Himself as He creates that artist, then as we study artists and their work, for our fullest pleasure, we should also be seeking to better understand their Author, God. Specifically, what can we learn of God's eternal power and divine nature, spanning the full range between the simple beauties and the impossibilities of God, as He gives glimpses of Himself in each of His creations?

There is something of the grandness of God that is specially made known when some of His creatures can express their affections with melodies that please the ear, or with words carefully chosen for rhyme, or with the muscular fluidity and grace and stamina and strength summoned for a dance. Be discerning now. Do not hear me say that one

person is more special than another; all men are sinners (Romans 3:23). Rather, something unique about God's creative genius is being displayed through each and every one of His creatures, and in how their affections are expressed. Special they are, all. God has made everyone, the blind, the deaf, and the mute (Exodus 4:11). Consider the blind, deaf, and mute artists of the world, then consider yourself, and then consider God in the fullness of His counsel.

God has made people with many different languages and has given them differing resources to work with. The span of God's creative design in the race of men is itself evidence of the amazing creativity of God. No two men are the same man, and there should be no boasting coming from the mouth of a man, especially from artist/creative types, except to boast of Christ who has made it possible for man to intimately know his Creator and behold the Being of infinite, genius, creative ability. And to do more than just know Him, but to actually be called a son of God by Him (Romans 9:25-26).

So when I say that the creation of the world is a model for artists, think about this: what creative work is more amazing, more grand, more aesthetically beautiful, more wrought with skill, more full of wonder, more laden with knowledge, or more benevolent than the creation of the world, the entire universe, and every single creation that is in them? Can you think of anything…? So what was their Author thinking about when He made them? What did He know and enjoy that moved Him to express Himself by creating in such a way? From what motive did He create?

Since God created so incredibly, it seems to follow that we would do well to take a few lessons from God. This is what I am trying to get our minds around when I say that the creation of the world is a model for artists to listen to very seriously.

GOD HAS FELLOWSHIP WITH GOD

– SPHERE ONE

Follow me for a moment through these texts, observing the creation of the world by starting and ending with what we hear Jesus pray to the Father before He goes to the cross.

> ...lifting up His eyes to heaven, [Jesus] said, "Father, the hour has come; glorify Your Son, that the Son may glorify You, even as You gave Him authority over all flesh, that to all whom You have given Him, He may give eternal life. This is eternal life, that they may know You, the only true God, and Jesus Christ whom You have sent. I glorified You on the earth, having accomplished the work which You have given Me to do. Now, Father, glorify Me together with Yourself, with the glory which I had with You before the world was" (John 17:1b-5).

> In the beginning, God created the heavens and the earth. ...God said, "Let Us make man in Our image, according to Our likeness..." (Genesis 1:1, 26).

> In the beginning was the Word, and the Word was with God, and the Word was God. He was in the beginning with God. All things came into being through Him, and apart from Him nothing came into being that has come into being... And the Word became flesh, and dwelt among us, and we saw His glory, glory as of the only begotten from the Father, full of grace and truth (John 1:1-3, 14).

> And [Christ] is the image of the invisible God, the first-

born of all creation. For by Him all things were created, both in the heavens and on earth, visible and invisible, whether thrones or dominions or rulers or authorities – all things have been created by Him and for Him. And He is before all things, and in Him all things hold together. He is also head of the body, the church; and He is the beginning, the firstborn from the dead, so that He Himself will come to have first place in everything. For it was the Father's good pleasure for all the fullness to dwell in Him, and through Him to reconcile all things to Himself, having made peace through the blood of His cross; through Him, I say, whether things on earth or things in heaven (Colossians 1:15-20).

(Now back to Jesus' prayer)

Father, I desire that they also, whom You have given Me, be with Me where I am, so that they may see My glory which You have given Me, for You loved Me before the foundation of the world. O righteous Father, although the world has not known You, yet I have known You; and these have known that You sent Me; and I have made Your name known to them, and will make it known, so that the love with which You loved Me may be in them, and I in them (John 17:24-26).

In John 17:1-5 we hear Jesus say that God the Father and God the Son were glorious before the world existed. In Genesis 1 and John 1 we see that God created the world, and that it was all created through the Son. In Colossians 1:15-20 we see that the Son is preeminent in everything as all things are summed up in Him. And in John 17:24-26 we hear Jesus speak of the love that existed between God the Father

and God the Son before the foundation of the world. And then we hear the most amazing thing: Jesus says that He has made the Father's name known to us "so that the love with which [the Father] loved [the Son] may be in [us]!" (v. 26). There was some serious fellowship going on in the Godhead before the world existed that the Godhead means for us to partake in with Them.

John Piper explains God's pleasure in creation like this:

In creation, God "went public" with the glory that reverberates joyfully between the Father and the Son. There is something about the fullness of God's joy that inclines it to overflow. There is an expansive quality to His joy. It wants to share itself. The impulse to create the world was not from weakness, as though God were lacking in some perfection that creation could supply....

God loves to behold His glory reflected in His works. So the eternal happiness of the triune God spilled over in the work of creation and redemption. And since this original happiness was God's delight in His own glory, therefore the happiness that He has in all His works of creation and redemption is nothing other than a delight in His own glory. This is why God has done all things, from creation to consummation, for the preservation and display of His glory. All His works are simply the spillover of His infinite exuberance for His own excellence.[1]

Jonathan Edwards says this:

God seeking Himself in the creation of the world...is so far from being inconsistent with the good of His creatures that

it is a kind of regard to Himself that inclines Him to seek the good of His creature. It is a regard to Himself that disposes Him to diffuse and communicate Himself. It is such a delight in His own internal fullness and glory that disposes Him to an abundant effusion and emanation of that glory. The same disposition that inclines Him to delight in His glory causes Him to delight in the exhibitions, expressions, and communications of it.[2]

Edwards saw the themes of knowing, loving, and enjoying so clearly in God's motivation for creating the world.

The emanation or communication of the divine fullness, consisting in the knowledge of God, love to Him, and joy in Him, has relation indeed both to God and the creature: but it has relation to God as its fountain, as the thing communicated is something of its internal fullness. The water in the stream is something of the fountain; and the beams of the sun are something of the sun. And again they have relation to God as their object: for the knowledge communicated is the knowledge of God; and the love communicated, is the love of God; and the happiness communicated, is joy in God. In the creature's knowing, esteeming, loving, rejoicing in, and praising God, the glory of God is both exhibited and acknowledged, his fullness is received and returned. Here is both an emanation and remanation. The refulgence shines upon and into the creature, and is reflected back to the luminary. The beams of glory come from God, are something of God, and are refunded back again to their original. So that the whole is of God, and in God, and to God; and He is the beginning,

and the middle, and the end.[3]

What better motive could we create from, than the motive that God Himself creates, namely, to communicate the knowledge of, love for, and joy in the glory of God!

We experience an image of this kind of delight in communicating when we find ourselves enjoying a song or painting that we've been working on and then take the occasion to express or show or share that joy, where there is no fishing for compliments intertwined. It is just a pure emanation (which is a joy in itself) of the joy that we are experiencing.

But be careful here. God's pleasure in all that He is as He knows, loves and enjoys Himself in the three persons of the triune God – the Father, the Son, and the Holy Spirit - and then the emanation or spillover of what He knows, loves, and enjoys of Himself in His creating is different from us. It does not mean that we should then, in all that we know, love, and enjoy of ourselves, spill over in creating so that others can share in *our* joy of *us* (as the source and end of our joy), but rather in the joy we know from and in God as our Source. To borrow Edwards' theme, we are only a stream of the fountain, we are not the fountain. And in being a stream, we can take great pleasure in being a stream, as it is a part of the fountain. But when we entertain our pride, and demand to be recognized as a fountain ourselves, and we engineer a dam at our stream-head, separating ourselves from the fountain, all we will do is dry up. And our little dam doesn't hinder the fountain's ability to flow for a second. It just keeps flowing, laughing at our little dam project while it births new streams.

In creating, we should follow our Creator's lead as He knows, loves and enjoys Himself (we enjoy God as the source and end of what we find pleasure in, not, we enjoy ourselves as the source and end of our pleasures – which is idolatry). Then in our enjoyment of God, and all that God is for us, we create from and for our pleasure in God, and we display it so that others can share in the joy that we have known in God (I John

1:3-4).

To apply this motive by which we create is not to apply a fetter, as one may be tempted to think. Rather, it is freedom from fetters! And so you can know just how artistically free this could set you with regard to topic, articulation and medium in your creating, take five minutes and begin a list of how many things God has created as an emanation of His knowledge, love, and enjoyment of Himself. I'll start you off: salt, sand, oxygen, tiger, feather, man, thunder, gravity, woman, light, silver, ant, rat, water, gold, redwood tree, humming bird, oil, flax, deer, uranium, cobra, glacier, scientist, hemp, crab, varying elevations, angel, komodo dragon, musician, time, fur, eye, scent, iron ore, radio wave, atmosphere, temperature, corn, fire, cilantro, horse, snow, volcano, hell....

In the name of Jesus, be free to enjoy what God delights to communicate of Himself!

THE CREATION TESTIFIES OF GOD TO OTHERS
– SPHERE TWO

Psalm 19:1-4a says:

> The heavens are telling of the glory of God; and their expanse is declaring the work of His hands. Day to day pours forth speech, and night to night reveals knowledge. There is no speech, nor are there words; their voice is not heard. Their line has gone out through all the earth, and their utterances to the end of the world.

When a sky breaks with lightning and thunder, such declaration is a work of God's hand. But is that what we see and hear when we are blinded by the light and deafened by thunder's peal? When a girl sings

the most beautiful melody, again, a work of God's hand is evinced. But is that what we hear with the ear of our soul?

Augustine confesses:

> And what is this God? I asked the earth, and it answered, "I am not he"; and everything in the earth made the same confession. I asked the sea and the deeps and the creeping things, and they replied, "We are not your God; seek above us." I asked the fleeting winds, and the whole air with its inhabitants answered, "Anaximenes was deceived, I am not God." I asked the heavens, the sun, moon, and stars; and they answered, "Neither are we the God whom you seek." And I replied to all these things which stand around the door of my flesh: "You have told me about my God, that you are not he. Tell me something about him." And with a loud voice they all cried out, "He made us."
>
> My question had come from my observation of them, and their reply came from their beauty of order. And I turned my thoughts into myself and said, "Who are you?" And I answered, "A man." For see, there is in me both a body and a soul: the one without, the other within. In which of these should I have sought my God, whom I had already sought with my body from earth to heaven, as far as I was able to send those messengers - the beams of my eyes? But the inner part is the better part; for to it, as both ruler and judge, all these messengers of the senses report the answers of heaven and earth and all the things therein, who said, "We are not God, but he made us."
>
> My inner man knew these things through the ministry of the outer man, and I, the inner man, knew all this - I,

the soul, through the senses of my body. I asked the whole frame of earth about my God, and it answered me, "I am not he, but he made me."[4]

The inner man is made cognizant by the ministry of the outer. They each are necessary to the other. "The heavens declare the glory of God" (Psalm 19). I am to grow in perception and not ignorance, recognizing God when my eyes and ears and skin and mind and nose and mouth experience the heavens. If I suppress the truth that God is the heaven's creator and that He is righteous, I will meet the wrath of God.

> For the wrath of God is revealed from heaven against all ungodliness and unrighteousness of men, who suppress the truth in unrighteousness, because that which is known about God is evident within them; for God made it evident to them. For since the creation of the world His invisible attributes, His eternal power and divine nature, have been clearly seen, being understood through what has been made, so that they are without excuse. For even though they knew God, they did not honor Him as God, or give thanks; but they became futile in their speculations, and their foolish heart was darkened. Professing to be wise, they became fools, and exchanged the glory of the incorruptible God for an image in the form of corruptible man and of birds and four-footed animals and crawling creatures. Therefore God gave them over in the lusts of their hearts to impurity, that their bodies might be dishonored among them. For they exchanged the truth of God for a lie, and worshiped and served the creature rather than the Creator, who is blessed forever. Amen (Romans 1:18-25).

Artists and lovers of art, take heed that no creature worship be among you. Rather, enjoy the Creator and enjoy His creatures as other evidences of the glory of God's creative genius. Fix your joy, hope, and loyalty in your artistic pleasures on "God, who richly supplies us with all things to enjoy" (I Timothy 6:17b). God gives us artistic expression to enjoy God. What do we do with it?

PRAISING GOD AS THE SOURCE
OF OUR CREATIVE ABILITIES

If we study God's motives in creating, and apply the same motives when we create, how can we be disappointed? God's resources and His creativity, who can match? "Oh, the depth of the riches both of the wisdom and knowledge of God! How unsearchable are His judgments and unfathomable His ways!" (Romans 11:33).

> Then God said, "Let Us make man in Our image, according to Our likeness, and let them rule over the fish of the sea and over the birds of the sky and over the cattle and over all the earth, and over every creeping thing that creeps on the earth." And God created man in His own image, in the image of God He created him; male and female He created them. ...And God saw all that He had made, and behold, it was very good...(Genesis 1:26-27, 31a).

God's affections are for Himself, the creator, when He declares His work to be good.

When a man composes a song, we must understand that his composing abilities were given to him by God. There is an important difference here to understand, the difference between when man creates

The Creation of the World as a Model for Artists

and when God creates. God as creator was never given abilities by anyone. No one made God to be God. God always was (John 1:1-3, John 17:5, Ephesians 1:3-4). God is right to ascribe final praise to Himself as the source of a work, but man would be incorrect, in fact sinful, to ascribe final praise to himself as the source of a work. Man, as a creator of art or tools, is only able to create because he is enabled by God to do so. Behind any talent of man, or underneath a talent, or however you want to say it, is God.

Listen to Spurgeon meditate on Psalm 34:1,

> To Jehovah, and not to second causes our gratitude is to be rendered. The Lord hath by right a monopoly in his creature's praise…we are not to rob God of his meed of honour because our conscience justly awards a censure to our share in the transaction. Though the hook was rusty, yet God sent the fish and we thank him for it.[5]

God gives us a clear lesson through Herod about what can happen when we do not acknowledge God as the source of our creativity.

> …Herod, having put on his royal apparel, took his seat on the rostrum and began delivering an address to them. And the people kept crying out, "the voice of a god and not of a man!" And immediately an angel struck him because he did not give God the glory, and he was eaten by worms and died (Acts 12:21b-23).

Listen to how Paul talks on this theme. "And for this reason we also constantly thank God that when you received from us the word of God's message, you accepted it not as the word of men, but for what it really is, the word of God, which also performs its work in you who

The Creation of the World as a Model for Artists

believe" (I Thessalonians 2:13). The people hear the truth and wisdom and good news that Paul brought and recognize it as being from God. And Paul is not jealous, wishing that the people would praise him for all his labor in bringing the message, but he is "constantly thanking God" that the people accepted it as from the Lord. What stories we would hear if all story tellers would be free of self and full of God, and all listeners would be mature listeners, recognizing the story for what it is – a story revealing something about God in the life of His creature.

Any work that an artist creates is the result of a portion of grace from God. This is true of the believer and unbeliever alike. David prays to the Lord for deliverance from the wicked men "…of the world, whose portion is in this life; and whose belly Thou dost fill with Thy treasure…" (Psalm 17:14a). The Lord is the dispenser of treasures. The Lord's graces fall on the just and the unjust (Matthew 5:45). The artist would be nothing if God had not given him the ability, talent, discipline, means, state of mind, emotion, and means of expression. All this is from God.

Paul says, "For who regards you as superior? And what do you have that you did not receive? But if you did receive it, why do you boast as if you had not received it?" (I Corinthians 4:7). The artist is merely doing what he was made to do when he creates. But let's be clear, that he was made artistically capable is an evidence of the greatness of God's work. The artist's boast can only rightly be in God, not himself.

So what is the object of an artist's affections in his artistry? God, self, or some other thing? John errors when he sees the angel, a fellow work of God, and bows to worship it. But the angel responds rightly when he tells John not to worship him. John records, "I fell at his feet to worship him. And he said to me, 'Do not do that; I am a fellow servant of yours and your brethren who hold the testimony of Jesus; worship God'" (Revelation 19:10a).

Do we understand that without God, we would not have ability, let alone exist? "For all things come from You O Lord, and from Your

hand we have given You" (I Chronicles 29:14b). God is the end of all that
He does. Until our affections are calibrated to ascribe final praise to God
in all things, we will forgo pleasures intended our enjoyment.

PRAISING GOD IN EXHORTING MAN

Once we understand where the final praise is correctly attributed
in the glory of man's work, then we can begin to know the full pleasures
in the place and purpose for exhorting men with praise as we see evidence
of the grandness of God in and through them.

Every once in a while in church, at least in the upper Midwest, we
find ourselves in that awkward moment of desiring to respond to some
evidence of the beauty of God in His creatures with applause or some
other noise-making affirmation, and yet a cultural atmosphere pressures
us to refrain from expressing our joy in that way. "…There is a time to
be silent, and there is a time to speak" (Ecclesiastes 3:7b). There is a time
when the right response is to vocalize nothing. Employing silence can be
a very appropriate and powerful affirmation. We in this Midwest culture
seem to know how to express silence pretty easily (though not often very
well). It seems, though, that there is a blessing we miss when we only
apply silence as the appropriate or default "awe-of-God" response.

To sonicly express our affections of praise is not wrong. We err
when we do not attribute that praise ultimately to God. I think one
reason for the breakdown in our Midwest cultural practice of "default
silence" is because we have a hard time seeing what man does beautifully
as a manifestation of the grandness of God. Frankly, we have a hard time
presenting something beautiful as being evidence of the grandness of
God, which is most often the root of the problem. We mostly think that
what we do beautifully demonstrates our grandness since we labored in
making something beautiful. And sometimes, when being overly bound-

by-law not to end up praising man, we barely praise God at all. Why not respond with praise to God for the beauty He creates when His creatures manifest the genius of their Author? The angels know how to respond with joy to God when seeing the beauty of His creative work (Job 38:7).

When I hear a man blow on his horn, swinging as hard as a man can swing, and his sound pushes me over into absolute joyfulness, and I tell him, "Jack, that was swingin'!" and I stop short in understanding or in attributing his ability to swing as being from God, I evidence my ignorance in how that swing just happened. My heart should feel or my mouth might even say something like, "Man, God has given you the swing!" All ability is from God whether I admit it or not. When I try to claim the glory in my abilities for myself, I sin (remember Herod). But when my praise runs through man and terminates on God when seeing an evidence of God in His creature, I will know an even greater, lasting joyfulness that does not fade away once my ear has forgotten the man's tune. Praising God for a work of art is not a barrier to my happiness, as the devil would want me to believe, it is a multiplying enabler of my greater happiness.

Here is another example of how we might express praise to a man in a way that honors God ultimately, acknowledges that the man is a means of God's blessing to us, and yet encourages the man to find his satisfaction in being faithfully obedient to God, rather than hoping to find his satisfaction in the praises of men.

> [John] to the beloved Gaius, whom I love in truth. Beloved,
> I pray that in all respects you may prosper and be in good
> health, just as your soul prospers. For I was very glad when
> brethren came and bore witness to your truth, that is, how
> you are walking in truth. I have no greater joy than this, to

hear of my children walking in truth. Beloved, you are acting faithfully in whatever you accomplish for the brethren, and especially when they are strangers (III John 1-5).

John is blessed to see his friend Gaius being faithful to God in his generosity to the brethren. It pleases Gaius to be generous: his soul prospers, which shows that Gaius hopes in God for his provision, and it does not cause him to lose any pleasure to give of his own in order to be a fellow worker with the brothers in the spreading of the truth of the Gospel. So Gaius' actions bless John because God is honored through Gaius' faithfulness with what God has given him. So John tells him! John applauds Gaius. He exhorts Gaius. John's praise even makes it as its own book in the Bible, III John.

But notice. John applauds Gaius for his faithfulness to God in his generosity to the brothers. Gaius' motive for generosity is grounded in the pleasure of God that he experiences when being faithful to God. A few verses later, in verse nine, John rips into Diotrephes for his selfishness. "I wrote something to the church; but Diotrephes, who loves to be first among them, does not accept what we say. For this reason, if I come, I will call attention to his deeds which he does…" (III John 9-10a). Diotrephes SEEKS his pleasure in his standing before men. Gaius FINDS his pleasure in being faithful to God. "The one who does good is of God; the one who does evil has not seen God" (III John 11b)

One more, Paul to Timothy:

I thank God…as I constantly remember you in my prayers night and day, longing to see you, even as I recall your tears, so that I may be filled with joy. For I am mindful of the sincere faith within you…. And for this reason I remind you to kindle afresh the gift of God which is in you… (II Timothy 1:3-6).

The Creation of the World as a Model for Artists

Timothy's faith, evidenced by his good works, is a blessing and encouragement to Paul, so Paul tells him. Paul tells Timothy in a way that honors the Lord as the source of Timothy's faith and good works, which both encourages Timothy in his laboring to be faithful and also reminds Timothy that his faith is a gift from God.

In the presentation of an artwork, there are two people involved - the creator and the beholder. It is possible for a creator to craft a painting of great beauty, recognized as pleasing by all eyes, and for the creator to claim, in his heart, all the glory. This is idolatry in the heart of the creator. However, a beholder of the same work, who recognizes God as the source and means of all the pleasing creativity fleshed out through the hand of a man, could respond with praise to God. Praise to God for God's work in creating the artist with such amazing skill. Praise to God for a veil lifted and a truth now seen through the means of a work of art. Praise to God for the grace given to that artist, as he was disciplined in the work of his hands. Praise to God that there are people who can express truths in ways that are different from how he is able to express them. Praise to God for His diversification of talent and function within mankind. Praise to God for all the enjoyment He gives us to experience in artistic expression. On and on we can go. Both Godly-worship and idolatry can result from beholding the same work.

If we could, in this life, see all artists creating from the overflow of their soul's enjoyment in God, and all beholders looking from the foundation of patient discernment, understanding that the artist was made by God and asking what God might be declaring of Himself through the artist and his art, what beauty we would see! Much more of God would be seen, and man would be seen to be what he is: man – an amazing creation of God (Psalm 8).

If we were more biblically discerning in how to give praise and how to accept praise, I believe we would see so much more of God and

would thereby receive so much more blessing and pleasure from God through a work of art.

GOD'S CREATION LEADS TO
THE DEMONSTRATION OF GOD'S MERCY

God is an amazing sculptor. He makes a man from the dust that He just made out of nothing. Then He breathes into that dust the breath of life, and the man lives! The man thinks, the man has emotion, the man hungers, the man takes pleasure. The man has life. When God endowed man with creative abilities, He did not give man the ability to breathe "life" into any of his works. While man is made fantastically creative, he is not the creator that God is.

God makes clear in Isaiah 46:3-13 that: we are a creation of His, we are subordinate and inferior to Him, He is merciful to the unrighteous as He desires.

Listen to Me, O house of Jacob,
And all the remnant of the house of Israel,
You who have been borne by Me from birth,
And have been carried from the womb;
Even to your old age I will be the same,
And even to your graying years I will bear you!
I have done it, and I will carry you;
And I will bear you and I will deliver you.
To whom would you liken Me,
And make Me equal and compare Me,
That we would be alike?
Those who lavish gold from the purse
And weigh silver on the scale

82

Hire a goldsmith, and he makes it into a god;
They bow down, indeed they worship it.
They lift it upon the shoulder and carry it;
They set it in its place and it stands there.
It does not move from its place.
Though one may cry to it, it cannot answer;
It cannot deliver him from his distress.

Remember this, and be assured;
Recall it to mind, you transgressors.
Remember the former things long past,
For I am God, and there is no other;
I am God, and there is no one like Me,
Declaring the end from the beginning
And from ancient times things which have not been
Done,
Saying, "My purpose will be established,
And I will accomplish all My good pleasure;"
Calling a bird of prey from the east,
The man of My purpose from a far country.
Truly I have spoken; truly I will bring it to pass.
I have planned it, surely I will do it.

Listen to Me, you stubborn-minded,
Who are far from righteousness.
I bring near My righteousness, it is not far off;
And My salvation will not delay.
And I will grant salvation in Zion,
And My glory for Israel.

There is no one like God. How wise God is in setting boundaries

The Creation of the World as a Model for Artists

on our creative abilities! If any of the songs that I wrote were somehow able to return some sort of praise to me for writing them, I would be all the more tempted to claim for myself the glory of my abilities. This is the nature of our flesh. We want all the credit. We want to be God. But we are not God. We are a creation of God, one of many amazing creations of God! Study the human body and enjoy the genius of your Maker! God did give man great skill to work with the human body, but He didn't give man the ability to breath "life" into it. Only God is the giver of life, which makes it plain to me that there is a great difference between man and God, between my creative abilities and His creative abilities.

Understanding this difference between God the Creator and man the created should help me know then why I should labor in creating. I was not created to attempt to establish a name for myself as some amazing, creative creature (Genesis 11:1-9). God has already established that name for Himself. I was created to uniquely evidence, know, and enjoy the greatness of my Creator, who is immeasurably greater than I. So, for my joy, I should labor to that end.

There is an attribute of God that is particularly demonstrated in that He made me a man and not a tree, namely, that I might be a visible, living evidence that God is, amongst His countless attributes, merciful.

I bring up mercy because Paul tells us in Romans 1 that we have all suppressed the truth about God that is made plain in creation, bringing the wrath of God upon ourselves by rejecting His truth. Then he says to the Ephesians:

> But God, being rich in mercy, because of His great love with which He loved us, even when we were dead in our transgressions, made us alive together with Christ – by grace you have been saved – and raised us up with Him, and seated us with Him in the heavenly places, in Christ

Jesus, in order that in the ages to come He might show the surpassing riches of His grace in kindness toward us in Christ Jesus. For by grace you have been saved through faith; and that not of yourselves, it is the gift of God; not as a result of works, that no one should boast. For we are His workmanship, created in Christ Jesus for good works, which God prepared beforehand, that we should walk in them (Ephesians 2:4-10).

Christ died so that sinful men could be reconciled to God their Maker. Our flesh desires to be God, which is the reason it will die (which is in itself a merciful act of God that I do not have to live in this sinful frame forever – Genesis 3:22-24). Christ did not die so that angels or demons or dogs or planets can experientially know the mercy of God upon them. But through sinful man being given mercy by God, to all who would repent, all of creation, including angels, demons, dogs and planets will see the demonstration of what God knows and enjoys of His mercy (Romans 8). God's mercy is uniquely made known in general through the race of men and specifically in each individual person He shows mercy to. And as I have tasted the beauty of the mercy of God, it is truly pleasurable to be an evidence of it. His mercy is so beautiful! I praise God that He created in such a way that we could know and enjoy the beauty of His mercy!

Artists, what do our artistic creations demonstrate about us? Do they demonstrate our pride or our joy; our rights or our humility; our demands for recognition or our servanthood; "our" skill or God's skill in us; our love for ourselves or our love for one another. "But God demonstrates His own love toward us, in that while we were yet sinners, Christ died for us" (Romans 5:8). God's love, demonstrated in His mercy, is immeasurably more beautiful than our pride. What does your art-working demonstrate of you?

The Creation of the World as a Model for Artists

GOD CREATED US CREATIVE – NOT WE OURSELVES

People who are creative in the arts must understand that it is God who made them, and made them creative. Psalm 100:3b "It is He who has made us, and not we ourselves." People who are blessed by creative people in the arts must understand that it is God who gave their favorite artist such creativity. When either group rightly attributes the ultimate source of the creativity as being God, then their affections are set to enjoy the fullest potential pleasures. But where their praises stop at the artist, the artist is then worshiped in measure, which is idolatry, yielding a truly lesser pleasure.

Our minds must be transformed to understand all of life with God as the chief supplier and end, which He is.

> I urge you therefore, brethren, by the mercies of God, to present your bodies a living and holy sacrifice, acceptable to God, which is your spiritual service of worship. And do not be conformed to this world, but be transformed by the renewing of your mind, that you may prove what the will of God is, that which is good and acceptable and perfect (Romans 12:1-2).

The artist must renew his mind to know how to create and display his work in faith, pointing to God and His grace, so that his labors are pleasing to God. God is the ultimate and final audience, not man. Only then can the artist know the full pleasures to be had in his artistic labor. And the viewer must renew his mind to see and delight in God in the artistry of man, that his viewing would be pleasing to God. Only then will the viewer experience the full measure of pleasure in a work's beauty.

All artwork is an image that flows from an author's heart, "…for

86

his mouth speaks from that which fills his heart" (Luke 6:45b). An image is a representation, and man, being an image of God, is not God. Man is an image, and he should image forth God. From the perspective of "ought to," man ought to be a good image because he is a testimony (Sphere Two) to others of the greatness of his Imager. From the perspective of "desire," man should desire to be a good image of God so that he might experience (Sphere One), at least in part, the pleasures of God that are to be experienced when being (Sphere Two) a good image of God. Marrying these two perspectives together, we need grace to "ought to desire" so that we would grow in grace to where we "desire to ought."

Artists, let's be still and know that God alone is God. We have so much to learn, love, and enjoy of Him regarding creating.

Art for the Sake of Art?

Worthy are you, our Lord and God, to receive glory and honor and power, for you created all things, and by your will they existed and were created. (Revelation 4:11 ESV)

...the builder of a house has more honor than the house itself. For every house is built by someone, but the builder of all things is God. (Hebrews 3:4 ESV)

In its most innocent sense, we understand "art for the sake of art" to mean something like this:

An artistic work created with the intent to skillfully express a truth, a thought, an emotion, an image, an exploration, a discipline, etc., that is not compromised by outside influences or ulterior motives.

A compromising outside influence (something that comes to the artist) might be an economic market, a fad, or another person who attempts to persuade the artist as to what he should say in his art, or how he should express it. A compromising ulterior motive (a motive coming

90

from within the artist) would influence the artist so that something else might thereby be obtained through his art: money, status, recognition, etc. When either of these two influences govern the artist, the artwork (the expression) is going to be compromised in some way. And so the cry for "art for the sake of art" has been sounded by both artists and audience alike to say: "Let the artist express himself freely."

While this desire for freedom is honest and beneficial to a degree, it has also caused some to over-regard an artwork as a kind of living, protected being whose worth cannot be questioned or scrutinized. Call something "art" today and it becomes untouchable, protected! And even more than that, there is an unspoken demand upon the observer to affirm, enjoy, and defend the artwork, especially if the observer hopes to be accepted in that particular circle of art-lovers. Unfortunately for artist, audience, and even "art," these winds of untouchability seem to be prevailing today. And so the cry "art for the sake of art" has morphed from a protection against expression contamination, into a warrant for praiseworthy existence.

But even if protection from expression contamination is all that we mean or all that we pursue in "art for the sake of art," and nothing more, we evidence that we are still ignorant of why art exists. I don't believe that this creed will ultimately satisfy the artist or observer.

GOD RICHLY SUPPLIES US WITH
ALL THINGS TO ENJOY

One reason that artistic expression exists is so that man can take pleasure and enjoyment in it, and thereby take pleasure and enjoyment in its author, God. Art exists in this capacity by the direct design of God "who richly supplies us with all things to enjoy" (I Timothy 6:17). That art is enjoyable to us is due to God conceiving that artistic expression

exist and giving it to us with the design that it would be pleasurable to our bodies and soul. God has given us art for our enjoyment. To try to understand just how connected God is to our enjoyment in art, or in anything, I ask this question: Can anyone experience enjoyment apart from God? Solomon, who had everything a man could attempt to take pleasure in (and all of that directly from the hand of God - I Kings 3:11-14) said this; "There is nothing better for a person than that he should eat and drink and find enjoyment in his toil. This also, I saw, is from the hand of God, for apart from Him who can eat or who can have enjoyment?" (Ecclesiastes 2:24-25 ESV)

Apart from God, nothing would exist. Nothing can be considered as being apart from (independant of; having no direct subordinate relationship to) God. God "created all things, and by [His] will they existed and were created" (Revelation 4:11 ESV). "For by [Christ] all things were created, both in the heavens and on earth, visible and invisible, whether thrones or dominions or rulers or authorities -- all things have been created through Him and for Him. He is before all things and in Him all things hold together" (Colossians 1:16-17). "All things came into being through [Christ], and apart from Him nothing came into being that has come into being" (John 1:3).

Consider this: not even the wicked can enjoy the pleasures of life apart from God. David cries out to the Lord to save him from the "men of the world whose portion is in this life." David continues, "You fill their womb with treasure; they are satisfied with children, and they leave their abundance to their infants" (Psalm 17:14). Even the pleasures that the wicked find are a measure of grace from the hand of God. Everything is from the hand of God. The reality of artistic expression, man's abilities in it, and its purpose for bringing the body enjoyment, are all from the hand of God. Apart from God, there would be no such thing as artistic expression. We should honor God by considering what He is revealing about Himself when one of His creatures expresses himself artistically for

our enjoyment.

But this is where we have gone astray. We have more often dishonored God, which has resulted in experiencing a lesser degree of pleasure in artistic expression, when we have enjoyed art as something apart from Him, or more defiantly, in place of Him. To enjoy anything that God has made apart from enjoying God in it and for it, is to not enjoy the full pleasures that God has designed for my enjoyment with it.

Whatever God creates is a testament to Him, its Creator. The created is always a demonstration of the glory of its creator. The creator is always more glorious than the created, as the created is ever only a manifestation of the skill of its creator. So the created (here I mean this category we refer to as the ability to artistically express one's heart) in all the ways that it proves to be pleasurable, points to a greater pleasure to be known and enjoyed in the enjoyment of its Creator, God. God is a greater pleasure than is His pleasant creation - artistic expression. This is why I believe that "art for the sake of art" is a deficient creed. It culminates and terminates on art, and not God. It cannot attain the full freedom and pleasure for which it cries.

We also go astray when we enjoy anything that God has made for a purpose other than that for which God has given it to us for our pleasure (i.e., the pleasures of sex pursued in adultery, the pleasures of food pursued in gluttony, etc.). We make this navigational error when we choose to take the path that ends at us (or art), rather than the path that ends at God. That we take pleasure is not the issue. God desires that we do (Ecclesiastes 2:24-25). It is the end of our pleasure that proves to be the issue. When we are the end of our pleasures in art, we will find less pleasure than when God is the end of our pleasures in art. Just consider for a moment the wisdom and genius of man versus the wisdom and genius of God. The two don't even slightly compare. So why are we so quick to settle with the wisdom and genius of man's ways for enjoying art, when we could be enjoying art according to the wisdom and genius

of God?

I want to look again at King Solomon's conclusion that there is nothing better for a person than to "eat and drink and find enjoyment in his toil." We will only find the most satisfying enjoyment in our toil if it is honest and free from deceit and all evil motives. If a man's work proves to be good, to be faithful in its execution and valuable in its purpose, it is so from the hand of God. Its goodness is not apart from God.

Just because I am not aware of where a gift comes from does not mean no giver was involved. God is always the giver in our lives whether or not we acknowledge Him to be. When I find a gift in the mailbox with no hints as to who had put it there, that doesn't mean that it spontaneously appeared, or that it put itself there. There was a giver. To push even further, I do not have to know who the giver was to be able to enjoy the gift. But when I attribute a gift as coming from someone other than the actual giver, I prove my ignorance. I've shown that I cannot discern its giver rightly. And, I dishonor the true giver when I offer my gratitude for the gift to another giver.

This is what we have often done to God with His gift to us of artistic expression. We have attributed art to the genius of man and have disregarded the fact that the omniscient genius of God created the limited genius of man. I have no excuse for disassociating artistic expression from God because I can read Romans 11:36 which says, "from Him and through Him and to Him are all things - to Him be the glory forever. Amen." God is the giver of all things, whether or not I want to admit it.

"I AM AN ARTIST FIRST, AND I HAPPEN TO BE A CHRISTIAN"

Another danger in using this "art for the sake of art" talk is that we begin to set inaccurate boundaries in our minds. We treat God as if

we can put Him in and take Him out of what we create. How ignorant of us. There is nothing that is, that is apart from God. "All things came into being by Him, and apart from Him nothing came into being that has come into being" (John 1:3). "…The worlds were prepared by the word of God, so that what is seen was not made out of things which are visible" (Hebrews 11:3b). I cannot take anything and push on it hard enough and not end up back at God. Not microphones, not digital technology, not lighting or film, not distribution channels, not ink or replicators, nor the people who have imagined and built all these things. Not the muscles, heart, and brain of man, not the materials used, not the skills exercised. Nothing. In everything, we will always end up at God. Art as we know it would not exist if God did not give man the abilities to dream and imitate and compose, and then sustain man such that he could work out his ideas into works of art.

In Christian circles I often hear talk like this: "I am an artist first, and I happen to be a Christian, and I create art to be true to art (or something to that effect)." This is often the response that's given when an artist is asked if, or told that, he is a "Christian artist." In such cases, he is usually trying to distance himself from sloppy attempts at artistically articulating something of God without much skill or discipline being applied in the expression. It is often combined with the demand that the person's work be recognized as a "work of art," and he be recognized as an "artist." And so, not wanting to be associated with that group, some artists think the right response is to divide the title and invert the order rather than to biblically understand and clarify how, or even if, the two fit together. Let's deconstruct this "artist first…" statement to help us see again how it will not lead us to the fullest pleasures we are hoping to enjoy when we employ it as our creed.

To say that first I am an artist, and then I am a Christian, or even an agnostic or atheist, is just incorrect. Art is an expression from the soul of a man. The man is not birthed out of art. Art is birthed out of the

man. A Christian is a known being long before he is even aware of his being. Ephesians 1:4 says, "...[God] chose us in [Christ Jesus] before the foundation of the world, that we should be holy and blameless before Him." Revelation 13 tells of the future events where the beast is allowed to make war on the saints and conquer them, and all who dwell on the earth will worship the beast, that is, "everyone whose name has not been written before the foundation of the world in the book of life of the Lamb that was slain" (vs. 8 ESV). David says, "Your eyes saw my unformed substance; in your book were written, every one of them, the days that were formed for me, when as yet there were none of them. How precious to me are your thoughts, O God!" (Psalm 139:16-17a ESV). A Christian is in Christ long before he is even aware of art. A Christian is God's offspring, not art's offspring. "Being then God's offspring, we ought not to think that the divine being is like gold or silver or stone, an image formed by the art and imagination of man" (Acts 17:29).

As the process of becoming aware of my need for Christ unfolds, I learn that I should have no other gods before God (Exodus 20:3). I learn that I should not covet anything of my neighbor's, like his paintings, or his season tickets to the jazz club, or his wife (Exodus 20:17). I learn that in whatever I do, whether eating or drinking, I should "do all to the glory of God" (I Corinthians 10:31b).

"To the glory of God" involves not being ashamed of God. So if the motive for saying "I'm an artist who happens to be a Christian" is because you first want to be recognized by what you do and who you hang with on earth, rather than by who made you and gives you the grace and pleasure to be able to compose a work of art, then take this warning from Jesus in Matthew 10:33, "But whoever shall deny Me before men, I will also deny him before My Father who is in heaven."

However, just because I acknowledge God in my art does not mean that the work is being done to the glory of God. My work may

be motivated, in my heart, by the glorification of myself. How often do we hear people say, "I want to thank God for this opportunity..." while they evidence no love of God for the opportunity. An artwork of mine can surely evidence something of the glory of God to others, and yet can profit me nothing when I seek my own glory in its composition or performance, even though I thank God with my mouth for it. Such a labor proves to have not been done to (motivated by the enjoyment of) the glory of God.

Or maybe we say "I am an artist first and then a Christian" because we are truly honest that our heart loves art more than it does Christ. I ask those of whom this is true to consider Christ who prayed to God for you like this on His way to the cross, to bear the full justice of God's wrath upon his body for the guilt of your sins:

> But now I [Jesus] come to Thee [Father]; and these things I speak in the world, that they may have My joy made full in themselves. I have given them Thy word; and the world has hated them, because they are not of the world, even as I am not of the world. I do not ask Thee to take them out of the world, but to keep them from the evil one. They are not of the world, even as I am not of the world. Sanctify them in the truth; Thy word is truth. As Thou didst send Me into the world, I also have sent them into the world. And for their sakes I sanctify Myself, that they themselves also may be sanctified in truth. I do not ask in behalf of these alone, but for those also who believe in Me through their word; that they may all be one; even as Thou, Father, art in Me, and I in Thee, that they also may be in Us; that the world may believe that Thou didst send Me. And the glory which Thou hast given Me I have given to them; that they may be one, just as We are one; I in them, and Thou in

Me, that they may be perfected in unity, that the world may know that Thou didst send me, and didst love them, even as Thou didst love Me. Father, I desire that they also, whom Thou hast given Me, be with Me where I am, in order that they may behold My glory, which Thou hast given Me; for Thou didst love Me before the foundation of the world. O righteous Father, although the world has not known Thee, yet I have known Thee; and these have known that Thou didst send Me; and I have made Thy name known to them, and will make it known; that the love wherewith Thou didst love Me may be in them, and I in them (John 17:13-26).

Has any art loved you like this? Has any artist loved you like this? The love of, or from, the created (man and his artistic expression) does not compare to the love of Christ, its Creator! The current pleasures you are enjoying in art without enjoying God pale in comparison with the pleasures you could be enjoying of God when enjoying art.

Sometimes the statement "I am an artist first..." is given in an effort to justify why the name of God isn't explicitly stated in the artwork. When this is the motivation for such a clarification, without intending to sound harsh here, it seems to reveal the immaturity in the knowledge of God on the part of the one who needs the justification. God is able to declare His glory to us without saying His own name.

The heavens are telling of the glory of God; and their expanse is declaring the work of His hands. Day to day pours forth speech, and night to night reveals knowledge. There is no speech, nor are there words; their voice is not heard. Their line has gone out through all the earth, and their utterances to the end of the world (Psalm 19:1-4a).

Art for the Sake of Art?

And again in Romans 1:18-25:

> For the wrath of God is revealed from heaven against all ungodliness and unrighteousness of men, who suppress the truth in unrighteousness, because that which is known about God is evident within them; for God made it evident to them. For since the creation of the world His invisible attributes, His eternal power and divine nature, *have been clearly seen, being understood through what has been made, so that they are without excuse.* For even though they knew God, they did not honor Him as God, or give thanks, but they became futile in their speculations, and their foolish heart was darkened. Professing to be wise, they became fools, and exchanged the glory of the incorruptible God for an image in the form of corruptible man and of birds and four-footed animals and crawling creatures. Therefore God gave them over in the lusts of their hearts to impurity, that their bodies might be dishonored among them. For they exchanged the truth of God for a lie, and worshiped and served the creature rather than the Creator, who is blessed forever. Amen (emphasis mine).

God is confident that His glory has been declared through what He has made because He knows that He is the source of it all. But we are not confident that the glory of God can be declared unless we explicitly mention His name because we don't know, or recognize, or want to admit that He is the source of all. We are terrible observers. We need to grow in our knowledge of God so that we can be confident where God is confident. With confidence that is grounded in truth will come our freedom. And with freedom comes the ability to see more of what God is declaring of Himself in all that He has made, including His creation

Art for the Sake of Art?

- the artist.

To take a defense behind the line, "I am an artist first who happens to be a Christian..." is really an attempt to position oneself before men ("Oh, he's not a 'Christian artist,' he's just an artist, so he doesn't need to mention the name of Jesus. I can then take pleasure in his work without feeling like he is pressuring me to enjoy God somehow for it"). Or it is a revelation of the desire to reserve the right to decide when God should be the object of our affections, or when he, the artist, should be the object of our affections.

It seems to me that the most fruitful scenario would be where all of mankind, on either side of the artwork, would have the eyes to see and the motivation to enjoy and display the glory of God in an artwork so that this feeling for a need of sub-categorization (like "Christian" artist) would not exist and thereby eliminate the problems and confusion brought on by employing it.

Artists, understand and confess and enjoy the reality that you are made by God, to the glory of God. And in a unique demonstration of His glory, He made you artistic. Then, when asked what you do in life, you can with great freedom say from faith, "I'm an artist," because God has made you an artist. The market didn't make you an artist. God made you an artist. The market doesn't keep you an artist. God keeps you an artist. And if God made you and keeps you an artist, then art is never the end because both you and your art have their beginning in, are sustained by, and demonstrate a portion of the glory of the creative genius of God.

FREEDOM FROM GOD IS NOT FREEDOM

Look what happens when we do not accept the truth and acknowledge the fact that God is a greater end than art itself:

Art for the Sake of Art?

And just as they did not see fit to acknowledge God any longer, God gave them over to a depraved mind, to do those things which are not proper, being filled with all unrighteousness, wickedness, greed, evil; full of envy, murder, strife, deceit, malice; they are gossips, slanderers, haters of God, insolent, arrogant, boastful, inventors of evil, disobedient to parents, without understanding, untrustworthy, unloving, unmerciful; and although they know the ordinance of God, that those who practice such things are worthy of death, they not only do the same, but also give hearty approval to those who practice them.... And we know that the judgment of God rightly falls upon those who practice such things (Romans 1:28-32, 2:2).

Does this not sound like the bondage in the arts community? Artists have demanded, both subtly and not-so-subtly, to be God, and God has given them (us) over to their (our) desires. The refusal to acknowledge God in the artistic arenas is a terrifying creed to hold. Freedom from God is not freedom. It's a curse. And the curse is this: being given over by God Himself to be enslaved to the flesh which desires all the evils mentioned above. But, if you want to experience true freedom in the arts, enslave yourself to God who "richly supplies us with all things to enjoy" (I Timothy 6:17b). "If you continue in My word, then you are truly disciples of mine; and you will know the truth, and the truth will make you free" (John 8:31b-32). God is a much better Master than art could ever be.

We should hear a warning from the life of Belshazzar, the Chaldean king. Belshazzar held a feast and ordered the gold and silver vessels from the temple in Jerusalem to be brought in so he and his nobles and wives could drink from them. After they had drunk from them they "...praised the gods of gold and silver, of bronze, iron, wood and stone" (Daniel

5:4). Then a hand appeared and wrote on the wall as they were feasting. "The king's face grew pale, and his thoughts alarmed him; and his hip joints went slack, and his knees began knocking together" (Daniel 5:6). Daniel was summoned to interpret what the hand wrote. The writing said, "...God has numbered your kingdom and put an end to it...you have been weighed on the scales and found deficient...your kingdom has been divided and given over to the Medes and Persians" (Daniel 5:26-28). That very night Belshazzar was slain.

So what brought all this upon Belshazzar? He was full of pride and did not acknowledge that God is the ruler over all mankind, and that He alone is to be the end of his praise. Belshazzar even had his father's example (Nebuchadnezzar's arrogance and then humbling) right before his very eyes, but he did not listen to it. Daniel rebukes Belshazzar, "...You have praised the gods of silver and gold, of bronze, iron, wood and stone, which do not see, hear or understand. But the God in whose hand are your life-breath and your ways, you have not glorified" (Daniel 5:23b).

God, give us ears to hear this! If we, in our proud, arrogant hearts do not acknowledge the Giver of our life-breath and our artistic ways and pleasures, we will be found deficient as well when we are weighed.

How often do we praise art as some kind of god? When pleasure is had from silver and gold, paintings and music, wood and iron and stone, theater and dance, we would be wise to understand that the pleasures we experience in those things (the unadulterated pleasures) are given to us from God for our enjoyment. They are gifts to us from God for our pleasure. But when we praise the "gods of art," when we apply the mind of "art for the sake of art" as we observe and create, we set up art to be the end of art, and thereby find ourselves standing in opposition to God.

Earlier, Nebuchadnezzar's thoughts were found standing in opposition to God's and he was shown, in no uncertain terms, who the actual Giver of authority was. God cursed Nebuchadnezzar to roam

around as a field beast for his arrogance. But when God restored his reason, Nebuchadnezzar confessed:

> [God's] dominion is an everlasting dominion, and His kingdom endures from generation to generation. All the inhabitants of the earth are accounted as nothing, but He does according to His will in the host of heaven and among the inhabitants of earth; and no one can ward off His hand or say to Him, "What hast Thou done?" (Daniel 4:34b-35).

The creed "art for the sake of art" just does not stand as majestically as we hoped it would when behind all artistic pleasure stands God. But when we yield and acknowledge that God is the giver, the means, and the end of all things, whether that's kingdoms or artworks, then we can fully experience the very feelings, emotions, satisfactions, pleasures and joys we were hoping to find in them, but could not fully know due to our misplaced affections as we exchanged the glory of the Creator for that of the created.

DELIGHTS THAT DO NOT PROFIT

Let's look from another angle at this "art for the sake of art" effort as an attempt to free artistic works from so many of the commandeering motives that are involved in artistry today. To say "art for the sake (or purpose) of art," rather than "art for the sake of (put in here all motives or objects that have tempted you to curb what your heart truly desires to express because of money, status, provision, fame, etc.), while sounding more pure, only eliminates some of the most obvious villains. We are trying to find a pure joy in art by setting up the filter of "art for the sake

Art for the Sake of Art?

of art." But that filter does not strain out the artist's pride. And no art is apart from its creator, contrary to some assertions. Offer ten million dollars for a work of art and you can be sure its creator will step forward to claim authorship and authority over the work. As soon as we make art the end of art, we will either terminate our enjoyment on the artist, the "creator" of the "pure art," or we will make the artwork, that has no life in it, the final object of our affections of delight. Both of which are passing like the grass.

Regarding the pride in our hearts, we will look at that more in depth later. Regarding the artwork itself, God tells us in Isaiah 44:9-21 that:

> All who fashion idols are nothing, and the things they delight in do not profit.... The carpenter stretches a line; he makes it out with a pencil. He shapes it with planes and marks it with a compass. He shapes it into the figure of a man, with the beauty of a man, to dwell in a house. He cuts down cedars, or he chooses a cypress tree or an oak and lets it grow strong among the trees of the forest. He plants a cedar and then the rain nourishes it. Then it becomes fuel for a man. He takes a part of it and warms himself; he kindles a fire and bakes bread. Also he makes a god and worships it.... Half of it he burns in the fire. Over the half he eats meat; he roasts it and is satisfied.... No one considers, nor is there knowledge or discernment to say, "Half of it I burned in the fire; I also baked bread on its coals; I roasted meat and have eaten. And shall I make the rest of it an abomination? Shall I fall down before a block of wood?" He feeds on ashes; a deluded heart has led him astray, and he cannot deliver himself or say, "Is there not a lie in my right hand?" (ESV).

We have modernized how we commit this foolishness, this sin. We are not so primitive, but we do the very same thing when we put our hope or trust or glory in our work of art, a thing which has no life in it, rather than in God. Anytime we put our hope in our work, and not in God, we make our work an idol of our heart. So when we employ "art for the sake of art" as our creed, we still haven't pushed hard enough to satisfy our quest to know the fullest measure of pleasure to be had in art.

ART FOR THE SAKE OF ENJOYING GOD THE GIVER OF ART FOR OUR ENJOYMENT

We should push to enjoy "art for the sake of enjoying God, the giver of art for our enjoyment." We will only be able to tap into the full pleasures to be had in a work of man's hands when we recognize God as the ultimate giver of the work. "For every house is built by someone, but the builder of all things is God" (Hebrews 3:4). I say "fully enjoy," because if I do not see God in a work, that shows that not all of my receptive senses are working. If I were blind, I could not enjoy a painting as fully as one with sight. If I were deaf, I could not enjoy Duke Ellington's swing as fully as one who hears. And if I do not have discernment, I cannot unlock a riddle and enjoy its treasure. Without discernment, all that I can enjoy is the verse and penmanship of the riddler.

I want to enjoy every pleasure an artwork has to offer. But I will only begin to fully enjoy anything when I understand its source and end as being God. Color is not man's idea, but God's – "Then God said, 'Let there be light' and there was light" (Genesis 1:3). Form is not man's idea, but God's – "Then God said, 'Let the waters below the heavens be gathered into one place, and let the dry land appear'; and it was so" (Genesis 1:9). Sound is not man's idea, but God's – "Listen closely to the thunder of His voice, and the rumbling that goes out from His mouth"

(Job 37:2). Discipline is not man's idea, but God's – "For God has not given us a spirit of timidity, but of power and love and discipline" (II Timothy 1:7). Skill is not man's idea, but God's – "…in the hearts of all who are skillful, I have put skill…" (Exodus 31:6b). Man is not man's idea, but God's – "Then God said, 'Let Us make man in Our image, according to Our likeness; and let them rule…" (Genesis 1:26a).

When we set up the filter "art for the sake of enjoying God, the giver of art for our enjoyment," everything undesirable will be forced to be strained out, including our pride, because it is impossible to fully enjoy both God and something from God, in a way other than how God delights in it and intends for it to be pleasurable to us. It is impossible to fully enjoy God and boast in myself. Where there is any boasting in myself, I prove that I don't fully know or enjoy God.

This filter will accomplish what "art for the sake of art" hoped to accomplish. The creed "art for the sake of art" set up a guideline that sought purity but never fully provided it. As soon as all motives appeared to be for the sake of art, our own boasting raised its head and proved that it was not for the sake of art anymore. It was for the sake of the name of the artist. So "art for the sake of art" cannot bring about the purity that it hopes to. It comes close, and it helps make us aware of our many tainted motives. We pursue a kind of purity because it is written on our conscience to do so (Romans 2:14-15). And when we clean all the outward mechanisms, we find that within ourselves lies the corruption, "I find then the principle that evil is present in me, the one who wishes to do good" (Romans 7:21). We are in need of the grace of God to come in and eliminate our boasting, and only then will we experience the pleasures of the aroma of true purity (Romans 7:24-8:1). Only then will we be able to experience, in full measure, the pleasure to be found in works of art as God has given artistic expression to us for our enjoyment. Our enjoyment in, not apart from, Him!

God gave Michelangelo artistic ability so that Michelangelo could learn of, love, and enjoy (worship) his Creator (Michelangelo's Sphere One). Was Michelangelo faithful? He, we, will find out one day. And God gave the world Michelangelo so that the world could learn of, love, and enjoy (worship) God when considering His work - Michelangelo (God's Sphere Two). Are we faithful in our seeing? We will find out one day. God is a gracious God. He loves to give good gifts to His people (Psalm 81) of which Michelangelo was one. And God is rightly jealous. He will not give His glory to another (Isaiah 42:8).

Once Nebuchadnezzar acknowledged God as the giver of his kingdom, his earthly sovereignty was restored and "surpassing greatness was added" (Daniel 4:36) to his reign. Nebuchadnezzar had new faculties that were capable of seeing, or squeezing, more pleasure from each portion which now yielded a far greater quality of pleasure.

If we are seeking after the greatest and purest pleasures in art, the creed "art for the sake of art" won't provide it, as art is not the end of art. We can try to make it an end, like a cul-de-sac is an end of a road. But understand this: a cul-de-sac is just a dead end with much more land to be enjoyed lying beyond it's curb. However, the creed "art for the sake of enjoying God, the giver of art for our enjoyment" will take us to pleasures unsettled and beyond what we are capable of taming. We will need all of eternity to see, explore, and enjoy the glory of its terrain.

What Defiles a Man?

Listen to Me [Jesus] all of you and understand: there is
nothing outside the man which going into him can defile
him; but the things which proceed out of the man are
what defile the man. (If any man has ears to hear, let him
hear)... That which proceeds out of the man, that is what
defiles the man. For from within, out of the heart of men,
proceed the evil thoughts, fornications, thefts, murders,
adulteries, deeds of coveting and wickedness, as well as
deceit, sensuality, envy, slander, pride and foolishness. All
these evil things proceed from within and defile the man.
(Mark 7:14b-16, 20b-23)

But I [Jesus] say to you that everyone who looks at a woman
with lust for her has already committed adultery with her in
his heart. (Matthew 5:28)

Defiling comes from within, not without. When an artist creates
a work, the work is an expression of what lies within the artist. If a
musician desired to motivate a listener for action, he would probably
employ a tempo that would prod the listener off his emotional couch and

prime him for action. Certain tempos, chords, and rhythms will act to relax while certain tempos, chords, and rhythms will act to stimulate. The tempo, chord, or rhythm is not what defiles a man, as they have no heart. The author has the heart. What end or action is the author's heart desiring that we be relaxed or stimulated towards? Are we being relaxed towards fornication or relaxed from burdens and anxieties? The exact same tempo, chord, and rhythm could be used to elicit both. Are we being stimulated towards a God-pleasing love, or are we being stimulated towards adultery? Again, the exact same tempo, chord, and rhythm could be used for both. We must be careful to understand that an artistic expression is just that: an expression that evidences a heart. It is the heart, where evil proceeds from, which renders a man defiled.

There is a time to relax and be calmed, and there is a time to rouse and be zealous. Music can be a helpful catalyst for both, but if we employ the catalyst of music to encourage the desires of the flesh rather than those of the Spirit, sin is not far behind. The music does not sin. The man sins. Music does not have a heart. Man has a heart. A tempo, chord, or rhythm is just a catalyst employed by an author's heart to attempt to communicate or encourage a certain desired understanding or response. A catalyst is something that causes another thing to happen without being affected or consumed itself. So I say that music is employed as a catalyst when an author uses it to express (communicate) what his heart is enjoying (whether that is joy, pity, sorrow, lust, despair, hope, excitement, anger, etc.) to another's heart. But the music itself is unaffected in the process because it has no heart. So when I tell my young children, "That was a bad song. It is not good for you to listen to that." I'm not talking about the music, the sound, I'm talking about the foul expression of the author's (or the character's) heart. It is always the author, and never the music, which will be judged defiled.

THE EXPRESSION EVIDENCES THE HEART

So the question is: what end are we pursuing when we express ourselves through a composition or a painting? The end, which is the beginning, is the issue. Are we pursuing fornication? Fornication begins in our heart. Are we pursuing encouragement? Encouragement begins in our heart. Are we pursuing envy? Envy begins in our heart. What good or evil thing (desire, thought) is the heart expressing as it uses the means of music or painting or dancing or words to communicate itself? Answer that question and you will find whether or not the author stands in defilement as his music or poetry makes known his heart. "That which proceeds out of the man, that is what defiles the man. For from within, out of the heart of men, proceed the evil thoughts…" (Mark 7:20b-21a). The expression evidences the heart.

Now the listener or viewer has his own heart, a different heart. As the viewer observes and takes in a work of art, it is not the mere taking in that defiles the listener. I don't mean to imply that anything should be taken in without discretion. That is not helpful, nor the point. What I take in may be unhealthy for me and make me sick. "All things are lawful, but not all things are profitable. All things are lawful, but not all things edify" (I Corinthians 10:23). There is quite a difference between hearing and embracing. They are not the same.

But don't get cocky with this difference! "Pride goes before destruction, and a haughty spirit before stumbling" (Proverbs 16:18). David resolves to guard his heart from temptation in Psalm 101:3-4, 5b when he says, "I will set no worthless thing before my eyes; I hate the work of those who fall away; it shall not fasten its grip on me. A perverse heart shall depart from me; I will know no evil…. No one who has a haughty look and an arrogant heart will I endure." David resolves to be alert and not let the evil of another man's heart have any ground in his.

LOSS OF PLEASURE DUE TO IGNORANCE
OR ERRONEOUS TRADITION

I am pushing to discern how defiling happens and what it is that defiles so that I don't enslave myself with unnecessary fetters, or even forfeit pleasures, due to ignorance or erroneous tradition.

I say forfeit pleasures because Jesus says to the scribes and Pharisees in Mark 7 (just before He unpacks what does defile a man):

> Rightly did Isaiah prophesy of you hypocrites, as it is written, "This people honors me with their lips, but their heart is far away from me. But in vain do they worship Me, teaching as doctrines the precepts of men." Neglecting the commandment of God, you hold to the tradition of men…. You nicely set aside the commandment of God in order to keep your tradition. For Moses said, "Honor your father and your mother"; and, "He who speaks evil of father or mother, let him be put to death"; but you say, "If a man says to his father or his mother, anything of mine you might have been helped by is Corban" (that is to say, given to God), you no longer permit him to do anything for his father or his mother; thus invalidating the word of God by your tradition which you have handed down; and you do many things such as that.

So the son here misses out on the pleasure of helping his father and mother, and he also misses out on knowing God's pleasure on him when heeding God's commandment to honor his father and mother, all due to following an erroneous tradition of men, and that in an effort to not "defile" himself.

We must get this defiling issue right or we will continue to walk in

Legality's chain gang, trading rusty fetters for shiny or transparent ones. We will continue to forfeit the pleasures in God through what He has given us for our enjoyment in Him (like the pleasures the son missed in not sharing in the sufferings of his parents). We will continue to fool ourselves into thinking we stand blameless if we haven't carried into action the evil desires that brew in our heart. "But I [Jesus] say to you that everyone who looks at a woman with lust for her has already committed adultery with her in his heart" (Matthew 5:28). The heart is always the issue in matters of defilement.

CARRIED AWAY AND ENTICED BY MY OWN LUSTS

When I listen to or view a work of art, I am defiled when I am "carried away and enticed by my own lusts. Then when lust has conceived, it gives birth to sin" (James 1:14b-15a), my sin.

If someone screams a word from a murderous heart into my ear, it is his heart that stands defiled, not mine, so far. But, if, when hearing that word, I embrace the expression of his heart, and confirm with him that his evil desire is pleasing, then I engage in defilement along with him. On the other hand, I can reject his heart as I hear its expression, and I do not stand defiled. I may feel dirty, and want to be bathed with truth to recalibrate my emotional pH, but that is not the same as standing in guilt of defilement myself.

As we are taking in art, we must practice discretion so that we do not fill our minds with the evil thoughts or motives of others and give opportunity for our own hearts to be carried away by their influence, and so defile ourselves. Our own soul is immeasurably more valuable than the grandest work of art. So if an artwork (an artist's expression) encourages you towards sin, let it lie. It is far better to be without a particular artwork in your library and to be in heaven, than to be choked out by following

the deceits of a deceived artist's heart (Luke 8:14, Matthew 18:9).

We must set our minds on the things of the Spirit so that He will guide our discernment as we listen to and view the artistic expressions of artists' hearts.

> Do not quench the Spirit; do not despise prophetic utterances. But examine everything carefully; hold fast to that which is good; abstain from every form of evil. Now may the God of peace Himself sanctify you entirely; and may your spirit and soul and body be preserved complete, without blame at the coming of our Lord Jesus Christ (I Thessalonians 5:19-23).

Yes, abstain from every form of evil. When evil expresses itself in music or film or dance, we must examine our affections very carefully and honestly. If we are drawn to embrace the evil, then we must be ready to abstain from the work for the sake of our soul. But let's be careful not to confuse music or film or dance (sound, light, and movement) for the evil. Music, film, and dance are often employed by Evil to express itself, but Love will employ them too.

Let's look at a few examples of how "words" are the means (catalyst) employed by a writer to express the writer's heart so that a listener or reader could understand his heart.

> 1. May he kiss me with the kisses of his mouth! For your love is better than wine.
> 2. Come let us drink our fill of love until morning; let us delight ourselves with kisses.
> 3. How handsome you are, my beloved, and so pleasant! Indeed our couch is luxuriant!

What Defiles a Man?

4. I have spread my couch with coverings, with colored linens of Egypt. I have sprinkled my bed with myrrh, aloes and cinnamon.

5. I must arise now and go about the city; in the streets and in the squares I must seek him whom my soul loves.

6. She is now in the streets, now in the squares…she seizes him and kisses him….

7. You have made my heart beat faster with a single glance of your eyes, with a single strand of your necklace.

These words are a means of expressing a thought or affection of someone's heart. Without knowing the author's intended expression, in that I may not know the context in which they are expressed, these words, as they stand alone, can be a catalyst that my heart may use for it's own benefit or detriment.

What does your heart embrace when you read these expressions of love? Does it embrace a God-favoring love or a fleshly lust? As they stand alone, my heart could embrace all of these expressions in the context of a husband and bride, and be blessed and undefiled. Or, my heart could embrace all these expressions in a context of fornication or adultery, be carried away by lust, and give birth to sin. The hearing of the information is a different and separate thing than the embracing of the information. So I ask, does hearing these expressions of love defile a man? If the plain hearing of a word defiles me, then reading the Bible defiles me, as these expressions of a kind of love are all in the Bible.

The love context of the odd numbered lines is of a husband and his bride (Song of Solomon 1:2; 1:16; 3:2a; 4:9b). The love context of the even numbered lines is of an adulteress and her prey (Proverbs 7:18; 7:16-17; 7:12-13b). Now that I know the author's context, I can better understand his heart in enjoying Godly love and his warning to recognize lust. And so these same words, on their own, can be employed to express

both a desire of love or lust, the exact same words.

As my heart embraces what it reads, my heart could embrace either love or lust, depending on what bed my heart is in. My heart's cleanliness or defilement is my issue. This doesn't mean that I can set my own definitions of what good or evil love is. These definitions have already been established by God. But we need to understand that our heart is very capable of perverting what is clean, or yet in gracious innocence, it may even assume good from what is presented with evil intent.

I have a responsibility to guard my heart as I listen and view. Discernment must never be set aside. If guarding my heart means that I should stop viewing certain things because my heart only runs towards sin when I view them, then I should stop viewing. "If your eye causes you to stumble, pluck it out and throw it from you. It is better for you to enter life with one eye, than two eyes and be cast into the fiery hell" (Matthew 18:9).

But, just because I should stop, for my own good, doesn't necessarily mean that what I viewed is an expression from a defiled heart. It may not be. I may have perverted another's expression. Or, where my faith is weak or the temptations are strong in one area, I may, from faith, need to abstain for the sake of conscience (Romans 14). Again, don't get cocky and fool yourself here. A sly temptation often deceitfully commends your supposedly "strong faith." Where two people are involved with the same expression, one may embrace it as a blessing, while another embraces it as a lust. We each must be first concerned with our own heart.

Paul talks about this when he says:

So then each one of us shall give account of himself to God. Therefore let us not judge one another anymore, but rather determine this – not to put an obstacle or a stumbling block in a brother's way. I know and am convinced in the

Lord Jesus that nothing is unclean in itself; but to him who thinks anything to be unclean, to him it is unclean (Romans 14:12-14).

Again, it is not that cleanliness or defilement is relative. I can bring perversion to things that in and of themselves are clean when I don't act or use them in faith. "…Whatever is not from faith is sin" (Romans 14:23b). And the statement, "...nothing is unclean..." should not be taken out of context. A man's defiled heart is unclean whether he thinks it to be or not. God will be the Judge.

DANIEL / LITERATURE / DEFILEMENT

So how does a man study art and not defile himself when the art canon is so laden with expressions of evil with no intention of edification? A man finds himself to be skilled by God in artistic disciplines; he finds that he takes honest, Godly enjoyment in them; and yet he finds himself blasted with so many expressions of evil as he studies art. What is a man to do? I find Daniel's life to be very helpful.

By order of the king of Babylon (a God-less king), Hebrew youths "in whom was no defect, who were good-looking, showing intelligence in every branch of wisdom, endowed with understanding, and discerning knowledge, and who had ability for serving in the king's court" (Daniel 1:4a) were to be educated in the literature and the language of the Chaldeans for three years and then to be presented before the king for his personal service. So while studying the literature and the language of the Chaldeans (a God-less people), Daniel resolved that he would not defile himself in the practices of these God-less people.

Daniel made up his mind that he would not defile himself

with the king's choice food or with the wine which he drank; so he sought permission from the commander of the officials that he might not defile himself. Now God granted Daniel favor and compassion in the sight of the commander of the officials... (Daniel 1:8-9).

Daniel finds himself in a situation where he has to make decisions about his own actions, which is a different matter than being knowledgeable of the king's customs in order to serve the king well. Daniel cannot eat the king's food in faith. He can study the practices of the king and his people and their culture, but that is not the same as engaging in what the king engages in. Daniel's defilement here, in the sense of sin defilement regarding food, would be from disobeying God's commandments governing food laws for His people. A disobedient and faithless heart before God, expressed in the action of eating the king's food (fearing the king over fearing God) would render Daniel defiled (guilty of sin), not the food itself.

So Daniel and the Hebrew youths heeded the counsel and commands of the Lord as they had to immerse themselves in the Chaldean culture, as God ordained, by order of the king. Daniel understood that his fullest pleasures would be found and enjoyed in being faithful to God, and not from being faithful to the local culture. Daniel was steadfast in his fear of the Lord. He didn't use his abilities for selfish, fleshly gain. He loved the favor of God over the gifts of the king (Daniel 5:17). He disciplined his body and mind. And because of his faith in and fear of God, he saw amazing things in his lifetime. Amazing pleasures amongst humiliating circumstances! Daniel knew how to be in Babylon, and yet not of Babylon.

And so Daniel's knowledge of the Babylonian literature and culture, grounded and acquired in the fear of the Lord, was a means by which God made Himself known to Daniel (Sphere One), and through

Daniel to many kings (Sphere Two). May God raise up many Daniels in the arts; Daniels who know how to enjoy their Maker even as they study the lion, another creature of God, while in his den.

THE HEART DEFILES A MAN

As we read the Bible, we see many examples where God has informed us of all kinds of evils. The writing or hearing of this information is not defiling. God wrote it for our benefit, even the detailed descriptions of sin. What my heart does with the information is the issue.

There is a way and place where the hearing of evil will be helpful to me. I guarantee that if you read your entire Bible in faith, even with all its graphic record of sin, you will be helped. There are necessary times to talk of evil, but that is not the same as being evil, or promoting evil (artists, consider how you write what you write about), or engaging in evil in an effort to make it known. There are many necessary times to expose evil through works of art, which artistic expression is very well suited to do. But I would encourage you to do as God does and bring that presentation of evil through to its completion. Make the end known. Hell is a real end. Heaven is a real end. It may take a series of works to make the end known, but make the end known. Point to the end of evil. You will better see the holiness of God.

Where the context is clear that an evil heart has just expressed an evil affection via a neutral means, then apply discernment in your assessment of that work so you make an accurate judgment. A sound, color, or decibel level is not to be confused for a live heart. A man, not a gun, murders. A heart, not a melody, breeds corruption. What proceeds from, not what enters in, defiles a man. With that said, take care what art you feed your heart.

Where all things in themselves are clean, be free to know and

enjoy more of God through enjoying all of His various creative means of expression. And artists, we must proceed from faith with what God has given us for our enjoyment. Let's not cause our brothers and sisters to stumble for the sake of our artistic liberties. We will each have to give account to God for our artistic expressions and how we shared, withheld, or forced them upon others (Romans 14:12).

Images

"For I say to you, I will not drink of the fruit of the vine from now on until the kingdom of God comes." And when He had taken some bread and given thanks, He broke it, and gave it to them, saying, "This is My body which is given for you; do this in remembrance of Me." And in the same way He took the cup after they had eaten, saying, "This cup which is poured out for you is the new covenant in My blood." (Luke 22:18-20)

Therefore let no one pass judgment on you in questions of food and drink, or with regard to a festival or a new moon or a Sabbath. These are a shadow of the things to come, but the substance belongs to Christ. (Colossians 2:16-17 ESV)

For Christ did not enter a holy place made with hands, a mere copy of the true one, but into heaven itself, now to appear in the presence of God for us. (Hebrews 9:24)

Jesus loved images, as we can tell from His many parables.

"What is the kingdom of God like, and to what shall I compare it? It is like a mustard seed, which a man took and threw into his own garden; and it grew and became a tree; and the birds of the air nested in its branches." And again He said, "To what shall I compare the kingdom of God? It is like leaven, which a woman took and hid in three pecks of meal, until it was all leavened" (Luke 13:18b-21).

"The kingdom of heaven is like a treasure hidden in the field, which a man found and hid again; and from joy over it he goes and sells all that he has and buys that field. Again, the kingdom of heaven is like a merchant seeking fine pearls, and upon finding one pearl of great value, he went and sold all that he had and bought it. Again, the kingdom of heaven is like a dragnet cast into the sea, and gathering fish of every kind; and when it was filled, they drew it up on the beach; and they sat down and gathered the good fish into containers, but the bad they threw away. So it will be at the end of the age; the angels will come forth and take out the wicked from among the righteous, and will throw them into the furnace of fire; in that place there will be weeping and gnashing of teeth. Have you understood all these things?" They said to Him, "Yes." And Jesus said to them, "Therefore every scribe who has become a disciple of the kingdom of heaven is like a head of a household, who brings out of his treasure things old and new" (Matthew 13:44-52).

Jesus has given us images of what the kingdom of heaven is like. The image does not in complete fullness tell us everything about the kingdom because the image isn't the kingdom. And the kingdom's

characteristics are not limited to all that we can learn about a mustard seed, or a pearl of great price, or leaven, or fishing with a dragnet. But there is truth in each of those examples, or images, which communicates to us a truth about the kingdom of heaven. They image forth something of the kingdom of heaven. They bring us closer in our understanding than where we are currently.

Since we do not know much about the kingdom of heaven, Jesus says that just as we understand the desire to own the field that holds the treasure (so we can have that treasure), that desire which we do understand is an example for us to listen to and learn from as it teaches us how we should desire a greater treasure, namely, the kingdom of heaven. Jesus knows the kingdom of heaven and knows its value and says "the kingdom of heaven is like…." In the same way that the man considered everything that he owned to be less valuable than the field that held the treasure, so we are to understand from the imagery that the greatest treasures of earth are nothing compared to having the kingdom of heaven.

But imagery has this beautiful way of breaking apart or falling short, which helps us not confuse the image for the actual. Jesus is not saying that the kingdom of heaven is a chest full of gold bigger than any chest we've ever dreamed of (…and yet it is…) where we will be wealthier than we've ever thought possible on earth (which we will be), so we should desire the kingdom of heaven for its abundance of gold! That is not the desire He is teaching us to have here, and so the image demonstrates that it can only be helpful to a degree. If I cannot discern the limitations of the image, I will surely err in comprehending the actual.

There is a way in which a treasure accurately images or describes something of the kingdom of heaven, but there are a thousand ways which it does not image forth the kingdom of heaven. An image is only a partial representation. An actual treasure will always be only an image of the kingdom of heaven, but the actual kingdom of heaven will never be an image of any earthly treasure. Getting that order right will help us

discern more accurately the true nature of the kingdom of heaven as well as the proper value of treasures on earth.

Is gold (the created) the end of the kingdom of heaven, or is God (the creator of gold and heaven) heaven's end? As we labor in and enjoy art, where "great art" is the end of our pleasure, and not God, then we prove that our affections are misplaced since we've enjoyed the image (the pleasures we enjoy in art alone) apart from or instead of the actual (the pleasures we enjoy of God in enjoying the art He has given us to enjoy). Isaiah 42:8 says, "I am the Lord, that is My name; I will not give My glory to another, nor My praise to graven images."

This doesn't mean that a treasure or a beautiful work of art is of no value to us. Remember, God has given us all things to enjoy (I Timothy 6:17), so they must have a value of some kind. If treasures on this earth were not valuable to us in some way, Jesus would not use treasures as images to spur us on towards something of greater value to be desired. We just need to understand the limits and place of their value. What would be the benefit of using a fresh, hot pile of manure to describe the desirable glory of the kingdom of heaven? That image would not help me desire to dwell in the kingdom of heaven. It might possibly be used as an image of hell, which could be helpful in understanding hell's inheritance. And yet, even manure, as fertilizer, has its place where it is desirable. So images are helpful and valuable, but they are incomplete. They are not the actual, which is why they are called images.

Artists, we must become disciples of the kingdom of heaven so that we would know the kingdom as it truly is with its grandest treasures, and grow in our enjoyment of its fullest pleasures. We need to be faithful, as a head of the household is to be, and bring out of our treasuries beauties old and new as we communicate, through works of art, what we've seen and enjoyed of what God has emanated already (Matthew 13:52). Remember,

our art is an expression (an image) of a thought or affection of ours. Art is not the thought. Art does not think. People think.

AN IMAGE IN THE ACTUAL BLOOD
OF BULLS AND GOATS

I want to look for ways in which images can be both helpful and harmful, depending on how we view them. Here is an image that God ordained and commanded to be practiced for many years until the revelation of its Object.

God requires of all people the shedding of blood for the atonement of sins. He established in Leviticus 4:22-26 that a male goat without defect should be slain as a sin offering before the Lord when a leader sinned. God gave several specifics on how the process should be commenced and then said in verse 26b, "Thus the priest shall make atonement for [the man] in regard to his sin, and he shall be forgiven."

Does the blood of a goat effectually cleanse a man from his sin? Hebrews 10:4 says, "It is impossible for the blood of bulls and goats to take away sins." "For the Law, since it has only a shadow of the good things to come, and not the very form of things, can never by the same sacrifices year by year, which they offer continually, make perfect those who draw near" (Hebrews 10:1). Everything surrounding the shedding of the blood of bulls and goats was an image that foreshadowed the shedding of Jesus' blood. "For by a single offering [Jesus] has perfected for all time those who are being sanctified" (Hebrews 10:14 ESV).

God gave His people bulls and goats and their blood as images of Jesus, the actual sacrifice whose blood is the effectual atonement for all our unrighteousness. When a bull, whether golden or live, is my hope for my atonement, the bull is no longer an image; it is an idol. But when a bull is slain on the altar in faith, out of obedience to the

commandment of God, trusting that God will be "...the faithful God who keeps covenant and steadfast love with those who love Him and keep His commandments..." (Deuteronomy 7:9), then the bull is not an idol, it is an image. It is an image of a redeemer, an image of Christ, and the action of the man in sacrificing the bull is the evidence of his faith in God's holiness and faithfulness.

The sacrifice offered in faith, in obedience to God, is commended by God as righteousness (Hebrews 11) that is bought with the shedding of Jesus' blood, not the goat's blood. We must probe deep in our hearts to discern on what foundation our faith is resting when offering a sacrifice. Is our faith resting in the image or in the faithfulness of God? Am I trusting in my act of sacrificing the bull to atone for my sins (my law-keeping for my righteousness), or am I trusting in God to be faithful to his promise as He commands me to offer a bull in faith so that my sins will be forgiven (speaking here as if a Hebrew in the Old Testament)? Faith is the issue for atonement, not the bull's blood. The obedient act as the proof of faith is the issue, not the technical performance of a sacrifice. Remember Cain and Abel: both performed an action, but only Abel's action was an evidence of his faith in God (Hebrews 11:4). And anything not proceeding from faith is sin (Romans 14:23b ESV).

WE LIVE IN IMAGES THAT ARE OBJECTS THEMSELVES

Anytime that I ascribe final power or final praise to any kind of image, whether that is man or something that man has made, or even something that God has made, and not to God Himself, I no longer regard it as an image. I have just made it an idol. We should learn from all objects, when they also serve as images, what they are intended to portray, which is more than what they just functionally serve as. Only then will we enjoy or regard the object-image rightly and wholly as we see it point to

an object of greater measure.

Let's consider Noah for a moment. "By faith Noah, being warned by God about things not yet seen, in reverence prepared an ark for the salvation of his household, by which he condemned the world, and became an heir of the righteousness which is according to faith" (Hebrews 11:7). Noah was saved from the flood because he acted in faith to God. He obeyed the Lord's command to build an ark, but his trust for salvation was in the Lord and not in the ark. In reverence to God, Noah prepared the ark, which stood in his yard as both an image of his faith in God and an image of his condemnation of the world. The ark had no power itself over God. It could have easily been sunk by God, but God kept the ark and was faithful to His word to Noah.

There is a sense in which the ark is an actual object, and there is another sense in which the ark is an image of another actual Object. The ark is a tangible image of the strength and fortitude of God against all destroying waters as it rises above all death and destruction. A very real image that Noah built with his hands that rocked and tossed and stunk, I'm sure. But notice, if Noah had trusted in the ark, the work of his hands for his salvation, he would have been an idolator.

The sons of Korah understood their weapons of war to be images or means of seeing deliverance and not the actual source of their deliverance from their adversaries. They said:

> Through [God] we will push back our adversaries; through Your name we will trample down those who rise up against us. For I will not trust in my bow, nor will my sword save me. But You have saved us from our adversaries, and You have put to shame those who hate us (Psalm 44:5-7).

The sons of Korah would play the part of the man in God's

trampling of their enemies, but they understood that God, not their bow or sword or skill in using them, was their deliverer as they experienced their own nerves, exhaustion, and adrenaline in the reality of war.

We use the word "image" in all sorts of ways. We can use the word "image" anytime an actual object is serving as an evidence or representation of something else. An image is a tangible manifestation of something that could be intangible itself, or unavailable at present, or not understood or known until put to image.

Let's think about this for a moment. War would be an image of a tension (an invisible feeling) that is very real between two peoples, that is expressed (known, realized, imaged) through fighting. A warrior might have in his mind an idea (another type of image) for being able to defend himself, and so he makes a shield and sword (an image of the idea which is now an actual object itself). He trains hard (works out his ideas, or puts to image his thoughts and fears) with these weapons because he knows in his mind (he imagines) that the enemy is very strong (a reputation, an image). The reason there is a tension between the two people in the first place may be because of evidences (images) of injustices (evil hearts that were expressed) that are prevailing. So the oppressed people put forward leaders (breathing objects) to be a representative (an image) of their hatred for the injustices that were done. We could play this out all day long seeing objects that serve as images themselves.

The reason I consider this line of thought is not to attempt to invalidate the value of an object by saying that it is only an image, but rather to see if there is even more to be understood, or more to be enjoyed from considering and discerning how any object in some way points to, or helps me better understand, something about the triune God since:

> ...by Him [Christ] all things were created, in heaven and on earth, visible and invisible, whether thrones or dominions

or rulers or authorities – all things were created through Him and for Him. And He is before all things, and in Him all things hold together (Colossians 1:16-17 ESV).

And remember, this Christ is "the image of the invisible God, the firstborn of all creation" (Colossians 1:15 ESV). The world exists and works in images that are as real and live as your blood, and yet all have their conception in the invisible God who put to image what He was thinking.

Often in works of art, as in all of life, the "art" is not mainly what we see displayed in the painting, but rather the displaying of an intangible discipline or imagination or love or skill or some other intangible quality of it's author who is made by God, in the image of God. So artists, where we are an image of God, we must grow in the knowledge of our Imager so that we can be an accurate image. God commands it! "You shall be holy, for I am holy" (I Peter 1:16b). "Be merciful, just as your Father is merciful" (Luke 6:36).

In enjoying holiness or justice or mercy, which are themselves technically invisible to the human eye, there is an action or an image that is put forth so that holiness, justice, and mercy could be experientially known. "But God demonstrates [puts to image] His own love toward us, in that while we were yet sinners, Christ died for us" (Romans 5:8). The glory of the love of God (who is the invisible God) is put to tangible image before men when He sends Christ to the earth in the flesh to die for the created man who hates Him. All that real, horrendous pain that Christ suffered demonstrates to us (images forth) how severe the wrath of God is towards unrighteousness, and, how great is His love for those who fear Him.

SELF IMAGE

I want to look for a moment at another kind of image. Images do not have to be a visible or tangible work. How much time do we spend working on our "image," meaning this: that thought, look or status we hope be associated with? We may not do things we ought to do, like associate with the lowly (Romans 12:16), as we fear such an association may hurt our "image." Or, we may involve ourselves where we shouldn't as we seek to be praised by or associated with a group of a certain artistic status. There is so much posturing today, it's almost assumed that the art of good posturing is a necessary discipline. We work so hard at portraying the "right image" that we often waste our resources working on our image (the shell) when they should have been invested developing the actual (the essence).

When Nebuchadnezzar set up the visible golden image on the plain of Dura in Daniel 3 and commanded that everyone worship it, threatening death by fire for all who would not bow the knee, there was more than one image being presented to the people that day. The visible golden image is obvious, but what about King Nebuchadnezzar's image? How many of the satraps, governors, treasurers and officials who bowed did so just to find favor in the king's eyes while regarding this bowing as only a means of keeping or acquiring favorable status with the king? The punishment of death wasn't really for not worshiping the tangible idol image, it was for disregarding the intangible authoritative image of the king. The king would render the judgment of death, not the golden image. Nebuchadnezzar's image was the other idol that day. Those who heeded the order to "bow or burn" yielded either to their own fear of man or their ignorant belief in the power of golden idols. But there were three who recognized the worthlessness both of the visible image, the golden idol, and the invisible image, the revered status of such a king.

All artists should ask themselves two questions. One: What are some

of the tangible images that others have erected on the "Plains of Dura" on which we rest our hopes? Do we bow to (place our hope in) ourselves, the Internet, radio, a certain distributor, a look, label, publisher, advertiser, marketer, gallery, status, camaraderie, etc...? Or is our hope only in God as He puts us in these relationships and theaters, as was Daniel's, Shadrach's, Meshach's and Abednego's hope when they found themselves in the court of King Nebuchadnezzar by the hand of God (Daniel 1:2)? And the second question is this: What are the intangible images or ideas that we embrace only as a means of gaining favor in the eyes of man? We are all tempted by the fear of man. And when we yield to this desire of our flesh, we sin and rob ourselves of the greater pleasures known through faithfulness. The reason we do this status seeking so much is because we put our hope for satisfaction in a status or in a man, an image of God, rather than in God Himself, the source of all that satisfies.

However, the three Hebrews introduced another image that day. It was an image that put its hope for satisfaction in the fear of God over the fear of man. Nobody valued that image, however, until Nebuchadnezzar and all within sight of the furnace saw the power of God! Nebuchadnezzar said:

> "Blessed be the God of Shadrach, Meshach and Abednego, who has sent His angel and delivered His servants who trusted in Him, and set aside the king's command, and yielded up their bodies rather than serve and worship any god except their own God. Therefore I make a decree: Any people, nation or language that speaks anything against the God of Shadrach, Meshach and Abednego shall be torn limb from limb and their houses laid in ruins, for there is no other god who is able to rescue in this way." Then the king promoted Shadrach, Meshach and Abednego in the province of Babylon (Daniel 3:28-30 ESV).

It is interesting that the people's self-image could now be technically associated with a seemingly God-fearing status, even by the command of the king, and yet they could still be found standing in opposition to God if their motive for respecting God was rooted in the fear or praises of the king, rather than faith in God. The wrong motive would sound something like this, "So now the king likes the God of the Hebrews – then I will like their God because I want the king to like me. I want to be found in the company of the king." From this motive of reverence to God, man is the end and God is the means. We may fool man, but we won't fool God.

Respecting God in order to gain favor in the eyes of man is really setting our mind on the desires of the flesh, which cannot please God.

> For the mind set on the flesh is death, but the mind set on
> the Spirit is life and peace, because the mind set on the flesh
> is hostile toward God; for it does not subject itself to the law
> of God, for it is not even able to do so; and those who are in
> the flesh cannot please God (Romans 8:6-8).

Artists, when you see a true, accurate, and God-honoring image, whether tangible or intangible, and you rejoice in its beauty and worth, do not make the mistake of putting your hope for satisfaction in that image you now associate with the truth or beauty it speaks of. It is still just an image. It is not the actual. We are to learn of the intangible from the tangible. We are to enjoy the intangible in our enjoyment of the tangible.

When we hear our brothers and sisters testifying rightly as the three Hebrews did, we see them cast forth a beautiful image of fearing the Lord no matter what the outcome, which makes us say, "I want the fear of God that they have." The beautiful image in the three Hebrew's faith points to the beautiful Source of their faith, namely, God. A desire to "want what they have" is a desire to know the Source as they knew Him.

Images

A desire to "want to be associated with them" could be a desire for their self-image or status and not necessarily their Source. I could desire to be associated with them to satisfy a revolutionary passion in my heart for the acclaim of being one who stood up to the king. We must be careful that we accurately discern our motives before we act, because only a motive in God-rooted faith will deliver the satisfaction and pleasure we are hoping to find from our actions.

ASSOCIATING WITH GOOD IMAGERS

There are good reasons to desire to associate with good imagers: "Iron sharpens iron, so one man sharpens another" (Proverbs 27:17). Surrounding ourselves with good imagers of faithfulness is one good way to learn how to be faithful ourselves. "Remember those who led you, who spoke the word of God to you; and considering the result of their conduct, imitate their faith" (Hebrews 13:7).

The writer of Hebrews says earlier, "And let us consider how to stimulate one another to love and good deeds, not forsaking our own assembling, as is the habit of some, but encouraging one another; and all the more, as you see the day drawing near" (Hebrews 10:24-25). He mentions here love and good deeds. We are encouraged to assemble together and even "all the more as we see the day drawing near" for the purpose of stimulating these affections and actions. That's a clear admonishment to associate with others for the sake of our own health.

But remember, a group's worth is in what binds them, and not in the gathering itself. A group is a tangible image of a particular intangible value. While a group's action may be a benevolent action, the motive may be for selfish gain. If so, the end value pursued is really then the bolstering of the individual's self-image in their doing of good. The Psalmist pleads like this in Psalm 119:36, "Incline my heart to your testimonies, and not

to selfish gain."

As artists, are we motivated to compose a certain way because we hope to be accepted in a particular artistic circle? If our hope is in being associated with an image of this kind, we lead ourselves astray. But if we run after the truth or value that that image represents, and it's a God-honoring truth/value, we will find the satisfaction we seek because we will end up at God, the Essence of truth and all that is valuable. God did not design us to be independent of each other. In fact, no one will abide with God apart from dependence in Christ. So yes, we should associate with good imagers, but associate for the sake of growing in the truth of God together, and not for a better posturing of our self-image.

Psalm 1 counsels us on which groups to avoid because of the values they image forth:

> How blessed is the man who does not walk in the counsel of the wicked, nor stand in the path of sinners, nor sit in the seat of scoffers! But his delight is in the law of the Lord, and in His law he meditates day and night. And he will be like a tree firmly planted by streams of water, which yields its fruit in its season, and its leaf does not wither; and in whatever he does, he prospers. The wicked are not so, but they are like the chaff which the wind drives away. Therefore the wicked will not stand in the judgment, nor the sinners in the assembly of the righteous. For the Lord knows the way of the righteous, but the way of the wicked will perish.

Notice this. When encouraging us to avoid wickedness and to run towards righteousness, does the Psalmist here first push the reader towards a good association or towards a good object? He says the blessed man's delight is in "the law of the Lord." There may be no one else around to meditate with, and yet a man can still delight in the law of the Lord

because he is not dependant upon an association to experience the delight of the actual: the beauty of the law of God. He is running after the actual (the law of the Lord) and not first an image (the association of those who love the law of the Lord). It is the actual that makes the image valuable. It is the Bible that makes the gathering of Bible lovers a valuable gathering. He doesn't first say "but rather, associate with the righteous and merciful" (which would not be wrong to do). But here he makes the point that the actual, the law of the Lord, is what we should put our delighting in foremost rather than merely in a camaraderie of lovers of the law. When our delighting is ultimately placed in the image of an association (those whom we hang with), we will forever be frustrated as we work to attain or keep up with the association's "image," whatever that is.

Yes, there is a great delight where brothers dwell together in unity. "Behold, how pleasant it is for brothers to dwell together in unity!" (Psalm 133:1). But the reason it is a delight is because they delight in the value that binds them together. And where God is that value, they will more truly love each other.

In the arts, we need to surround ourselves with a core of people who deeply desire the law of the Lord. "Do not be deceived: 'Bad company ruins good morals'" (I Corinthians 15:33 ESV). As we study with those who are better images than us of faithfulness, love, truth, the fear of God, humility, graciousness, perseverance, etc., we will learn more of God, the One whom they are imaging. But when we confuse the image for the Actual, the good company for God, that is where we err. That is when we will eventually be let down as all men fail and are hypocrites to some degree. And then, we will be tempted to make that second mistake of thinking that the original value (the actual) was in fact a fraud where the association (the image) fails to deliver. If we are not careful, we will desire the image of the "club" over the truth or value that the "club" is bound together by.

IMAGE FORTH FROM YOUR TREASURE

So artists, as we mature in our ability to communicate through imagery, let's discipline ourselves, by the power of the Holy Spirit, to discern the actual end of any work, keeping that which is good and discarding the dross, so that we may harvest more of God, the actual Treasure. Then, let us be generous scribes of the kingdom of heaven, and bring forth "out of [our] treasure what is new and what is old" (Matthew 13:52b ESV).

Psalm 40:9-10

I have proclaimed glad tidings of righteousness
 in the great congregation;
Behold, I will not restrain my lips,
 O Lord, Thou knowest.
I have not hidden Thy righteousness
 within my heart;
I have spoken of Thy faithfulness
 and Thy salvation;
I have not concealed Thy lovingkindness
 and Thy truth from
 the great congregation.

Artists, we live our lives running after either the pleasure-laced images of joy or the actual Source of overwhelming, satisfying, and perfect joy. When we run after God the Source, we will find the full pleasures to be had in all the various images that God has given us for our enjoyment. Then we will more accurately see and image forth Him. "Let your light shine before men in such a way that they may see your good works, and glorify your Father who is in heaven" (Matthew 5:16).

Images

Pride

Jesus said, "If I glorify Myself, My glory is nothing; it is My Father who glorifies Me, of whom you say, He is our God." (John 8:54)

A man's pride will bring him low, but a humble spirit will obtain honor. (Proverbs 29:23)

Everyone who is arrogant in heart is an abomination to the Lord; be assured he will not go unpunished. (Proverbs 16:5 ESV)

Now I, Nebuchadnezzar, praise, exalt, and honor the King of heaven, for all His works are true and His ways just, and He is able to humble those who walk in pride. (Daniel 4:37)

Artists are vessels of God often for displaying beauty, sometimes for instruction or teaching or healing or exhortation, sometimes for proclaiming, and sometimes for unifying or directing. But artists are always vessels and never God. And a vessel is a testimony to the handiwork

of its Maker.

We wouldn't attribute to the paintbrush the praise due a beautiful painting. We attribute the praise to the painter. It is the painter who made the brush and the paint and the canvas and the painting. I would not praise the ink and paper of a musical score when I heard it played, I would praise the composer. I would praise the orchestra for faithfully playing what the composer wrote. We would think a person to be crazy who would walk up to a score and praise it and would not even acknowledge its composer, in whose hands it is being held. I might say to the composer, "That song was so beautiful! May I study your score? I would like to see what you were doing with the…." But the praise is always due the author of the work, not the work itself. "…The builder of a house has more honor than the house itself" (Hebrews 3:3b ESV). The work itself is the image of what the author knew in his mind and heart.

In the same way then, I must understand that I have an Author who has made me, designed me, crafted me as a work of His own, and to Him be the ultimate glory in anything that I accomplish. "For every house is built by someone, but the builder of all things is God" (Hebrews 3:4 ESV). There is no room for my pride here. I did not make me. I am a living brush made by, and in the image of, God. Paul helps us understand our place when he says, "For who regards you as superior? What do you have that you did not receive? And if you did receive it, why do you boast as if you had not received it?" (I Corinthians 4:7).

So as we study and enjoy the artwork of man (who is himself a vessel, a score), we should be tuned to recognize and enjoy the handiwork of God (the Maker, the Composer). God is not out to rob us of any joy when He directs us to see and enjoy Him as the end of man, His creature. Our pride is out to rob us of God, as joy in Him is the end. Pride is the killjoy, not God.

SHOULD THE AXE BEGIN TO BOAST?

Here is a warning to all of us artists regarding how the Lord may deal with our pride and arrogance in the artistic labors that He gives us when we do not recognize that we are a vessel in His hand. The Lord sent Assyria as the rod of His anger upon Judah because Judah was not walking in the fear of the Lord. The king of Assyria is then found to be boasting in his might, completely disregarding God who has given him the might to conquer Judah. So the Lord says:

> I will punish the fruit of the arrogant heart of the king of Assyria and the pomp of his haughtiness. For he has said, "By the power of my hand and by my wisdom I did this, for I have understanding; and I removed the boundaries of the peoples, and plundered their treasures, and like a mighty man I brought down their inhabitants, and my hand reached to the riches of the peoples like a nest, and as one gathers abandoned eggs, I gathered all the earth; and there was not one that flapped its wing or opened its beak or chirped" (Isaiah 10:12b-14).

The king of Assyria did not recognize the One who gave him the power to wage war and win and take all the spoil. It was God who sent Assyria "against a godless nation and commission[ed] it against the people of [His] fury to capture booty and to seize plunder, and to trample them down like mud in the streets" (Isaiah 10:6). Artists, we must understand that our "power," or talent, was given to us by God, and God has a purpose for giving it to us. One of God's purposes is to demonstrate, or proclaim, or testify something about Himself both to the artist, and through the artist to others. Whether or not we desire to testify of God, God testifies of Himself in making us as He did.

Listen to what God says through Isaiah about the proud Assyrian king when the king attributes his strength to himself and not to God.

Is the axe to boast itself over the one who chops with it? Is the saw to exalt itself over the one who wields it? That would be like a club wielding those who lift it, or like a rod lifting him who is not wood. Therefore the Lord the God of hosts, will send a wasting disease among his stout warriors; and under his glory a fire will be kindled like a burning flame. And the light of Israel will become a fire and his Holy One a flame, and it will burn and devour his thorns and his briars in a single day. And He will destroy the glory of his forest and of his fruitful garden, both soul and body; and it will be as when a sick man wastes away. And the rest of the trees of his forest will be so small in number that a child could write them down (Isaiah 10:15-19).

This is what is in store for the proud and arrogant of heart.

Paul says that we should direct that urge to boast away from us and to the Lord in II Corinthians 10:17-18. "But he who boasts, let him boast in the Lord. For not he who commends himself is approved, but whom the Lord commends."

OUR PRIDE DEMANDS RECOGNITION

At times an artist can, in his pride, force a work upon a viewer and demand that it be called, in some sense, beautiful as he demands to be recognized as an "artist." Such pride is evidence that the desire for man's praise or some sense of superiority is ruling in that artist's heart. In Proverbs 27:2a we hear wisdom say, "Let another praise you, and not

your own mouth." How tired I am of a pile of junk being called "art" (meaning it is in some sense beautiful or valuable) just because a person proudly calls himself an artist and thereby somehow concludes that he is only able to produce meaningful works of art. Great works of art can be made out of junk. We have all seen them. The medium is not the issue. I am referring here to the notion that in our pride, we will call anything a work of art just because a self-proclaimed "artist" has made it, which then forces us to place a great positive value upon the work. Then afterwards, we labor to find something pleasing about the work in order to defend our stance. The more esteemed the "artist" is, the more we pre-esteem the work.

The pride in our heart to have a name is too often stronger than the discipline in our heart that produces a valuable name. Weak disciplines yield a narrow understanding of what we will recognize to be beautiful. I am not saying that a work is beautiful only if I recognize it as beautiful. My disciplines may be weak, which means that I will probably miss out on pleasure. Many people do not recognize Jesus and the cross as beautiful. My failure to recognize beauty may be due to my impatience or ignorance. I may have to get with the "artist" and have him translate a few things for me, have him educate me where I am less knowledgeable than he. But where the translation is accurately deciphered to be the pride of the artist, then the gut has proven to be trustworthy. Don't throw out your gut. Test it, but don't throw it out.

Let's look at this demand for recognition from another angle. Let's assume that an artwork is a genuine expression of a Godward affection that ends up edifying no one but the artist. Artist, would all be lost? Does your satisfaction in your toil hang in limbo until you hear the approval of other men? Is there no complete pleasure to be known in a faithful labor that is approved by God alone? This is another way in which pride deceives us and robs us of pleasure. Our pride whispers to us that a work's

value (and my pleasure) is proportional to its recognition or affirmation in the eyes of men. But if an artist would seek his satisfaction in that Sphere One fellowship with God, in being found faithful and obedient to God in his work, he can absolutely have his appetite for being accepted satisfied. We should seek to know God's praises in our work and entrust to God whether or not the work ever gets shown, or what might be the artwork's replication factor, or in which venue might it be displayed. Due to our pride, we often miss the port of satisfaction because we understand that port to be named "The Praises of Men" rather than "Faithfulness to God".

Paul helps us keep these motives in check with this verse: "for am I now seeking the favor of men, or of God? Or am I striving to please men? If I were still trying to please men, I would not be a bond-servant of Christ" (Galatians 1:10). Faithfulness to God must be the motive from which we work, which is so unnatural for our human heart. For it is faithfulness, and not our pride, that will garner the kind of recognition that satisfies.

HUMILITY KNOWS MORE PLEASURE THAN PRIDE

In Philippians 2:5-11, Paul exhorts us to be humble, obedient to our calling from the Lord, and to seek the approval of God rather than the approval of men. He gives us Jesus as a model:

> Have this attitude in yourselves which was also in Christ Jesus, who although He existed in the form of God, did not regard equality with God a thing to be grasped, but emptied Himself, taking the form of a bond-servant, and being made in the likeness of men. And being found in appearance as a man, He humbled Himself by becoming obedient to the

point of death, even death on a cross. Therefore also God highly exalted Him, and bestowed on Him the name which is above every name, that at the name of Jesus every knee should bow, of those who are in heaven, and on earth, and under the earth, and that every tongue should confess that Jesus Christ is Lord, to the glory of God the Father.

How are we doing in the obedience department, artists? Humbling ourselves and obeying to the point of death, even death on a cross? Are we obeying the "do not covet" command when we seek for ourselves the glory that God is due? That would be coveting God wouldn't it? But Christ was humbly obedient and God highly exalted Him.

When the time came for the cross, Jesus prayed like this, "Father, the hour has come; glorify Thy Son, that the Son may glorify Thee" (John 17:1b). As we work, we should take the lead of Jesus and pray something like: "Father, give me grace in this work that I may glorify You. Enable me to be faithful in this work that You would be glorified in its beauty, so that my joy would be full. I have seen You, and You are beautiful, and I want others to share in what joy I have known in You." To let the glory in our work run to God is to actually gain more pleasure by ultimately being exalted by God who is the authority on giving praise. No man's praises are better than God's praises. So, putting pride to death and walking in humble obedience before God, in faith, is the key to realizing the full pleasures in our art working. But in order to truly obey, we need to know what God delights in. "For I delight in loyalty rather than sacrifice, and in the knowledge of God rather than burnt offerings" (Hosea 6:6).

Nebuchadnezzar, the king of Babylon, said, "Is this not Babylon the great, which I myself have built as a royal residence by the might of my power and for the glory of my majesty?" The writer of Daniel continues:

While the word was in the king's mouth, a voice came from heaven, saying, "King Nebuchadnezzar, to you it has been declared: sovereignty has been removed from you, and you will be driven away from mankind, and your dwelling place will be with the beasts of the field. You will be given grass to eat like cattle, and seven periods of time will pass over you, until you recognize that the Most High is ruler over the realm of mankind, and bestows it on whomever He wishes" (Daniel 4:30-32).

And so Nebuchadnezzar was immediately driven away from mankind to eat grass like the cattle. His hair had grown like eagles' feathers and his nails were like the claws of a bird, all as a judgment from God for his pride and arrogance. God bestows whatever He wishes on whomever He wishes.

The story continues with the mercy and grace of God now being displayed:

But at the end of that period, I, Nebuchadnezzar, raised my eyes toward heaven, and my reason returned to me, and I blessed the Most High and praised and honored Him who lives forever; For His dominion is an everlasting dominion, and His kingdom endures from generation to generation. And all the inhabitants of the earth are accounted as nothing, but He does according to His will in the host of heaven and among the inhabitants of earth; and no one can ward off His hand or say to Him, "What hast Thou done?" At that time my reason was returned to me. And my majesty and splendor were restored to me for the glory of my kingdom, and my counselors and my nobles began seeking me out; so I was reestablished in my sovereignty, and surpassing

greatness was added to me. Now I, Nebuchadnezzar, praise,
exalt, and honor the King of heaven, for all His works are
true and His ways just, and He is able to humble those who
walk in pride (Daniel 4:34-37).

God is able, no doubt! It would be wise for us artists to ask the
Lord where we are full of pride, and ask Him for mercy and humility
before we stiffen our necks only to feel them broken by Him (Proverbs
29:1).

Jesus warns us in Mark 12:38-40 about the condemnation that
will be ours if we are full of ourselves:

In His teaching He was saying: "Beware of the scribes
who like to walk around in long robes, and like respectful
greetings in the market places, and chief seats in the
synagogues and places of honor at banquets, who devour
widows' houses, and for appearance's sake offer long prayers;
these will receive the greater condemnation."

Now, the desire for man's praise is not the same as the desire to
see men fed. The former seeks to take while the latter seeks to give. The
former is selfishness while the latter is a pleasure-gaining selflessness. Being
a scribe is not where the scribes erred. A scribe whose motive was to know
the word of God so that he could be fed and so that he could, in turn,
feed other people had a God-pleasing reason for being a scribe. A scribe
who used that title to improve his self-esteem or advance his authority
or rank in the eyes of men was in danger of the greater condemnation.
Philippians 2:3-4 says, "Do nothing from selfishness or empty conceit,
but with humility of mind let each of you regard one another as more
important than himself; do not merely look out for your own personal

interests, but also for the interest of others."

Our pride urges us to say such stupid things. James and John asked Jesus to do for them whatever they would ask in Mark 10:35-45. Jesus answered:

> "What do you want me to do for you?" They said, "Grant that we may sit in Your glory, one on Your right, and one on Your left." But Jesus said to them, "You do not know what you are asking for. Are you able to drink the cup that I drink, or to be baptized with the baptism with which I am baptized?" And they said to Him, "We are able."

What a stupid, ignorant answer! But that is how we all answer in our pride.

Our first error is that we think we deserve something special. Succumbing to that first bit of pride blinds us from seeing what it will cost us to be humbled, as we make our second error, the proud declaration of "We are able. Bring it on Jesus, we can handle it!"

Jesus responds to James and John:

> The cup that I drink you shall drink; and you shall be baptized with the baptism with which I am baptized. But to sit on My right or on My left, this is not Mine to give; but it is for those for whom it has been prepared…. Whoever wishes to become great among you shall be your servant; and whoever wishes to be first among you shall be slave of all. For even the Son of Man did not come to be served, but to serve, and to give His life a ransom for many.

Artists, are we serving our pride or our joy in our artistry? Is our pride our joy? If we are serving our pride, we will not have a servant's

heart. We may experience a kind of pleasure, but never full joy. But if we are looking to serve our joy, we will only realize the pleasures in the arts in full when we serve and give in our artistry. It is true that "it is more blessed to give than to receive" (Acts 20:35b).

I would like to ask artists, managers, and the like a question here. Is your mind set on serving the beholders in the gigging process, or is your mind set on being served by them? True serving stems from humility, but the mind that is set on "being served" stems from pride. Have ears to hear this, "God is opposed to the proud, but gives grace to the humble" (I Peter 5:5b). Don't find yourself standing in opposition to God, artists (Harms).

As we communicate with each other over an event, do we position ourselves to be the servant of the other party? I see such a proud attitude in the way we often write up agreements, contracts, riders, etc...these days. They are not framed from a motive of "How can I serve you? It's my pleasure to serve you." This is probably because serving is not our pleasure. Agreements are too often written up proclaiming, however gently disguised, "This is how you should serve me." Which is totally different from "I want to serve you well. These things would help me serve you, if you are able to provide them." Clear communication of what would be helpful in order to achieve a certain end is great and necessary. But what is the motivation - pride or humility, receiving or giving, serving or being served?

Artists, we do not deserve anything. Jesus, who deserves everything, took the position of a servant. We would do well to follow Him. Remember Mark 10:45, "For even the Son of Man did not come to be served, but to serve, and to give His life a ransom for many."

Artists, unburden yourselves by casting off your pride! Pride doesn't provide all the pleasure or security that it boasts of. You will be far better

for it in your countenance, in your satisfaction, in your work, and in your fruitfulness. Pride is not from our Father. It is from the world. "For all that is in the world, the lust of the flesh and the lust of the eyes and the boastful pride of life, is not from the Father, but is from the world" (I John 2:16). Then replace that hole in your heart with humility, and watch your pleasures mature as you clear a path for servanthood. "For what we proclaim is not ourselves, but Jesus Christ as Lord, with ourselves as your servants for Jesus' sake" (II Corinthians 4:5).

Skillfulness

(Give thanks...) to Him who made the heavens with skill, for His lovingkindness is everlasting. (Psalm 136:5)

Do you see a man skilled in his work? He will stand before kings; He will not stand before obscure men. (Proverbs 22:29)

Now Bezalel and Oholiab, and every skillful person in whom the Lord has put skill and understanding to know how to perform all the work in the construction of the sanctuary, shall perform in accordance with all that the Lord has commanded. (Exodus 36:1)

I am the Lord, and there is no other, besides me there is no God; I equip you, though you do not know me, that people may know, from the rising of the sun and from the west, that there is none besides me; I am the Lord and there is no other. (Isaiah 45:5-6 ESV)

It would be an error in discernment to conclude that if God is

pleased with the heart of the artist, we can then afford to be sloppy in the work. This is the slacker's mindset. God is incredibly skillful. Step back and behold the skillfulness of God! Let your mind pause and feed on the incredible precision with which God created anything that is, and all of which He made from nothing. Try to calculate that skill.

If I am to image forth God, I must pursue skillfulness. God is disciplined; I should be disciplined. God is patient with us who have lesser talent than He; we should be patient and not proud or arrogant with others of varying degrees of talent. God is continually showing new evidences of His grace; we should be continually testifying of new evidences of His grace. God creates with such great diversity; we should seek to know more about Him through the careful study of His diverse creation. God is clear; we should be clear. God holds things in mystery; we can hold things in mystery. God's mystery is firmly grounded in His truth and wisdom and will be revealed one day; any mystery we engage in imaging should be firmly grounded in His truth and wisdom so that it can be revealed one day and prove to have been valuable. God's word tells us plainly to "play skillfully with a shout of joy" (Psalm 33:3b). So artists, be skillful because God your Maker is incredibly skillful! "Thus says the Lord, your Redeemer, and the One who formed you from the womb, 'I, the Lord, am the maker of all things, stretching out the heavens by Myself, and spreading out the earth all alone...'" (Isaiah 44:24b). Who can even come close to the skillfulness of God?

GOD GIVES MAN HIS SKILL SO THAT MAN WOULD KNOW AND ENJOY GOD

If we are going to truly and fully benefit from pursuing skillfulness in anything, we must first understand that any skill a person has, he has from God. It is not that we choose our skills somewhere and then work

them and become skillful from our own doing. Any skill a man has originates from God.

In Exodus 28:3 God says, "You shall speak to all the skillful, whom I have filled with a spirit of skill, that they make Aaron's garments to consecrate him for my priesthood" (ESV). God gave the four youths in Daniel 1:17 "learning and skill in all literature and wisdom, and Daniel had understanding in all visions and dreams" (ESV). God filled Bezalel with:

> ...the Spirit of God, in wisdom, in understanding and in knowledge and in all craftsmanship; to make designs for working in gold and in silver and in bronze, and in the cutting of stones for settings, and in the carving of wood, so as to perform in every inventive work. [The Lord] has also put in [Bezalel's] heart to teach, both he and Oholiab, the son of Ahisamach, of the tribe of Dan. He has filled them with skill to perform every work of an engraver and of a designer and of an embroiderer, in blue and in purple and in scarlet material, and in fine linen, and of a weaver, as performers of every work and makers of designs. Now Bezalel and Oholiab, and every skillful person in whom the Lord has put skill and understanding to know how to perform all the work in the construction of the sanctuary, shall perform in accordance with all that the Lord has commanded (Exodus 35:31-36:1).

God commanded that a sanctuary be built and then provided the people with the skill to build it. A person's skill is from God.

In fact, every person's skills, whether in music (I Samuel 16:18), in destruction (Ezekiel 21:31), in intrigue (Daniel 8:32), in bronze work (I Kings 7:14), in battle (I Chronicles 5:18), in instruction in singing (I

Chronicles 15:22), in stone cutting (I Chronicles 22:15), in understanding
(II Chronicles 2:13), in inventing war engines (II Chronicles 26:15), in
the law of Moses (Ezra 7:6), or in subduing nations (Isaiah 45:1) are from
God whether or not the person understands them to be.

Artist, do you understand that your artistic skills are from God?
Do you understand that God intentionally gave you your abilities so that
you and others would know that there is no one like God? Do you know
and enjoy this God when you consider your skills?

God says to Cyrus as He gives him the "treasures of darkness and
the hoards in secret places" (Isaiah 45:3) to subdue the nations:

> For the sake of my servant Jacob, and Israel my chosen,
> I call you by your name, I name you though you do not
> know me. I am the Lord, and there is no other, besides me
> there is no God; I equip you, though you do not know me,
> that people may know, from the rising of the sun and from
> the west, that there is none besides me; I am the Lord and
> there is no other (45:4-6 ESV).

It is God who equipped Cyrus with this great commanding skill,
even though Cyrus did not know God, for the purpose that all would
know that there is no one like God.

All artists are given their skills by God, even before they know
God, so that they might begin to know and enjoy how skillful God is.

MY RESPONSIBILITY WITH THE SKILL
THAT GOD ENDOWS

Just as God's sovereignty does not negate human responsibility,
God's delight in a humble and contrite heart that trembles at His word

does not negate one's responsibility to be faithfully skillful. People can possess skill and yet be undisciplined. We do have a part to play in being effectively skillful. A skillful, yet undisciplined labor force will inefficiently erect a sloppy sanctuary. There is an applying of one's self in faith towards his skills for skillfulness to be realized to its full potential.

Be amazed at the skill of the Benjaminites. Judges 20:16 says, "Out of all these people 700 choice men were left handed; each one could sling a stone at a hair and not miss." A stone at a hair and not miss? Does this kind of accuracy happen without intense, disciplined practice? In I Chronicles 12:2 it says that "they were equipped with bows, using both the right hand and the left to sling stones and to shoot arrows from the bow, they were Saul's kinsmen from Benjamin." These Benjaminites were ambidextrous fighting machines!

While we can be encouraged from their fighting disciplines, we should take a warning from their undisciplined faithlessness to God in Judges 20. When they didn't fight on the right side of the issue, the Lord laid them low. All the skill in the world will not benefit me if God is not for me. It is not our skill that accomplishes victory for us. It is God who accomplishes our victory, and He may or may not use the skills He has given us to do it. Remember the sons of Korah:

> Through You we push down our foes; through Your name we tread down those who rise up against us. For not in my bow do I trust, nor can my sword save me. But You have saved us from our foes and have put to shame those who hate us. In God we have boasted continually and we will give thanks to Your name forever (Psalm 44:5-8 ESV).

When pursuing skillfulness, we must be careful that our skills do not become our hope or boast. Remember, our skill is from God, so then our boast must only be in God.

Notice Paul's understanding - his skillfulness is from God, and he must discipline himself to be responsible with it. "According to the grace of God which was given to me, like a wise master builder I laid a foundation, and another is building on it. But each man must be careful how he builds on it" (I Corinthians 3:10). Paul has been given grace to understand and teach us some of the mysteries of God. He must be careful to teach faithfully and accurately. If he neglects to lay a sure foundation, to be responsible with his skills, the house he builds will fall.

In the North, you can't just throw a bunch of rocks in a trench just below sod level, call it a foundation and expect your house not to heave when the frost comes. You have to dig down below the frost line to lay a solid footing, which demands much discipline. If you ever get the opportunity, dig footings some day with a shovel and pickaxe and learn how many calories you must burn in order to secure a solid foundation from which you can then start your building.

Skill is the understanding and ability needed to accomplish a task while discipline is the persistence and endurance applied to accomplish a task. Apart from the Lord, I will be neither skillful nor disciplined. "But by the grace of God I am what I am, and His grace toward me did not prove vain; but I labored even more than all of them, yet not I, but the grace of God with me" (I Corinthians 15:10).

In God's grace I labor, I sweat, I get really sore, my mind hurts, and yet it's the grace of God with me that accomplishes my artistic labors. Paul says, "for this purpose also I labor, striving according to His power, which mightily works within me" (Colossians 1:29). "I planted, Apollos watered, but God was causing the growth" (I Corinthians 3:6). "Not that we are adequate in ourselves to consider anything as coming from ourselves, but our adequacy is from God, who also made us adequate as servants of a new covenant" (II Corinthians 3:5-6a).

Paul encourages Timothy to engage his mind in the hard work of gaining understanding when he tells him, "Consider what I say, for the

Lord will give you understanding in everything" (II Timothy 2:7). God gives us a mind. We work our minds by considering, and we grow in understanding because of God, not apart from God. We do play a very real part in the maturing of our skills, so we must be disciplined if we are going to know the full pleasures that God has for us in being skillful.

Musicians, when practicing your scales or rudiments, do you start in humility before God who gave you this desire and affection for music and ask Him to give you understanding, to increase your skill, to grow in endurance, for pleasure in shedding the basics, for faithfulness in the sweet toil He gives you? The practice room is a beautiful place when practicing is about your mentorship and fellowship with the Lord on the theme of your favorite artistic pleasure. But it can quickly be a dreaded hell when it's just you and your instrument, and your instrument is playing master over you. Go to the Lord, know His pleasure towards you as He loves to give you good things. And by His strength, take pleasure in subduing your instrument.

If we are going to mature in our skills in a way that bears lasting fruit, we must not neglect to administer steady discipline over our heart's affections and our body's abilities. "Cease listening, my son, to discipline, and you will stray from the words of knowledge" (Proverbs 19:27). "Poverty and shame will come to him who neglects discipline..." (Proverbs 13:18a). Or to say it from a positive angle, "Incline your ear and hear the words of the wise, and apply your mind to my knowledge; for it will be pleasant if you keep them with you, that they may be ready on your lips" (Proverbs 22:17-18).

Paul rejoices to see the Colossians' "good discipline and the stability of [their] faith in Christ" (Colossians 2:5b). Good discipline results in stability, soundness, endurance, accuracy and dependability. Not only that, but great joy and pleasure and satisfaction. Whereas poor discipline leaves us in want, never experiencing the fruits and joys of a

hard, skillful labor.

> I passed by the field of a sluggard, by the vineyard of a man
> lacking sense, and behold, it was all overgrown with thorns;
> the ground was covered with nettles, and its stone wall was
> broken down. Then I saw and considered it; I looked and
> received instruction. A little sleep, a little slumber, a little
> folding of the hands to rest, and poverty will come upon
> you like a robber, and want like an armed man (Proverbs
> 24:30-34 ESV).

FAITHFULLNESS IS JUDGED ACCORDING TO
THE SKILL THAT IS GIVEN

I can hear pride raise its head here from those who have been given, by God, more skill than others to begin with. Pride will want to render a judgment based solely upon the value of the final sum, rather than the return on the investment.

In the parable of the talents in Matthew 25 Jesus says, "For it is just like a man about to go on a journey, who called his own slaves, and entrusted his possessions to them. And to the one he gave five talents, to another two, and to another one, each according to his own ability...." When the master comes back and finds that the slave with five talents gained five more, the master says, "Well done good and faithful slave...." The slave who was given two talents gained two more and his master says, "Well done good and faithful slave." The master does not say, "Good try, but your friend brought an additional five and you only brought an additional two." The master praises each slave according to that slave's faithfulness with what he was given, according to his ability. The master wants faithfulness. It would be wrong for the slave who was given five

talents to boast over the slave who was given two talents because his return was greater.

Remember what Paul says: "For who regards you as superior? And what do you have that you did not receive? But if you did receive it, why do you boast as if you had not received it" (I Corinthians 4:7)? Even our mental capabilities come from God. We have got to understand this. Our skillfulness is not from us. God has given us skill, and that in the portion He has desired. So when we are tempted to judge another's portion of skill or boast in our own, we must recognize that temptation as pride and slay it.

How many times, while boasting in our own skill or judging another's, have we robbed ourselves of the pleasures to be known in serving one another? How often do we look upon another's lesser skill with judgment and thereby miss the opportunity to have the pleasure of serving him? There was a third slave who was given one talent. He did not apply himself towards that talent and was pronounced a "wicked, lazy slave" by his master. What if the five-talent man, when seeing the one-talent man make a poor judgment in his application of the talent, came in grace and humility and offered to guide the one-talent man through some helpful disciplines? Both slaves could be blessed. It is not that we should cast off discernment and never assess someone's skillfulness. But when we assess, what do we do? Do we rejoice in the faithfulness according to the ability? Do we boast over differing returns? Do we see an opportunity for giving where we may have been given a supply for that need, understanding that this is our responsibility as a part of the greater body? God wants faithfulness from artists according to the skill He has given them. And to whom He gives much, much will be expected (Luke 12:48).

SELF-PRAISE, PRESUMPTION, PERFECTION, SLOTH:
ALL OBSTACLES TO THE POTENTIAL PLEASURES
FOUND THROUGH SKILL

Taking pride in our skills may tempt us towards a kind of self-praise. Not only is self-praise unbecoming, it is unhelpful. It often encourages us to overlook areas that need to be taken to the woodshed and worked out, a discipline we must exercise in order to realize our full potential ability and pleasure. We overlook these areas by offering or soliciting praise for what we are good at, with the hopes of concealing our weaknesses from others or even ourselves. Because we so naturally love the praises of men, if our disciplines are weak in one area, we are often tempted to take the easier, wider path of mediocrity rather than work on our weaknesses. The full pleasures in skillfulness are never found on the path of mediocrity.

Self-praise may be as simple as attributing my skill to myself rather than to God. This error will only lead to my downfall. "Pride goes before destruction, and a haughty spirit before stumbling" (Proverbs 16:18). "When pride comes, then comes dishonor, but with the humble is wisdom" (Proverbs 11:2).

Look at the downfall of Uzziah in II Chronicles 26:14-16 where he acted presumptuously in the self-adoration of all his skill.

> …Uzziah prepared for all the army shields, spears, helmets, body armor, bows and sling stones. In Jerusalem he made engines of war invented by skillful men to be on the towers and on the corners for the purpose of shooting arrows and great stones. Hence his fame spread afar, for he was marvelously helped until he was strong. But when he became strong, his heart was so proud that he acted corruptly, and he was unfaithful to the Lord his God, for he entered the temple of the Lord to burn incense on the altar of incense.

When we neglect to respect that it is God who has given us our skill, we often commit the error and sin of presumption.

Two other enemies that prevent us from knowing the full pleasures of skillfulness are perfection and sloth. To artists who struggle with perfection, who cannot enjoy an honest drawing from a child because the child demonstrates less skill, you will miss the beauty to be had in it if you do not learn to see as God sees. Perfection may keep you from attempting because you fear comparison or failure. Perfection is not an asset, but Persistance is. Perfection only measures in the negative and never encourages. It breeds jealousy and a judgmental heart. Persistance, however, encourages and motivates us towards realizing a mature and consistant skill.

To artists who are easily distracted (slothful or preoccupied) and do not cultivate their abilities with discipline, your pleasure return will be lacking. The slothful are like the third slave who was given the one talent, brought no increase to his master, and was pronounced wicked and lazy (Matthew 25:26).

The slothful artist often neglects his disciplines as he encourages himself that his work is just as good or better than others, while not understanding that he compares himself with those who have been given lesser skill or who may be slothful themselves. The perfectionist artist never attains artistic perfection, but while pursuing it, neglects to develop all sorts of other disciplines like grace, charity, gentleness, generosity, and humility. Neither artist will experience the full pleasures to be had in their artistic labors. We must concentrate on being faithful with our skills so we can enjoy all the fruits of a faithful, skillful labor. "He who tends the fig tree will eat its fruit; and he who cares for his master will be honored" (Proverbs 27:18).

The Master looks for faithfulness: "For I delight in loyalty rather than sacrifice, and in the knowledge of God rather than burnt offerings"

166

(Hosea 6:6). "By faith Abel offered to God a better sacrifice than Cain, through which he obtained the testimony that he was righteous, God testifying about his gifts, and through faith, though he is dead, he still speaks" (Hebrews 11:4).

Between Cain and Abel, who right now is still enjoying the fruits of his labor, long after his work has been consumed? Artists can lay a beautifully arranged work before the Lord, but unless it is done in faith, God will not be pleased. "…Whatever is not from faith is sin" (Romans 14:23b). A work may please all kinds of men with its skill, but God is the one whose affirmation matters.

If each member in the body of Christ focused on their given skills and played their part with great discipline, whether in the arts or finance or construction or culinary work or engineering or maintaining or researching or developing or defending or presenting or assembling or accounting or governing or serving or dreaming or tinkering or crafting or replicating or teaching or leading or enforcing or inventing or brokering or grooming, knowing when to step forward and knowing when to step back, all for the benefit of the whole, what beautiful, amazing skillfulness would be seen and enjoyed by all!

Artists, we must pursue the skill of faithfulness in order to realize the full potential pleasures in artistic skillfulness. Such pleasures can only be found through a skillfulness that is worked from faith.

"If I forget you, O Jerusalem, may my right hand forget her skill" (Psalm 137:5).

Boldness

And when they had prayed, the place where they had gathered together was shaken, and they were all filled with the Holy Spirit and began to speak the word of God with boldness. (Acts 4:31)

But after we had already suffered and been mistreated in Philippi, as you know, we had the boldness in our God to speak to you the gospel of God amid much opposition. (I Thessalonians 2:2)

...for what thing so worthy of the use of the tongue and mouth of men on Earth, as are the things of the God of Heaven? (Faithful, *The Pilgrim's Progress*)[1]

The Lord tells a bold story. Have you read His redemption story between Genesis and Revelation? Death is conquered when the Son of God faces it straight on, even giving Himself over to it, letting Death exert its might and have its run on Him. And while Death is rejoicing in its victory over its prey, the Son of God emerges from its grip, alive again, rendering ineffective all the power that Death could muster. And

all of that battling so that the full glory of God, which the Son already knew, could be known, loved, and enjoyed, unhindered by Death, by any jerk sinner who would love the Son as He stands preeminent in everything, reconciling all things to Himself through His blood on the cross (Colossians 1:18-20).

Do you recall some of the other characters in the story; their tests, their confidence, their failures, their obedience, their hope?

Joshua and Caleb are convinced that a victory is sure over the great mighty men of Canaan simply because the Lord said He would give them the land (Numbers 13:2). They said to the others:

> If the Lord delights in us, He will bring us into this land and give it to us.... Only do not rebel against the Lord. And do not fear the people of the land, for they are bread for us. Their protection is removed from them, and the Lord is with us; do not fear them (Numbers 14:8-9 ESV).

Jonathan's bold faith in the might of God shows itself when he says to his armor-bearer:

> Come let us go over to the garrison of these uncircumcised [Philistines]. It may be that the Lord will work for us, for nothing can hinder the Lord from saving by many or by few.... Behold, we will cross over to the men, and we will show ourselves to them. If they say to us, "Wait until we come to you," then we will stand still in our place and we will not go up to them. But if they say, "Come up to us," then we will go up, for the Lord has given them into our hand. And this shall be the sign to us (I Samuel 14:6-10 ESV).

When young David hears the arrogant warrior Goliath defy the armies of the living God, he says to the king:

> Let no man's heart fail because of [Goliath]. Your servant will go and fight with this Philistine…. Your servant has struck down both lions and bears, and this uncircumcised Philistine shall be like one of them, for he has defied the armies of the living God…. The Lord who delivered me from the paw of the lion and from the paw of the bear will deliver me from the hand of this Philistine (I Samuel 17:32, 36-37 ESV).

As Esther finds herself in the position of risking her own life for the sake of her people's welfare, Mordecai exhorts her to be bold. He sends this word to Esther:

> "Do not think to yourself that in the king's palace you will escape any more than all the other Jews. For if you keep silent at this time, relief and deliverance will rise for the Jews from another place, but you and your father's house will perish. And who knows whether you have not come to the kingdom for such a time as this?" Then Esther told them to reply to Mordecai, "Go gather all the Jews to be found in Susa, and hold a fast on my behalf, and do not eat or drink for three days, night or day. I and my young women will also fast as you do. Then I will go to the king, though it is against the law, and if I perish, I perish" (Esther 4:13-16 ESV).

There are so many examples of boldness throughout the Bible. Notice what they have in common. The victorious people are bold in the Lord's might and power, not in their own power. The victorious ones

trust that the Lord's word will be true. The victorious ones believe that God will be faithful to his promises. The victorious ones believe in God's sovereignty over all. They know they must play the man in the battle, they understand that the fight and the outcome belongs to the Lord, so they entrust themselves to Him. These insufficient people are very bold because they are bold in the strength of Another. Pusillanimous they are not.

In every event there is an opportunity to fear man. Take note that the fear of man manifests itself in so many ways besides fright. Any affection that moves you towards placing your hope in another person, or in their affirmation, is rooted in the fear of men. If, in the arts, we put ourselves in subjection to the laws of the Land of the Fear of Men, we will forgo the freedoms found and enjoyed in the Empire of the Pleasures of God. God, give us ears to hear and faith to heed these lessons in boldness throughout Your redemptive history.

BE BOLD IN THE TRUTHS OF GOD

God has boldy made known what truth is, and yet we are so timid to affirm, enjoy, and articulate His truths. But that is exactly one reason for the existance of the artist. If indeed artists are about communicating or expressing what their hearts are wrestling with, then why repeat the same old neutered song for the sake of acceptability or marketability? Why only sing what is tame or what comes at no cost? This smells like the fear of men to me. These songs have been sung enough. These stories have been written and filmed enough. Artists, I'm not saying that for the sake of being provocative we need to step up the lyric or the storyline. Being provocative for the sake of being provocative is not the goal. Knowing and enjoying the full beauty of truth is the goal. Why not unpack the truth in its fullness instead of just toying with it, and where the truth is

provocative, let the truth be as it is? That is part of truth's glory. God has given us artistic expression because there is a bold aroma of truth to be known and enjoyed through the disciplines of poetry whose scent is not as fragrant in prose. Let's stop wasting this gift of artistic expression on undisciplined, sterilized, fad-driven, postmodern-hearted, say-nothing collections of ingredients, having no stamens or pistils by which to pass along any truth. Artists, be bold! Wrestle to articulate something in your artwork that is worth the labor you spend trying to express it!

Of what true usefulness is a painting if it demonstrates less beauty or truth or skill or atttention or discipline than the bare wall on which it hangs? I'm not talking about what the painting looks like, I'm talking about what the author intends to say or elicit with it. Let it look like anything, that is not the battle. What is it evidencing? What is the artist revealing, asking, saying? A bare wall serves as a frame to focus my attention on that one piece of information confined to the space of the painting. I am so disappointed when I see more evidence of seriousness or truth in the construction of the wall (assuming that the issue here is not my ignorance) than in the work of art.

By truth here I mean this: a reality that is articulated or demonstrated through everything from its content to the disciplines exercised; sometimes words are used, most often they are not; honest questioning as opposed to thoughtless, arrogant pride; clarity and attention as opposed to a boastful sluggard's mess; etc. When God created the bird, He didn't neglect the truths and order that He expressed when creating the laws of gravity. No, in creating the bird He further articulated gravity's reign. The bird doesn't overrule gravity (it must eventually land), but there is a truth about gravity that is articulated or demonstrated through the flight of a bird that is not demonstrated through the running of a man.

When God creates or speaks, He doesn't put a finger to the wind to see what men might want to hear from Him, or what might grab their attention for a moment. No, He boldly articulates the truth and beauty

174

that He knows and enjoys, and that with almighty power and unending grace.

In John's account of the Gospel, John is in awe of the Son of God; "The Word became flesh, and dwelt among us, and we beheld His glory, glory as of the only begotten from the Father, full of grace and truth" (John 1:14). Jesus was not full of wimpy grace and half-truth, not wanting to offend anyone, hoping to be accepted by all. Jesus was gracious to us in giving us the full, hard truth, even when the truth divided our allegiances. It was Jesus' mighty, authoritative, compassionate boldness and not His appearance that drew the people to Him. "He has no stately form or majesty that we should look upon Him, nor appearance that we should be attracted to Him" (Isaiah 53:2b). Jesus was wise not to play both sides; the fear of God and the fear of men. In the end, He would have found Himself to be the friend of none. He knew God and He knew man, and He chose to fear God. "But Jesus, on His part, was not entrusting Himself to them, for He knew all men, and because He did not need anyone to bear witness concerning man, for He Himself knew what was in man" (John 2:24-25).

THE GOD OF PEACE SHALL BE WITH YOU, SO TAKE COURAGE TO BE BOLD

Artists, be bold. Entrust yourselves to God who knows your frame, your needs and your days. David took great comfort in this truth. He was so thankful that God made him, knew him, and was his Keeper. David says:

> I will give thanks to Thee, for I am fearfully and wonderfully made. Wonderful are Thy works, and my soul knows it very well. My frame was not hidden from Thee, when I

was made in secret, and skillfully wrought in the depths of
the earth. Thine eyes have seen my unformed substance;
and in Thy book they were all written, the days that were
ordained for me, when as yet there was not one of them
(Psalm 139:14-16).

So if God has made you and has ordained all the days you will
have, why fear what mere men may think of you?

When God is pleased as He examines a heart and finds faithful
boldness, He blesses that person with deep peace and joy and satisfaction.
Facing an opportunity requiring boldness, we may not be able to see the
peace or joy ahead, but we must entrust ourselves to God and proclaim as
He would lead. God will be faithful.

Paul encourages us to walk the path of boldness as he has set his
mind to do, in the power of God. And he testifies to us that God has
faithfully been with him. He says:

…the peace of God, which surpasses all comprehension
shall guard your hearts and your minds in Christ Jesus….
Brethren, whatever is true, whatever is honorable, whatever
is right, whatever is pure, whatever is lovely, whatever is
of good repute, if there is any excellence and if anything
worthy of praise, let your mind dwell on these things. The
things you have learned and received and heard and seen
in me, practice these things; and the God of peace shall be
with you (Philippians 4:7-9).

Paul is a great example for us of God-fearing boldness. Paul doesn't
say that he was never concerned with the unknowns he might find ahead.
He was flesh and blood. He had opportunities to be anxious or shrink
back from what he knew he should say. But when the temptation to fear

men presented itself, he fought for his faith and set his mind to fear God, not man. Listen to God encourage Paul when he was tempted to fear. "And the Lord said to Paul in the night by a vision, do not be afraid any longer, but go on speaking and do not be silent; for I am with you, and no man will attack you in order to harm you, for I have many people in this city" (Acts 18:9-10). God will encourage us as well. "No temptation has overtaken you but such as is common to man; and God is faithful, who will not allow you to be tempted beyond what you are able, but with the temptation will provide the way of escape also, so that you will be able to endure it" (I Corinthians 10:13).

"If God is for us, who is against us" (Romans 8:31b)? There is a sweet peace that is found in the boldness of God. God cowers to no one! Abide in God's boldness in your artistry and you will begin to enjoy what He enjoys in being bold.

BOLDNESS VS. ARROGANCE

Boldness is brother to Humility, while Arrogance is brother to Pride. The difference between boldness and arrogance is the object of their trust. Humble boldness trusts in God, while prideful arrogance trusts in self.

Put this verse in your pocket for when you need some motivation to be bold in what the Lord has for you to say in your artistry. God tells Jeremiah:

> Now gird up your loins and arise, and speak to them all which I command you. Do not be dismayed before them, lest I dismay you before them. Now behold, I have made you today as a fortified city, and as a pillar of iron and as walls of bronze against the whole land, to the kings of Judah, to

its princes, to its priests and to the people of the land. And
they will fight against you, but they will not overcome you,
for I am with you to deliver you... (Jeremiah 1:17-19).

Saying what the Lord has for you to say does not guarantee
acceptance with men, but it does with God. Men may hate you, but God
will defend you. And don't be alarmed if His defense lands you behind the
gates of heaven. What a defense! And what an entrance! Entering heaven
while being found faithful is surely different than entering while being
mercifully kept from making another mistake, yet entering nonetheless!
We might as well be bold. "For not one of us lives for himself, and not
one dies for himself; for if we live, we live for the Lord, or if we die, we
die for the Lord; therefore whether we live or die, we are the Lord's"
(Romans 14:7-8).

God, give us faith to believe this word of Yours:

For I am convinced that neither death, nor life, nor angels,
nor principalities, nor things present, nor things to come,
nor powers, nor height, nor depth, nor any other created
thing, shall be able to separate us from the love of God,
which is in Christ Jesus our Lord (Romans 8:38-39).

We can further sub-categorize by adding audience, market,
manager, label, artist, critic, etc.... Acceptance with these will not garner
us any love from God, and rejection from any one of them will not
separate us from the love of God. Run after God as He leads you through
these dangers in this world, and embrace and know the joys found in the
rugged terrain He sets before you in the arts. God has amazing things to
show us that can only be seen when we are pressed to fear Him alone.
Enjoy the sovereign surety of God!

178

Who is your provider, artist? Who pays the bills? You, the audience, or God? God may use the means of an audience to pay your bills. He may use ravens (I Kings 17:4). That is God's prerogative. Spurgeon corrects us:

> You are meddling with Christ's business, and neglecting your own when you fret about your lot and circumstances. You have been trying "providing" work and forgetting that it is yours to obey. Be wise and tend to the obeying, and let Christ manage the providing. Come and survey your Father's storehouse, and ask whether He will let you starve while He has laid up so great an abundance in His garner?[2]

Praise God that Jesus obeyed His Father in faith and did not give in to hunger or the Devil as the Holy Spirit led Him to and through that wilderness! Christ's provision was in God, and His "food" was to do His Father's will and accomplish what He was sent to do (John 4:34). Christ did not take that wilderness with arrogance, He prevailed through a humble, bold faith in the One who is faithful.

When you are tempted to compare your lot with others' when contemplating whether or not to obey the Lord in the arts, consider the lot of Jesus, the Son of God: nowhere to lay His head (Matthew 8:20), "despised and rejected of men, a man of sorrows and acquainted with grief" (Isaiah 53:3), led by the Holy Spirit into the wilderness for forty days to be tempted by the devil (Luke 4:1-2), without honor in His own hometown amongst relatives and in His own household (Mark 6:4). They didn't even like the way He told the stories (Matthew 13:10). Yet because of His bold obedience, even to the point of death on a cross:

> Therefore also, God highly exalted Him, and bestowed

on Him the name which is above every name, that at the name of Jesus every knee should bow, of those who are in heaven, and on earth, and under the earth and ...every tongue should confess that Jesus Christ is Lord, to the glory of God the Father. So then, my beloved, just as you have always obeyed, not as in my presence only, but now much more in my absence, work out your salvation with fear and trembling; for it is God who is at work in you, both to will and to work for His good pleasure (Philippians 2:9-13).

Artists, you can be bold because God is at work in you to accomplish bold obedience, which is part of your sanctification process. You will bow to Jesus one day whether you were boldly obedient or dastardly unfaithful to Him. Either way you will meet Jesus and find your knee.

After Jesus conquered death, He said to the disciples, "Peace be with you; as the Father has sent Me, I also send you" (John 20:21b). Now if you think about how the Father sent Him, you will think about what it cost Jesus in His body and relationships to be obedient to His Father's sending. The rejection, the scourgings, the crowds, the objections, the lies, the cross: this might tempt us to fear. Jesus also says, "Behold, I send you out as sheep in the midst of wolves" (Matthew 10:16a). Jesus does not tell us this to make us afraid, He tells us this to wake us up so that we would take up the shield of faith and prepare our hearts for boldness because boldness will be needed! Which is why He finishes the verse with "therefore, be shrewd as serpents, and innocent as doves" (16b).

Notice that Jesus begins the sending off with "Peace be with you..." (John 20:21a). He is giving us His peace as He sends us into the wilds. "For God has not given us a spirit of timidity, but of power and love and discipline" (II Timothy 1:7). Jesus was humbly bold, much in prayer, filled with the Holy Spirit, and He finished His course triumphant! And

you will finish well too if you remain faithful to God, in the strength that the He provides.

God has been bold in purchasing our pardon. Why would He require any less boldness from us in the telling of His bold pardoning? On our own strength, we will not be bold for long when the criticisms and afflictions come, and God knows it. We will only be arrogant or cowardly when working in our own strength. But in God's strength we can be fiercely, humbly, invincibly bold.

THE HOLY SPIRIT IS OUR BOLDNESS

Isn't Paul referring to the cost of testifying when he says, "Now I rejoice in my sufferings for your sake, and in my flesh I do my share on behalf of His body, which is the church, in filling up what is lacking in Christ's afflictions" (Colossians 1:24)? Being bold in what is true will cost us. It cost Jesus. It cost Paul. It cost every martyr of Christ. It costs everyone who loves as God loves. But no suffering in the Lord is in vain (I Corinthians 15:58), nor does God leave us to ourselves to accomplish the boldness that He asks of us. God does not send Paul or us out to testify about Him without equipping us for the testifying. He gives us the Holy Spirit. Jesus said, "…the Helper, the Holy Spirit, whom the Father will send in My name, He will teach you all things, and bring to your remembrance all that I said to you" (John 14:26).

This would be a great time to get to know the Holy Spirit. He is a gift to us from God and He groans for us to God.

> …the Spirit also helps our weakness; for we do not know how to pray as we should, but the Spirit Himself intercedes for us with groanings too deep for words; and He who searches the hearts knows what the mind of the Spirit is,

because He intercedes for the saints according to the will of God. And we know that God causes all things to work together for good to those who love God, to those who are called according to His purpose (Romans 8:26-28).

The Holy Spirit is our helper, given to us by God. Do we employ His leading and strength? The Holy Spirit will give us a holy boldness by which we would experience the fuller pleasures of God to be had through our artistic labors.

BOLDNESS DOES NOT FEAR OR HOPE IN THE MARKET, BOLDNESS FEARS AND HOPES IN GOD

I know and hear stories of artists and/or their managers/counselors/ labels/friends fearing the market such that they approach their artistry with this mindset: "Maybe we should be careful that we do not get too specific or bloody because then the stores might not carry our artwork" (and they are not referring here to the children's section in the store). "And if they don't carry our artwork, how are the people going to hear all of the Godly things we have to say? How are we going to provide for ourselves if we do not work within what is widely acceptable in the marketplace? And surely the Bible says in I Timothy 5:8 that I am worse than an unbeliever if I do not provide for my family? God uses the means of the market for my provision doesn't He?"

When this is our motivation for what we say or do not say in our artwork, we evidence that our hope for provision is really placed in the market or in our own devices, and not in God who establishes households (Exodus 1:21) and who raises the dead (John 11:43). This thinking is usually due to following man's logic and not the leading of the Holy Spirit. Of course God uses the market as a means of His provision

for us, but He also uses ravens as a means (I Kings 17:3-5). God, as He delights to be your provision, is not bound by any market or logic that He ordains.

These same stores carry the Bible don't they? Have you read your Bible lately? Murder, blood, rape, incest, adultery, homosexuality, prostitution, beheading, dismemberment, hanging, stoning, burning, boiling, cannibalism, exorcism, crucifixion, all addressed in relation to the holiness and wrath and justice and mercy and love of God. Thank God He didn't leave the bloodiness out of His book! We wouldn't know the beginning of the glory of His mercy if He did. He also didn't leave Hell out of it. Maybe if we all had a hauntingly dynamite painting of Hell in our house we would begin to live as if we believed in its existence!

What is our motivation for pulling a bold punch in our artistry? If we are motivated by the fear of man, we have failed in our "beautiful" work. But where the degree of our boldness is restrained due to the fear of God, meaning that God has encouraged you to restrain your articulation in some measure, then He will find you faithful where He desires that you display His gentleness that day. God is a bold God. We shouldn't be afraid to boldly tell others of His boldness. We should tremble, however, with being found in the end to be a poltroon servant in the eyes of Almighty God.

Artists, Jesus encourages us with this:

> What I tell you in the darkness, speak in the light; and what you hear whispered in your ear, proclaim upon the housetops. And do not fear those who kill the body, but are unable to kill the soul; but rather fear Him who is able to destroy both soul and body in hell (Matthew 10:27-28).

How this plays out in your artwork, let the Holy Spirit reveal to you. Follow Him, and God will show you beautiful vistas that can only be

viewed from the cliffs of faithful boldness; pleasures that cowards never see.

We must learn to trust God alone. It is part of our sanctification process. If I place my trust in anything other than God, I have become an idolater.

> Hear, O My people, and I will admonish you; O Israel, if you would listen to Me! Let there be no strange god among you; nor shall you worship any foreign god. I, the Lord, am your God, who brought you up from the land of Egypt; open your mouth wide and I will fill it. But My people did not listen to My voice; and Israel did not obey Me. So I gave them over to the stubbornness of their heart, to walk in their own devices. Oh that My people would listen to Me, that Israel would walk in My ways! I would quickly subdue their enemies, and turn My hand against their adversaries. Those who hate the Lord would pretend obedience to Him; and their time of punishment would be forever. But I would feed you with the finest of the wheat; and with honey from the rock I would satisfy you (Psalm 81:8-16).

"Open your mouth wide and I will fill it" was the verse that encouraged George Mueller to boldly ask the Lord for the provision for the orphan house in such a way "That God may be glorified, should He be pleased to furnish me with the means, in its being seen that it is not a vain thing to trust in Him; and that thus the faith of His children may be strengthened."[3]

The Lord gave provision to Mueller to the glory of Himself. What pleasures Mueller must have known in those days of God's unique

provision. I do not want to be left to my own devices, recognizing that even an accomplishment from "my own devices" is only due to the common grace of God to me. I want to see the bold power of Almighty God! "If God is for us, who can be against us? He who did not spare His own Son but gave Him up for us all, how will He not also with Him graciously give us all things?" (Romans 8:31a-32).

Before Jesus ascended back to heaven, He gave us one more reason to be encouraged to walk in boldness. "All authority has been given to Me in heaven and on earth. Go therefore..." (Matthew 28:18b-19a). The reason we are not bold as we should be in our artistry is because we do fear man, and we do not fear God. We believe man's enticements and threats more than God's power and pleasures. Jesus gives us our options when choosing whom to fear: "Everyone therefore who shall confess Me before men, I will also confess him before My Father who is in heaven. But whoever shall deny Me before men, I will also deny him before My Father who is in heaven" (Matthew 10:32-33).

Paul knows this Jesus who has all authority, and he exhorts us towards boldness in Christ when he says:

> But thanks be to God, who in Christ always leads us in triumphal procession, and through us spreads the fragrance of the knowledge of Him everywhere. For we are the aroma of Christ to God among those who are being saved and among those who are perishing, to one a fragrance from death to death, to the other a fragrance from life to life. Who is sufficient for these things? For we are not, like so many, peddlers of God's word, but as men of sincerity, as commissioned by God, in the sight of God we speak in Christ (II Corinthians 2:14-17 ESV).

So artists, will you truly be satisfied with continual silhouettes of audiences, or do you long to catch glimpses of God? Do you really want to perch only in the plains of common grace, or would you endeavor to hunt the hinterlands full of the bounty of God Himself? Spurgeon pushes us to be biblically bold:

> If we would venture more upon the naked promise of God, we should enter a world of wonders to which as yet we are strangers. Let Jeremiah's place of confidence be ours - nothing is too hard for the God that created the heavens and the earth. "Ah, Lord God, behold, Thou hast made the heavens and the earth by Thy great power and stretched out arm, and there is nothing too hard for Thee" (Jeremiah 32:17).[4]

Artists, let's put to death these Thieves of Timidity that seek our poverty through the fear of men. Great reward awaits the one who works in a God-fearing, God-enjoying, humble boldness. And let's own that word "pusillanimous" where we need to, because pusillanimous is what we are when we are not bold.

Beauty

And out of the ground the Lord God made to spring up every tree that is pleasant to the sight and good for food. The tree of life was in the midst of the garden, and the tree of the knowledge of good and evil. (Genesis 2:9 ESV)

And you shall make holy garments for Aaron your brother, for glory and for beauty. (Exodus 28:2)

As a ring of gold in a swine's snout, so is a beautiful woman who lacks discretion. (Proverbs 11:22)

It is a snare to say rashly, "It is holy" and to reflect only after making vows. (Proverbs 20:25)

Your heart was proud because of your beauty; you corrupted your wisdom for the sake of your splendor. I cast you to the ground…. (Ezekiel 28:17a)

The word "beautiful" is one of those flexible words that may need its parameters established as it is being used. It may be used to describe

an attractive, aesthetic appearance; a gratifying, invisible emotion; an agreeable action; a truth evidenced and secured; an inviting aroma; or a delightful sound. Furthermore, what I consider to be "beautiful" may be considered distasteful to another. When using the word "beautiful," it would be helpful to establish in what sense we consider or enjoy something as being beautiful.

Let me try to flesh this out with an example: "...[Abraham] said to [Sarah] his wife, "See now, I know that you are a beautiful woman; and when the Egyptians see you, that they will say, 'This is his wife'; and they will kill me, but they will let you live" (Genesis 12:11b-12). Abraham here is recognizing that his wife's form and appearance are such that even a stranger would find her beautiful and might even go to great lengths to enjoy her beauty. Abraham is making a judgment with his sense of sight that Sarah is beautiful.

Now in Isaiah 53, Jesus is described, with regard to a sense of sight, as being unattractive in form and appearance:

> He has no stately form or majesty that we should look upon Him, nor appearance that we should be attracted to Him. He was despised and forsaken of men, a man of sorrows and acquainted with grief; and like one from whom men hide their face, He was despised, and we did not esteem Him (Isaiah 53:2b-3).

My question then is: is Jesus not beautiful?

If Jesus and Sarah were standing next to each other, and I didn't know anything of their background and was asked, "Which person appears more beautiful to you?" I am sure that I would say Sarah, basing my judgment on my default sense of sight. But if I were standing at judgment, knowing all about Sarah's life and death and all about Jesus'

life and death and what each one of them means for my sins as I am standing in line to give account for my life before the Holy God, and was asked, "Which person appears to be more beautiful to you?", all I could say would be, "Only Jesus looks beautiful!"

So does my response here mean that Sarah is not, or was not, beautiful?

Do you see how a narrow understanding and use of the word "beautiful" can be unhelpful and even misleading? Sarah's beauty is of a different kind and weight than Jesus' beauty.

In today's culture, we assign the word "beautiful" all too quickly and much too superficially. We generally only use it when referring to aesthetic appearances. Rarely do we use the word "beautiful" as a description for someone when referring to their actions or character alone with no intention of describing their aesthetic appearance. Why is that? Is courage not beautiful? Is honesty not beautiful? Is resolve not beautiful? Is humility not beautiful?

We are a very impatient people today. And we have so many things vying for our attention. And, we are such suckers for easy pleasures. If we do not apply patience and discernment in our analysis of what we deem beautiful, we will pass over and never enjoy the breadth and depth of what God has called beautiful.

Manufacturers are aware of our impatience. It is almost as if they think, "No one thinks too much about what is inside the beautiful box in a disposable age. If the packaging looks beautiful, and the promises sound beautiful, people will desire it and buy it." Proverbs 20:25 warns us to exercise patience in our judgment of what we call beautiful. "It is a trap for a man to say rashly, 'It is holy!' And after the vows to make inquiry."

Our culture lives in its surface senses - the ones that get tickled. It is a trap to dwell here. If all we do is tickle each other's surfaces, we'll

never know the deep beauty and pleasures of wrestling together with all our might until our inner bones ache with exhausted joy. Our impatience blinds us from discerning what will prove to be beautiful in full. Our impatience will train us towards glancing rather than meditating and studying and proving.

And so, in today's climate, to seek to be beautiful or to create something of beauty has too heavily proven to refer to an outward aesthetic appearance with little regard for the value of the inner essence. If all we know how to do is glance and seek a tickle, we will never probe into the essence until after we have committed to the purchase and are forced to open the box. The "beautiful" reality is that most commitments cannot be returned without issue. And this is often the schooling that teaches us, through the pain, what the full measure of beauty is.

AESTHETIC BEAUTY DOES NOT TRUMP
THE BEAUTY OF RIGHTEOUSNESS

I am not at all saying that aesthetic appearance has no value. It obviously does. God designed the priestly garments "for glory and for beauty" (Exodus 28:2), so God must find pleasure in our enjoyment of the priestly garment's aesthetic beauty. But the aesthetic beauty in shape, form, and space does not cover over or trump the beauty of righteousness. Aesthetically beautiful appearances are of a different category and value than the beauty of truth and righteousness. Of course, truth and righteousness can manifest their own aesthetics that are incredibly beautiful! We will see this demonstrated once and for all when we see with our eyes the holiness of God! But immorality can put on an aesthetic beauty too, which is why we are all suckered into it so easily and so often. With all things beautiful, we have to be careful not to overvalue or even undervalue, but rather, rightly value according to the value that God has

given them.

We see in Genesis 2:9 that God delights in the appearance of the trees that He is going to put in the Garden of Eden. "And out of the ground the Lord God made to spring up every tree that is pleasant to the sight and good for food. The tree of life was in the midst of the garden, and the tree of the knowledge of good and evil." God decidedly put trees in the garden that were pleasant to the sight of man, for his pleasure. This is God's doing. Adam and Eve were to get the pleasure of enjoying the beauty of the appearance of the trees. And, the trees were even good for food; another pleasure altogether.

But, God also gave restrictions on how they were to enjoy what their senses found to be beautiful. There was a tree in the garden, created by God, that was beautiful in appearance yet was not to be consumed: the tree of the knowledge of good and evil. We know that it was beautiful in appearance because Eve says that it was "a delight to the eyes" (Genesis 3:6 ESV). Of this beautiful tree, God said, "...you shall not eat..." (Genesis 2:17 ESV). The problem was not that the tree was pleasant to the sight. The problem was going to be that Adam and Eve would delight more in the devil's enticements with what was beautiful in appearance than they would delight in the beauty of faithfulness to God. Eve, and Adam, enjoyed the tree in a manner that God told them not to. The serpent tempted Eve with false promises of greater pleasures and used the tree's beautiful appearance, among other things, as the bait. This is exactly where we ourselves err regarding what is beautiful in appearance, but not to be consumed for the gratification of the flesh. Artists, we must be very careful with what God has made pleasant to the eyes. Let not the tempter distract you from the beauty and pleasures of righteousness with the beauty and pleasures of aesthetics. Aesthetic pleasures are beautiful, but they are not as valuable or pleasurable as the beauty of faithfulness.

God abhors the presumption of Nadab and Abihu, the sons of

Aaron, as they offer "unauthorized fire before the Lord, which he had not commanded them" (Leviticus 10:1 ESV), so He consumes them with fire that comes "out from before the Lord..." (10:2). God doesn't overvalue the aesthetic beauty of a garment He designed for the priests to wear such that He passes over the heart of the man for the sake of not destroying the beauty of the garment. God's destruction of the world with a flood because of the unrighteousness of man would be another clear example of how He did not value the aesthetic beauty of His created world over the beauty of righteousness, and the lack of it in man. There are clearly different kinds and degrees of "beauty" pleasures to be enjoyed, but the same scalepan is not used in valuing each beauty.

Appearances can deceive us in two ways. A rough appearance may camouflage a true beauty, as with Jesus, or an attractive appearance may prove to have a bitter essence, as with the adulteress. "For the lips of an adulteress drip honey and smoother than oil is her speech; but in the end she is bitter as wormwood, sharp as a two-edged sword. Her feet go down to death, her steps take hold of Sheol" (Proverbs 5:3-5). This is why we must be mature in our understanding of what is truly beautiful. In anything artistic or otherwise, we need to dig through the surface until we reach the inner essence. The essence will always be the essence, and the shell will only be a shell. We need to train our sense of discernment to hunt for the essence, and then we will begin to realize, and in turn find the satisfaction we seek, once we understand the full counsel of beauty's disposition.

David says, "One thing have I asked of the Lord, that will I seek after: that I may dwell in the house of the Lord all the days of my life, to gaze upon the beauty of the Lord and to inquire in His temple" (Psalm 27:4 ESV). Did David see the attractiveness of the form and appearance of God? No. So why is he so sure that for the rest of his days he wants to "gaze upon the beauty of the Lord"? David knows a bit of the essence of

God. And that bit of the essence of God is so beautiful that David is not concerned that he hasn't seen the aesthetic beauty of the face of God.

One's beauty is so much more than their shell. Our culture does not understand this. Artists, we must learn more about God so that we would learn more about beauty. Train your eyes to see more of God in all of life, and you will see more beauty in all of life. The essence of God is where beauty originates, and from Him beauty is bestowed. "You grew exceedingly beautiful and advanced to royalty. And your renown went forth among the nations because of your beauty, for it was perfect through the splendor that I had bestowed on you, declares the Lord God" (Ezekiel 16:13b-14).

THE "SENSE" OF DISCERNMENT
IN THE HEART AND MIND

Since beauty embraced by the physical senses (sight, smell, hearing, taste, and touch) is rather easy to discern, I want to push on the "senses" in the heart and mind, the senses that need development. When I recognize more beauty because of matured senses, I then experience more mature joy. For the artist, a more mature joy spills over into a more mature expression, a more mature artwork. A poet expresses something from within himself when he writes a poem. If there is only a little portion of truth or love or wisdom inside the poet, then only a little truth, love and wisdom will be able to be expressed. But where a poet has a veteran understanding of love, gratitude, or discernment, much more will be expressed. In fact, much more would be expected from that poet.

Our physical senses are like the primer in a shot shell. The primer doesn't hold the power. The primer is used to ignite the power of the gunpowder. I won't land any live game if all I'm packing is primers. This is better known as a cap gun. Sure it was fun to run around as a

kid taming the wild prairie with a cap gun. But that bit of fun doesn't compare to the pleasure of that first time you felt all the fire power in a live round combust against your shoulder when you touched the trigger with live game in your sights! You don't go back to cap guns after that. Understand this, our physical senses are not like the gunpowder - they are like primers, with the beautifully necessary role of igniting. They give us a taste of what may be to come; the combustion of a much larger powder keg of joy, elation, comfort or wonder in our souls when our souls are hit with the impact of true, live, powerful beauty.

However, our senses can be fooled, so we must not trust in them, but rather take the information they give us and apply discernment to ascertain whether we have live game in our sights or a poacher's decoy. We are not the only ones hunting. While we are hunting for pleasures, the devil is hunting for suckers. Peter warns us to "be sober-minded; be watchful. Your adversary the devil prowls around like a roaring lion, seeking someone to devour. Resist him, firm in your faith…" (I Peter 5:8-9a). The devil knows how our senses work better than we do, and he uses them to draw us into his lair. So when Peter says "be-sober-minded; be watchful…Resist [the devil]," he is exhorting us to have our full capacities of heart and mind engaged while beauty hunting, not just the salivating palates of our physical senses.

When we are working with all our capacities (or senses) involved, and while on the path of obedience we smell hard labor ahead or sufferings of various kinds, and it sends up a warning that this is going to be a tough road, our discerning governor should encourage us to be steadfast amidst the adversities because this is the path that leads to pure and deep beauty. But if all I have developed is my sense of "smell", I will mislead myself away from the deep joys with the air of the first unpleasant aroma.

Peter exhorts the church elders to engage in the hard, dirty and beautiful work of eagerly "shepherding the flock of God that is among

them" (I Peter 5:2) with the encouragement that the hard labor has a beautiful end. "And when the Chief Shepherd appears, you will receive the unfading crown of glory" (I Peter 5:4). There is an "unfading crown of glory" at the end of a heavy, faithful labor where you may get old and torn and wrinkled and bruised and gray. You might not even be pretty anymore. Instead, you've become beautiful! Pretty has her time and place, but Beauty is ever welcome. Isaiah 52:7 says, "How lovely on the mountains are the feet of him who brings good news, who announces peace and brings good news of happiness, who announces salvation and says to Zion, "Your God reigns!" Feet are not pretty after a long hike, but a sure foot sure is beautiful.

It was shortsightedness (lack of discerning faith) that kept the Israelites out of the promised land for so long. The Lord told Moses to send spies into the land that He was going to give them. The spies went and recognized the land to be beautifully fruitful, flowing with "milk and honey" (Numbers 13:27). But only Joshua and Caleb applied faith to discern that the glory of God's strength was more beautiful than the glorious strength of the Nephilim, to whom the Israelites appeared to be as grasshoppers (Numbers 13). Because the other ten spies did not apply faith to discern that in the beauty of God's strength they could defeat the mighty inhabitants and have all that God promised them for their inheritance, but instead passed on their pessimism to the people, that generation never experienced the beauty of God's gift to them in the land of Canaan. They forfeited knowing and enjoying deep, satisfying beauty due to their immature faith.

We do this all the time with art. Because we don't understand and believe that everything is from God and through God and to God (Romans 11:36), we forfeit so many of the different beauties that God has given us for our enjoyment. We miss so much beauty in the world and in art because we can't see God as the beginning, the means, and the end of it. We must push on everything in life hard enough until we end

up at God so that we can discern and enjoy the full beauty that God has ordained things to have. And, so that we can learn what God enjoys and abhors in our interaction with what He has made beautiful.

What is "beautiful" about an artwork in the eyes of God? What is "ugly" about an artwork in the eyes of God? I suppose first we must learn to see as God sees, in His full counsel, if we are to answer those questions rightly.

One of the things so beautiful about Jesus is how He can discern through all appearances right down to the motives of the heart. In Matthew 23:27-28 Jesus says:

> Woe to you, scribes and Pharisees, hypocrites! For you are like whitewashed tombs, which on the outside appear beautiful, but inside they are full of dead men's bones and all uncleanness. Even so you too outwardly appear righteous to men, but inwardly you are full of hypocrisy and lawlessness.

While trying to "beautify" themselves through law keeping and appearances, the scribes and Pharisees did not discern that God could see through to the essence of their heart and was not deceived.

I Corinthians 4:5 says, "Therefore do not go on passing judgment before the time, but wait until the Lord comes who will both bring to light the things hidden in the darkness and disclose the motives of men's hearts; and then each man's praise will come to him from God." One of the things Paul is telling us here is that we must be patient. We shouldn't be too quick to pass a final value judgment either way. Things that appear to be beautiful will have their essence tested by the light of God and may prove to be a flower of an evil motive. Thistles produce a beautiful purple flower. And there may be a measure of sweetness to be gleaned from that flower. But a thistle is a thistle. Don't let that flower go to seed. Yet, other

flowers will be tested and prove to be the evidence of a faithful heart, by which they will receive praise from God.

Patience also needs to be applied where the beauty of appearance seems, at first glance, to be questionable. How often was Jesus misjudged by those who followed Him? When we are impatient with a glance that at first seems unpleasing, we may judge incorrectly as the disciples did at Simon's house and miss the beauty of "wasted oil." They found the rebuke of Jesus. "Why do you trouble the woman? For she has done a beautiful thing to me" (Matthew 26:10b ESV).

So, we must seek to see as God sees if we indeed want to deeply enjoy the riches of beauty in all her many expressions. Our sense of discernment must be developed so that we do not confuse the shell for the essence. The shell is not the essence. Again, it is not that the shell has no value in being beautiful. Remember God's intent for the trees in the garden and the priestly garments. Rather, it is that the worth of the shell's beauty is dependant upon the worth of the essence's beauty, because it is the essence that will or will not survive the fire. Gold will survive the fire. Gold colored plastic will not.

HOW DO I MAKE THE OUTSIDE TRULY BEAUTIFUL?

Be encouraged artists, Jesus gives the Pharisees and us a little counsel on how we should go about making the outside, or the shell, beautiful:

> Woe to you scribes and Pharisees, hypocrites! For you clean the outside of the cup and the plate, but inside they are full of greed and self-indulgence. You blind Pharisee! First clean the inside of the cup and the plate, that the outside also may be clean (Matthew 23:25-26 ESV).

Clean the inside so that the outside may be clean. If you want the outside to be clean, you should start with the inside. It is like a wound. If I only clean and suture the wound's surface, it may appear to be clean for a few hours. But any contamination left on the inside will eventually cause an infection that will erase all previously clean appearances.

Let's meditate on this advice from Jesus for a moment. We should clean the inside, so that the outside may be clean. We see this counsel to be true regarding our artistic disciplines. As I engage in the hard labor of working my scales and technique, and studying my theory, and cultivating my listening ear, I will see growth in my writing and playing. The more that I develop my inner musical disciplines, the more beautifully I will be able to express myself musically.

The worth of the beauty of the sound (the shell, or outside) is proportional to the investment in the disciplines applied (the essence, or inside). Little discipline yields little beauty. Greater discipline yields greater beauty. Now guard yourself here. Do not hear me say that where little discipline is needed only little beauty can be known. That is not true. I am referring to a discipline that is appropriate for the task. A rough picnic can yield as much or even more beauty than an elegant ballroom feast. They are different from each other and require a different kind and portion of discipline to enjoy their full potential beauty. Whatever the task is, the greatest amount of beauty to be enjoyed will be realized when the appropriate inner disciplines are exercised.

Artistic expressions are conceived in the soul. If there is little beauty in the soul, little beauty will be expressed through a beautifully pleasurable song. I should work first on the soul, so that the soul has something beautiful to say. I've got to develop the inside of my cup if I desire my outer expressions to be truly, maturely, effectively beautiful to their fullest potential. The artwork of a man is just one of his many shells. An artwork itself is not a man's essence. It may, however, clearly reflect a man's essence. A self-indulgent artist will never radiate the degree

of beauty that he could radiate if he were full of grace. So if we want our outer artistic expressions to be deeply beautiful, which is a beautiful desire, we get there by beautifying, or cleaning out, our inside.

And then we should be careful here that we do not abuse this counsel. If we are cleaning the inside only as a means of putting forth a more beautiful outside, we haven't understood Jesus. A beautiful inside is the goal, and it is not achieved by working on the outside. The closet doesn't get clean by sweeping the porch. But a clean closet will have an effect on the bedroom, which will have an effect on the den, which will have an effect on the porch. Do desire a beautiful outside, artist! But first learn what is truly beautiful. Then let the outside be a result of a deeply beautiful inside rather than a mask for an insufficient inside.

PATIENCE GIVES OPPORTUNITY
TO SEE THE ESSENCE SURFACE

The beauty of an artwork may accurately reflect the worth of the essence of the artist, but not always. God has given us a "beautiful" example of a deceitful beauty in the mistletoe. We often first associate the mistletoe with a kiss at Christmas time. I saw a picture once of the red mistletoe of New Zealand. Wow! What a vibrantly beautiful red plant! And then I looked a little closer and noticed that all the branches of the tree in which the red mistletoe was hanging were dying off. So I sought it out and found that the branches were dying because of the mistletoe. Mistletoe is a parasite. The word beautiful didn't seem to be the right word anymore for the red mistletoe without giving some clarification as to what about it was beautiful. The red color was still vibrant red and pleasing to my eyes. But now with the understanding that mistletoe in its essence is a parasite that will eventually destroy the "beautiful" tree, I see that I should be more careful as to how I throw around the word

beautiful. Red mistletoe may continue to be a knockout, gorgeous plant in form and appearance, but I cannot seem to call it a beautiful plant like I call a rose bush a beautiful plant while the mistletoe is sucking the life from it's host.

Do you see how we must be discerning? In my ignorance or carelessness with aesthetic beauty, I might plant the "beautiful" red mistletoe in my garden to enjoy its appearance, only to find out in the seasons to come that it would have spread from tree to tree, destroying the very garden in which I planted it. And so I lose the garden because I invited a destroyer in as I was seduced by the beauty of her shell without discerning the poison of her essence. "The simple believes everything, but the prudent gives thought to his steps" (Proverbs 14:15 ESV). "For the lips of an adulteress drip honey and smoother than oil is her speech; but in the end she is bitter as wormwood, sharp as a two-edged sword" (Proverbs 5:3-4). Artists, we need to be more prudent not to be simpleton suckers for veneer beauty.

I've seen patience to be a key discipline in the study of beauty. I was having my devotions one morning in the corner of the church sanctuary and was hearing Jesus teach in Matthew 23:12, "Whoever exults himself shall be humbled, and whoever humbles himself shall be exalted." Right then a friend of mine walked into the sanctuary, thinking he was there all alone, and raised his voice over and over saying, "Father, forgive me." My friend, who is very simple in appearance, was genuinely humbling himself before his Father. I had just read how Jesus says that he will be exalted. All I could see was beauty! The beauty of God's design in how true humility is the way to lasting exaltation (Philippians 2:1-11). The beauty of how a contrite heart in my friend outshines any simple outward appearances. The beauty of God's wisdom as He sculpted my simply humble friend with a shell and essence that shames the strong and wise (I Corinthians 1:27). The beauty of how the Holy Spirit enlightens the truths of the

Word of God with daily experiences – if I only have the patience and eyes to see them. The beauty of a love that is birthed for a brother when I embrace God's full definition of beauty rather than the world's partial understanding of beauty (I Corinthians 12:22). A powder keg of joy was ignited! My eyes and ears were used to send information to my discerner, which was being enlightened by the Word of God and the Holy Spirit, to show me clearly that I was beholding beauty. So I embraced it!

When I was in Thailand, I was exposed to all sorts of fruits that were not familiar to my palate. Some of them looked "beautiful" to my eyes, and my mouth would salivate in anticipation of how beautiful they might taste. Some fruits were rather bland in appearance and my first thought was a cautious one towards their flavor. If I assigned each new fruit that I experienced to a category of either "beautiful" or "bland" in appearance, I would find in each of those categories fruits that tasted both delightful and nauseating. However, most of the delightful tastes were due to familiarity and most of the nauseating tastes were due to unfamiliarity. Over the course of the two weeks, my impressions changed as I became more familiar with the fruits. In most cases, it was not that the fruits were actually nauseating, it was that they were different than what my palate and stomach were familiar with. And so patience needed to be applied before I rendered a judgment on their beauty factor. The benefit of applying patience is that we grow in knowledge, and with time we may taste or see or hear more clearly the fuller counsel of what God has made to demonstrate beauty.

PRIDE CORRUPTS WHAT IS BEAUTIFUL

When we find a true beauty, we have to be on guard against pride. Pride is in our nature as weeds are in our soil. The Lord says in Ezekiel

28:17a, "Your heart was proud because of your beauty; you corrupted your wisdom for the sake of your splendor. I cast you to the ground...." This casting to the ground will happen to us as well, artists, when we turn from seeking out wisdom to seeking our splendor.

Is this not a temptation we face in the arts? For the sake of our splendor, our glory in the eyes of others, we will play with wisdom only as long as others praise us for it. But where wisdom is not valued, and the splendor of our name is at stake in our artwork, we are tempted to loosen our grip to wisdom and grab for whatever will increase, or at least retain, our splendor in the eyes of men. We corrupt our own wisdom with our pride and the fear of men. We do this because we do not know or believe that the pleasures found in the beauty of wisdom are far more pleasurable than the pleasures found in our splendor in the eyes of men. When we make our enjoyment of beauty dependant upon how others respond to the beauty in question, we prove that we are not really after beauty, but praise. Artists, ask yourself how much beauty you have robbed yourself of, due to setting aside wisdom for praise.

Or maybe we make the mistake of seeking the splendor of wisdom rather than seeking wisdom herself. Are we seeking splendor or are we seeking wisdom that gives off a splendor? Sometimes as we admire the beauty of wisdom, we get caught up in the admiring, rather than in the mining of wisdom. Then we get careless in fortifying the mineshafts as we dig, until one day we find we've cut our angles a little too grand as we were admiring all the splendor and beauty, and the ceiling collapses, slamming us to the ground. Seek wisdom, not splendor, artists, and wisdom will result in a splendorous beauty. "The beginning of wisdom is this: Get wisdom, and whatever you get, get insight. Prize her highly, and she will exalt you; she will honor you if you embrace her. She will place on your head a graceful garland; she will bestow on you a beautiful crown" (Proverbs 4:7-9 ESV).

As the "what is beauty" debate churns endlessly on and on, it seems that we have made it far more complicated than needs be, mostly because our natural man refuses to be governed and set free by the Word of God. When we refuse to recognize God as the end of all things, the source from which streams everything that is beautiful, we feverishly search high and low for another object to shape our definition; hence, the bloated debate. Our pride renders so many things adversely sophisticated. Since God is the source and creator of all that exists, therefore, beauty is then defined in God.

Artist, do you find something to be pleasing to your senses, to be enjoyable, to be beautiful? It probably is. In what sense is it beautiful (pleasing)? Is this not the theme to expound on? Can you enjoy its beauty from faith that is from God (study Romans 14)? If so, then from faith, enjoy its beauty and enjoy its Author! But if you cannot enjoy something from faith, then what might be beautiful in one sense may not be beautifully enjoyed in another.

Do you find something to be seemingly beautiful, but you sense that you may be ignorant in measure and therefore cannot fully enjoy what others seem to be absolutely enjoying? If so, ask the one who has more knowledge to help you better understand. And then test his "in what sense" beauty counsel with the Bible. Most of the debate, however, seems to be driven by the pride of the one who wants to be revered as an "authority" in some regard over what is deemed pleasurable or valuable. So he argues for fact when he should really be plainly articulating what it is that he finds to be beautiful in something (the lines, the color, the theme, the swing). Beauty is not defined by certain lines, colors, or sounds as some demand to argue. Lines, colors, and sounds may be arranged beautifully (pleasurably). Let's lighten up. Beauty is not so hard to recognize that we first need a definition to see it.

Sometimes beauty is confused with value. In this case, when one desires that their work be valued, they demand that it be deemed beautiful.

This is backwards. A voluntary proclamation of "beautiful" is expressed or awarded to something that evokes pleasure. A mere title assigned or qualification met does not ensure enjoyment. A performance degree does not guarantee a beautiful performance. Nor does a beautiful performance depend upon a performance degree. The value is determined by what is produced. And, something may be valuable without being beautiful. But let's not let our pride try to make the two equivalent because they are not. Beauty and value are distinct from each other. They may exist together, but they are not the same. Beauty spends itself on you, while value results in your expenditure. And where your value is beautiful, you get the pleasure of spending yourself for the enjoyment of others. What an image of Christ!

Artists, may our beauty be "the hidden person of the heart with the imperishable beauty of a gentle and quiet spirit, which in God's sight is very precious" (I Peter 3:4 ESV). May that inner beauty radiate through, producing many outer beauties. May God grant us discernment to be able to separate honest beauty from deceitful beauty so that we are not enticed to embrace beautifully pleasant aromas that land bitter in our soul. "The prudent sees danger and hides himself, but the simple go on and suffer for it" (Proverbs 27:12). And may God give us patience so we don't miss the imperishable treasures, beautifully concealed for those who are patient enough to enjoy their worth.

In the strength that God provides, may we better see, acknowledge, desire, embrace, and with all our might emanate true, biblical beauty, so that our own joy can be full with all the pleasure of God Himself, all that pleases God, and all that God is pleased to give us for our enjoyment of Him. True beauty derives its splendor from the beauty of God Himself. "You will make known to me the path of life; in Your presence is fullness of joy; in Your right hand there are pleasures forever" (Psalm 16:11). "This is eternal life, that they may know You, the only true God, and Jesus

Christ whom You have sent" (John 17:3).

We must calibrate our beauty palates to the Word of God if we are ever going to enjoy, and attempt to articulate through our artistry, the pleasures that are to be had from beauty's fullest counsel.

Satisfaction

For He satisfies the longing soul, and the hungry soul He
fills with good things. (Psalm 107:9)

Blessed are those who hunger and thirst for righteousness,
for they shall be satisfied. (Matthew 5:6)

How blessed is the man who has made the Lord his trust,
and has not turned to the proud, nor to those who lapse
into falsehood. (Psalm 40:4)

Here is a question that I routinely ask myself: in my artistry, is my
soul's satisfaction dependant upon a favorable affirmation from man, or is
my soul's satisfaction dependant upon the favorable affirmation of God?

This is the question that I pose to try to discern where my hope is
truly resting, and what my affections are truly seeking as I engage in my
artistry. Am I actually entrusting a portion of my soul's state of satisfaction
to an audience's affirmation of my artistry, or is the affirmation of an
audience a different kind of satisfying pleasure to be known; like the kind
of pleasure that is had in an honest dialogue where there is no fishing for
compliments going on beneath the surface? In an artistic labor, is there

not a "complete" satisfaction (like a "complete" protein) to be known in the fellowship had with God in a work and its outcome, or do I need another person to tell me that my work is "good" before my soul enjoys a "complete" satisfaction?

When an audience's affirming response is actually a bonus pleasure, an addition to my already satisfied soul, I find that I receive their response as an evidence that they too enjoyed (fruit of my Sphere Two), at least in part, what I was enjoying (Sphere One). Now this is entirely different from receiving their affirming response as being what my heart puts its hope in, or seeks, or thinks is due me. I do not mean that I could care less whether the audience is blessed or not. My desire is always that they would be blessed through a work just as I have been. But my end-of-the-day satisfaction in my artistic labor is not dependant upon man's affirmation, but on God's affirmation when my soul hears (or does not hear) from Him, "Well done good and faithful servant…enter into the joy of your master" (Matthew 25:21).

THE SATISFACTION KNOWN IN GIVING

This positioning of my heart puts me in the mind of giving. "It is more blessed to give than to receive" (Acts 20:35). There is such a pleasure in sharing what I have found to be pleasurable. It is a different pleasure if an artwork of mine proves to be a blessing to another. But that is a bonus pleasure to me – an addition to the pleasures I already enjoyed through a faithful labor and through sharing. I do genuinely desire that others be blessed, but I am not dependent upon another's affirmation of my work in order to experience the satisfaction that is known through giving.

The most satisfying joys in my artistic labors are dependant upon the fellowship that is had with God in them, and my desire is that others know and enjoy the joys that I have known. So I have got to give. "…That

which we have seen and heard we proclaim also to you, so that you too may have fellowship with us; and indeed our fellowship is with the Father and with His Son Jesus Christ. And we are writing these things so that our joy may be complete" (I John 1:4 ESV). By desirable I mean this: I hope and work to see that others could experience the pleasures that I am enjoying. And when they do, I am happy for them that they could share in its pleasures with me (which is totally different than me being proud of me that they enjoyed it; or worse, proud that they enjoyed me). And by dependant I mean this: I have already had so much complete pleasure in playing the role of the wrestler/expresser/giver that I find my necessary joys (the joys that I must know in my toil) to be satisfied through faithfully wrestling, expressing, and giving.

If my satisfaction sights are set on a favorable response, I will be forever catering to man's whims, burdening my thoughts as I constantly wonder, "what are they thinking now?" And by the time I figure out what they were thinking, they will have changed whims. This is not a way to live. This is not even a path that leads to satisfaction if I could keep up with the whims of man because that path ends at man and not at God. Moreover, this is not giving, this is fishing.

GOD'S REWARDS FAR OUT-SATISFY
THE REWARDS OF MAN

If my sights are set on God, and He leads me to play a certain song, I will know a satisfaction in my soul through being faithful to Him even if it leads to my disapproval in the eyes of men. How can a man be satisfied if God is displeased with him, even though every man would be his friend (Jeremiah1:17-19)? In actuality, all the satisfaction that I have ever known when hoping in man for it has been a kind of short-changed satisfaction, a lesser reward. Most of the time I never knew this because it

did bring a certain level of satisfaction, but it was never full or complete or lasting. Enough, though, to let me know that I could go back and get a little bit more if I would just work it right.

When I hope in man's affirmation for my satisfaction to be complete, it means that I am dependent upon the praises of men. Listen to what Jesus says to us about this:

> Beware of practicing your righteousness before men to be noticed by them; otherwise you have no reward with your father who is in heaven. When therefore you give alms, do not sound a trumpet before you as the hypocrites do in the synagogues and in the streets, that they may be honored by men. Truly I say to you, they have their reward in full.... And when you pray, you are not to be as the hypocrites; for they love to stand and pray in the synagogues and on the street corners, in order to be seen by men. Truly I say to you, they have their reward in full (Matthew 6:1-2, 5).

Jesus does not deny that there is no reward felt when men are the final audience. There is a kind of reward in the praises of men. That is just all the reward that we will see. There is no lasting reward with our Father in heaven, which is the very reward that I want.

It played out for me like this one day. The Lord was searching me to expose my anxious thoughts to see where there were any "grievous way[s] in me" (Psalm 139:23-24). He gave me a gig, which was a blessing, but it alone wouldn't cover all the financial demands I was hoping to cover when I was asking Him for a gig. I knew immediately that the test for me was this: would I be faithful to God in giving the people what He wanted to bless them with through me, or would I trust in my own devices to "bless" the audience and work the gig in such a way as to all but surely garner enough through merchandise sales to pay the bills that I

was asking God's provision for? Would I humble myself, put my trust in God's sufficiency, and say and sing as He led me, or would I filter what I felt Him leading me to share with the people through my mind's "fear-of-man" sieve as I looked for man's reward?

The temptation to soften what the Lord is leading me to say and sing at a gig often sounds like this: "be careful that you don't give them too much truth that they may be offended and then not pick up the recording where they can better meditate over the lyrics again and again." At this point, if I yield to this motive of thinking, I am trusting in my own devices and not the Lord's steadfast love for those who fear Him (Psalm 33:18 ESV).

Do I even ask the Lord what I should give the people that night, or do I just presumptuously gig as I know how? When I entertain these temptations, I find that I am really setting my affections on the value of money over the value of a brother's soul (or my soul for that matter) being nourished by the Lord. Hebrews 13:5-6 says:

> Let your character be free from the love of money, being content with what you have, for He Himself has said, "I will never desert you, nor will I ever forsake you," so that we confidently say, "The Lord is my helper, I will not be afraid. What shall man do to me?"

So when I am tempted to be anxious about money, I preach to myself: "The Lord is my helper. He will never desert me nor forsake me, so I will not yield to the fear of man for my provision, because what can man do to me that is outside the rule of God's sovereignty?"

If we think about it, how many financial burdens are we carrying right now because we haven't been content with what we have had in the first place? When we are not looking at God as the satisfaction of all our desires, we are looking elsewhere. The first elsewhere often involves

spending money, and when what we've purchased doesn't satisfy, we'll spend more money. Artists, we must set our affections free from the love of money and learn how contentment in what God has given us is very satisfying. Contentment is not some negative attitude that says, "I'll just deal with it." Biblical contentment is a positive embracing of what God has given us, be that dessert or desert, and knowing its joys. Psalm 40:8a says, "I desire to do your will, O my God." Do we desire to do His full will or only His sugary will?

There are enough occasions for asking God for more provision. We almost understand that we should be asking Him for it daily. But we are quite immature in our character development of contentment. When we find biblical contentment, we've just found more of God. And when we find more of God, we find the satisfaction we seek. Paul says:

> …for I have learned to be content in whatever circumstances I am. I know how to get along with humble means, and I also know how to live in prosperity; in any and every circumstance I have learned the secret of being filled and going hungry, both of having abundance and suffering need. I can do all things through Him who strengthens me (Philippians 4:11b-13).

"Through Him" means that fellowship is happening, and that fellowship with God is the source of our satisfaction.

That night at the gig, God gave me faith to put my full hope in Him alone and let the results fall where they fall. What sweet fellowship! I was so satisfied. It is a lie from the devil that the truth will not satisfy you. A clean conscience is a feast for the soul. I was so blessed to experience the sound reality that the trajectory of complete abandonment to God could satisfy a soul as no praises of man ever could, even in a season of severe uncertainties.

God is mindful that we are only flesh, and He wasn't done giving that night. As we were taking stock of the merchandise, we saw a bonus blessing. More was moved that night than we had seen move in a long time and He did it in such a way as to show me the most beautiful blessing as being Himself as my provision.

Moses teaches us:

> …man does not live by bread alone, but man lives by every word that comes from the mouth of the Lord…. Beware lest you say in your heart, "My power and the might of my hand have gotten me this wealth." You shall remember the Lord your God, for it is He who gives you power to get wealth…. And if you forget the Lord your God and go after other gods and serve them and worship them, I solemnly warn you today that you shall surely perish. Like the nations that the Lord makes to perish before you, so shall you perish, because you would not obey the voice of the Lord your God (Deuteronomy 8:3b, 17-20).

Paul's exhortation to Timothy is for all artists, "…[do not] fix [your] hope on the uncertainty of riches, but on God, who richly supplies us with all things to enjoy" (I Timothy 6:17b).

So when I am tempted to "fix" what the Lord has to say through me, I fight that temptation with Deuteronomy 8 and ask for grace to deliver the song as He would desire, full of truth and love. And I also fight it with Isaiah 64:4-5a, "From of old no one has heard or perceived by the ear, no eye has seen a God besides you, who acts for those who wait for Him. You meet him who joyfully works righteousness, those who remember You in Your ways…" (ESV).

MY DESIRE TO SEE OTHERS SATISFIED

Let's look at satisfaction now from this angle: the longing of my soul that the audience be satisfied through what I serve them.

When my soul's satisfaction is firmly resting in God (Sphere One), then I actually have a solid hope that they can experience satisfaction along with me (Sphere Two). I work for their satisfaction not in my own strength, but in the strength that God provides to those who walk in obedience (II Timothy 4:17). In all of his letters, Paul is seeking his listeners' satisfaction. Not their satisfaction in him, but in God. He knows that he cannot open the eyes of the blind soul, but God can. And so Paul pushes his own soul to trust wholly in God so that his labors, when found to be executed faithfully (which is not to be confused with perfectly, nor is there such a thing as slothfully faithful), would be a means of God opening the eyes of the blind to see that God is the soul Quencher, the Satisfier (II Corinthians 4:7).

Notice how Paul, after he has poured out his heart in his letters to see his audience have their longings satisfied, entrusts to God his desires for their satisfaction realization by closing with: "the grace of the Lord Jesus Christ be with you" (Rom. 16:20, I Cor. 16:23, II Cor. 13:14, Gal. 6:18, Eph. 6:24, Phil. 4:23, Col. 4:18). He starts his labor of satisfying his own heart's desire that they be satisfied with a prayer and blessing of "grace to you from God" (Rom. 1:7, I Cor. 1:3, II Cor. 1:2, Gal. 1:3, Eph. 1:2, Phil. 1:2, Col. 1:2). Paul begins and ends with the grace of God as the quencher of our desires for satisfaction.

Paul recognizes a longing in his heart. It is a longing for others to be satisfied as he is satisfied. Paul is not satisfied in himself. He is satisfied in God. Paul knows that God is able to satisfy others, but Paul himself isn't able. He knows that God does work through man as a means of distributing His grace. So when Paul feels the Lord burden his heart for his brothers and sisters, he plays the man. He strives in faithful obedience

to God, that when he has accomplished all that God has given him to do, he can entrust the outcome to the faithfulness of God. Paul knows that God says:

> For as the rain and the snow come down from heaven, and do not return there without watering the earth and making it bear and sprout, and furnishing seed to the sower and bread to the eater; so will My word be which goes forth from My mouth; It will not return to Me empty, without accomplishing what I desire, and without succeeding in the matter for which I sent it (Isaiah 55:10-11).

So my desire to see another person satisfied can begin to be quenched when I yield that longing over to God and entrust Him to do the heavy lifting in their soul, as He sends me to be a means of His grace to them, possibly through the artistry He has given me. I need to focus on being faithful to God (Sphere One) if I truly desire that others be deeply satisfied.

Faithfulness to God, however, is more than just technically following an order. Faithfulness also involves graciousness, gentleness, firmness, humility, zeal, love, etc.:

> If I speak with the tongues of men and of angels, but do not have love, I have become a noisy gong or a clanging cymbal. And if I have the gift of prophecy, and know all mysteries and all knowledge; and if I have all faith, so as to remove mountains, but do not have love, I am nothing. And if I give all my possessions to feed the poor, and if I deliver my body to be burned, but do not have love, it profits me nothing (I Corinthians 13:1-3).

Without love in my giving and sharing, it profits me nothing.

This is where Jonah erred when he finally went to Nineveh. He finally relayed the message of repentance, but he had no love for the people. And while they did benefit from hearing and heeding the message, Jonah wasn't satisfied because he didn't have a heart of mercy and love for the people as God did (Jonah 4:1-3). So Jonah's attempt to obey the Lord was not a satisfying labor to him because he was not fully faithful. I'm sure it was more satisfying than being in the bowels of a fish, but it wasn't a labor full of joy because of his selfishness. Jonah was dissatisfied not because of the job, but because of his faithlessness in the job.

SATISFACTION WILL NEVER BE KNOWN
THROUGH COMPARISON

There is a strong temptation to compare ourselves with others for the purpose of trying to determine where we think we will find the satisfaction we seek. I am not talking about studying or analyzing others for the purpose of growing in discipline or knowledge, I am talking about being distracted away from faithfulness by giving ear to the whispers of comparison. Comparison tends to encourage us towards envy and jealousy. We are often dissatisfied with our lot and portion not because there is no satisfaction to be found, but because we are looking at the lot of others and envying their portion or responsibilities. Our satisfaction, however, will be enjoyed through the faithful tending of our own lot, not in comparing our lot with others.

Jesus unpacks this truth with a parable of a master who went to hire laborers for his vineyard (Matthew 20:1-16). At the top of the day, the master agreed with some hired hands upon a price for a day's labor, and they began their work. Later in the day, the master hired a few more men to work for him. Still later, he hired a few more. Two more times the

master hired new workers. When the time came to pay the men for their day's labor, the master started with the last workers hired and paid them the same amount as he agreed upon with the first laborers he hired. The men who worked the whole day grumbled at this "unfair" correlation between the amount of work done and the wages earned. The master says to one of them, "Friend, I am doing you no wrong. Did you not agree with me for a denarius? Take what belongs to you and go. I choose to give to this last worker as I give to you. Am I not allowed to do what I choose with what belongs to me? Or do you begrudge my generosity?" (Matthew 20:13b-15 ESV). Then Jesus says, "So the last will be first, and the first last" (20:16).

So why were these first workers satisfied at the beginning of the day to work for a denarius, but when they learned about the other's portion, they became dissatisfied? It is nothing other than envy and jealousy. They were satisfied when they weren't busy comparing. This demonstrates how their satisfaction was ultimately dependent upon how their portion compared to another's, not whether they were found faithful in their own.

We have got to recognize these motives of our hearts if we are ever going to know steady satisfaction in our artistic labors. The reason we are so often dissatisfied is really because we are being unfaithful with what we have been given to do. If all we had was God alone, could we be satisfied? Would we be satisfied? Asaph says, "Whom have I in heaven but you? And there is nothing on earth that I desire besides you. My flesh and my heart may fail, but God is the strength of my heart and my portion forever" (Psalm 73:25-26 ESV). Honestly now, artists, is this the affection of our hearts?

Before Asaph rejoices in God as his portion, he finds himself comparing his lot in this life to others'. He says:

For I was envious of the arrogant when I saw the prosperity

of the wicked. For they have no pangs until death; their bodies are fat and sleek. They are not in trouble as others are; they are not stricken like the rest of mankind…. All in vain have I kept my heart clean and washed my hands in innocence. For all the day long I have been stricken and rebuked every morning…. But when I thought how to understand this, it seemed to me a worrisome task, until I went into the sanctuary of God; then I discerned their end. Truly you set them in slippery places; you make them fall to ruin. How they are destroyed in a moment, swept away utterly by terrors. Like a dream when one awakes, O Lord, when you rouse yourself, you will despise them as phantoms (Psalm 73:3-5, 13-14, 16-20 ESV).

Asaph sees quickly that if there is any comparing to be done, it is to compare the end results of walking in faithfulness against walking faithlessly in this world.

Artists, be faithful in your lot and portion, and you can realize deep satisfaction in the Lord's sufficient grace for you, portioned perfectly for your artistic lot. In this life, you will not see all the fullness of God's portion of grace for you. There is much more grace to come. "In the new world…everyone who has left houses…for my name's sake, will receive a hundredfold and will inherit eternal life" (Matthew 19:28-30 ESV). But if we are unfaithful in our lot in this life, we may never see any more of the grace of God.

In John 21, Peter yields to the temptation of comparison. Jesus asked Peter three different times if he loved Him. Peter says:

"Lord, you know everything; you know that I love you."
Jesus said to him, "Feed my sheep. Truly, truly, I say to you,

when you were young, you used to dress yourself and walk wherever you wanted, but when you are old, you will stretch out your hands, and another will dress you and carry you where you do not want to go." (This he said to show by what kind of death he was to glorify God) (17b-19a ESV).

So then Peter turns and sees John and asks Jesus, "'Lord, what about this man?' Jesus said to him, 'If it is my will that he remain until I come, what is that to you? You follow me!'" (John 21:21b-22 ESV).

Could Jesus make it any clearer that we are not to compare our lot with others? We are to be faithful in our lot that is portioned out to us from the Lord Himself. And if that lot is in the arts, then why not enjoy it! It is a beautiful lot! Don't complain that you don't make the money a broker makes. Financial accounts will all be leveled one day, and all that will remain standing is our faithful accounts. So why not enjoy faithfulness today while laying up treasure for tomorrow! If you need something, ask the Lord for it. His purse has no bottom, and His wisdom has no error. It is through faithfulness that we will find the satisfaction we long to know. Whether abasing or abounding, whether facing plenty or hunger, whether a record deal or never a recording at all, whether the gig is in a stadium or a closet, whether you conduct a whistler or an orchestra, whether you are John the Baptist or Gaius, whether you are Charles Spurgeon or John Bunyan, Paul says the secret for experiencing satisfying contentment is that we "can do all things through Him who strengthens [us]" (Philippians 4:13). Do you exercise this secret in the arts, artists?

Comparing, in an envying sense, is really only destructive fantasizing, which if let to run its course makes you more addicted to its poison and more numb to its evils. Israel would find herself running after other lovers all the time as she allowed herself to be distracted with the "beauties" of the world. She would stray from God and play the whore,

looking for satisfaction elsewhere but never finding it.

> ...you played the harlot with the Assyrians because you were not satisfied; you played the harlot with them and still were not satisfied. You also multiplied your harlotry with the land of merchants, Chaldea, yet even with this you were not satisfied (Ezekiel 16:28-29).

Isn't this how we act when we place our hopes for satisfaction in the praises of men or some artistic pursuit rather than in God in our artistic labor? We may actually land that dreamed artistic status, but once we get there we realize that it doesn't satisfy the way we fantasized it would. So we look for the next passing lover even more aggressively, never to experience complete satisfaction.

Artists, be quick to smell this air of comparison in your hearts, and throw wide the windows of faith. May the Lord be your satisfaction in the arts as you enjoy the arts from, in, and because of Him!

AS FOR ME, I WILL BE SATISFIED WITH GOD'S LIKENESS WHEN I AWAKE

This whole issue boils down to my fighting for faith to believe that God's praises are more satisfying than all the praises of men. It's the perspective that kept Jesus from disobedience (Philippians 2:8-9). It's a fight to believe that no matter what the response is from men, even if it is one of obvious rejection, if my labor is done in faithful, joyful obedience in the Lord, it is not in vain (I Corinthians 15:58), and the Lord will satisfy me sufficiently.

David gives us a beautiful example of this theme in Psalm 17. Granted, he is facing death and we are rarely facing being killed for our

artistic expressions in America. But all the more encouraging, if God alone can satisfy us in the greater trial, how much more true for the lesser trials. Artists, hear David's adversaries here as being our own sinful fear of men. David asserts that his heart hopes in God. He acknowledges that the threat to fear man is at hand and resolves that he will look to God and be satisfied.

Psalm 17

Hear a just cause, O LORD, give heed to my cry;
　　Give ear to my prayer, which is not from deceitful lips.
Let my judgment come forth from Your presence;
　　Let Your eyes look with equity.
You have tried my heart;
　　You have visited me by night;
　　You have tested me and You find nothing;
　　I have purposed that my mouth will not transgress.
As for the deeds of men, by the word of Your lips
　　I have kept from the paths of the violent.
My steps have held fast to Your paths
　　My feet have not slipped.
I have called upon You, for You will answer me, O God;
　　Incline Your ear to me, hear my speech.
Wondrously show Your lovingkindness.
　　O Savior of those who take refuge at Your right hand
　　From those who rise up against them.
Keep me as the apple of Your eye;
　　Hide me in the shadow of Your wings
From the wicked who despoil me,
　　My deadly enemies who surround me.
They have closed their unfeeling heart,

With their mouth they speak proudly.
They have now surrounded us in our steps;
They set their eyes to cast us down to the ground.
He is like a lion that is eager to tear,
And as a young lion lurking in hiding places.
Arise, O LORD, confront him, bring him low;
Deliver my soul from the wicked with Your sword,
From men with Your hand, O LORD,
From men of the world, whose portion is in this life,
And whose belly You fill with Your treasure;
They are satisfied with children,
And leave their abundance to their babes.
As for me, I shall behold Your face in righteousness;
I will be satisfied with Your likeness when I awake.

Artists, our greatest satisfaction in the arts will be enjoyed when our ground and chief satisfaction rests in God. God will not disappoint us. We will experience a deeper satisfaction with the Lord's praises alone than if we could hear the praises of all mankind. When this is the affection of our heart in the arts, we will find God pouring more of Himself into us than we are able to contain, and His beauty and lovingkindness will spill over into our artistic labors for our joy and the satisfaction of others. "'I will fill the soul of the priests with abundance, and My people will be satisfied with My goodness,' declares the Lord" (Jeremiah 31:14).

Spiritual Gifts

But now God has placed the members, each one of them, in the body, just as He desired. (I Corinthians 12:18)

And the eye cannot say to the hand, "I have no need of you;" or again the head to the feet, "I have no need of you." On the contrary, it is much truer that the members of the body which seem to be weaker are necessary. (I Corinthians 12:21-22)

…since you are zealous of spiritual gifts, seek to abound for the edification of the church. (I Corinthians 14:12)

There is one who scatters yet increases all the more, and there is one who withholds what is justly due, but it results only in want. (Proverbs 11:24)

God has made all people, believer and unbeliever alike, and some He made able to dance gracefully and some He made not able to dance gracefully. If we in the church are indeed members of one body in Christ, and Paul tells us that one member cannot say to another, "I have no need

of you" (I Corinthians 12:21b), and every member is in fact necessary, "it is much truer that the members of the body which seem to be weaker are necessary" (I Corinthians 12:22), then we all better start playing the part of the body that God created us to be. That part is, in fact, necessary. This may be a different part than we wish to play, but it is the only part by which we will realize full and true satisfaction when we play!

ARE ARTISTIC TALENTS SPIRITUAL GIFTS?

To have a deeply healthy body of Christ, I think we need to ask a few questions so that we can benefit from a more accurate understanding of how artists may or may not prove to serve or edify the body.

My first question is: Are artistic talents spiritual gifts? More specifically, does an artistic talent or giftedness or skill of some kind equate to a spiritual gift? I think we need to be discerning because we see that not all talent is employed to edify. Surely all talent, giftedness, and skill is from God. That is not in question. But just because someone is gifted by God with vocal talent, and can lead all the rats across town, does not mean that they have any spiritual gift of leading, teaching, exhorting, or serving for the edification of the body. To equate a talent with a spiritual gift seems to be an error, and will lead us to trust in our talent rather than in the Holy Spirit. Or it will cause us to despair that we have no gift for the body if we lose the ability to exercise our talent. If a pianist lost his hands, the exercisers of his talent, does that mean then that he has also lost his spiritual gift of leadership or service? You can see how we have to be very careful not to confuse the powers that God has granted to talent with the powers that God has granted to a spiritual gift.

I have seen a lot of great talent that has only worked to tear down the body. Look anywhere in the arts and you will find ample evidence of talents that actually prove to destroy man's soul rather than edify it.

However, an artist may have a spiritual gift of exhortation, or teaching, or prophesy, or healing that manifests itself most often through his artistic talent. The talent may be a vehicle that uniquely deploys the spiritual gift (which is another evidence of just how grand the creative genius of God is). I do not mean to imply that the spiritual gift can only be deployed within the execution of a particular talent, but rather that the talent may be the most effective delivery vehicle for that person's spiritual giftedness to edify the body, or a part of the body. A singer may exhort most effectively with a song. An actor may teach most clearly through a film. A poet may prophesy most poignantly through a poem. A painter may have a gift of healing that manifests itself through a painting that calms the troubled soul.

But what happens when it's not a song (talent) that is needed? Does that mean that exhortation (spiritual gift) is not needed or service (spiritual gift) is not needed? No! It would be incorrect for someone to say, "My spiritual gift is in playing the Hammond B3 organ and since there is no organ of this kind around, I guess I have no way to exercise my spiritual gift for the edification of the body." This thinking confuses a talent with a spiritual gift. You may have a talent on the organ and have a spiritual gift of leadership. And those two can work very nicely together. But you can also exercise leadership directing traffic in the parking lot.

This error could be due to ignorance or it could be due to pride. If it is pride, then repent and be free! If it is ignorance, be encouraged and be free! Paul says:

> Having gifts that differ according to the grace given to us, let us use them: if prophecy, in proportion to our faith; if service, in our serving; the one who teaches, in his teaching; the one who exhorts, in his exhortation; the one who contributes, in generosity; the one who leads, with zeal; the one who does acts of mercy, with cheerfulness (Romans

12:6-8 ESV).

Do you see that when Paul mentions a gift he mentions a way of employing that gift. When he says "the one who leads," he is talking about those who have been given a spiritual gift of leadership, and when he finishes with the application "with zeal," he is saying, "use [the gift] zealously" (vs. 6), and use it wherever you can. Artist, there was spiritual leadership going on long before the B3 was around so there must be other ways to zealously lead without employing the organ.

(I must interject here a note of personal, immense thanksgiving to God for the Hammond B3 as a means of employing the spiritual gift of leadership. And I also want to praise Him for those in the body that He has granted the skill [talent] to lead and serve [spiritual gift] with it!)

So let's be careful not to confuse categories and thereby miss out on edifying pleasures. A talent is from God and a spiritual gift is from God, and they are both given to us for our pleasure in the glory of God in the edification of His body. How are we using them?

FOR THE EDIFICATION OF THE BODY

Artists, God has made you a member of the body, just as He desired. You must labor and endure and practice and study and speak and use your imagination just as He desires, that is, for the edification of all. Only then will you feel truly satisfied in your artistic labor.

I do not think that serving by means of your talent "for the edification of the body" can or should only happen in the church service or even in a religious venue. The point is edification. Edification can happen anywhere. Edification needs to be happening everywhere. Let's say that God has given you a very unique talent in carving that employs you all around town, and God has also granted you the spiritual gift of

serving. You should serve with your talent in such a way that you edify others with what is true, no matter where your artistry takes you. "Let your light shine before men in such a way that they may see your good works, and glorify your Father who is in heaven" (Matthew 5:16).

I Peter 4:10 says, "As each one has received a special gift, employ it in serving one another, as good stewards of the manifold grace of God." I wonder how many blessings and pleasures we have forfeited when our attentions and affections in the arts have tended to default towards the ways of the market rather than the way of our responsibility in and to the body of Christ. Peter tells us to "employ [that gift] in serving one another." This is where the disconnect often happens because artists in today's culture tend not toward serving others in their artistry, but towards wanting service, towards being known or made much of, towards "standing out" rather than "stepping up."

Artists may talk about giving to the community or to the people, but it seems too often our motive isn't really one of giving, it's one of purchasing. It's a motive of purchasing when our pleasure is dependent upon their "buying" what we are putting before them (I am not refering to an exchange of money here). But true giving is motivated by the desire to share a pleasure that is already enjoyed. The presentation of art (I am talking about motive here) is too often an act in which the artist tries to gain a blessing through garnering praise of some kind as he displays his art (which is more like bartering or selling), rather than actually gaining a blessing by giving (in motive) to the beholder what he has already found pleasure in (which is gracious sharing). We gain, not lose, satisfaction and pleasure when we give and release, because the source spring of giving and releasing is neither in us, nor in the audience. The source spring of this kind of giving is God. God gives us grace, and in such abundance that we must, for our health and the edification of the body, share it. And as we share it, He gives us more. "...give and it will be given to you. Good measure, pressed down, shaken together, running over, will be put into

your lap. For with the measure you use it will be measured back to you"
(Luke 6:38). What measure are we using, artists?

Let's be "good stewards of the manifold grace of God" by putting
our gifts and talents to work in serving one another, that our joy might
be full and that the body would be healthy. "There is one who scatters yet
increases all the more, and there is one who withholds what is justly due,
but it results only in want" (Proverbs 11:24). Artists, where have we been
withholding what is justly due the body, resulting only in an unhealthy
body, of which we are a member?

We artists often teach by our actions the very opposite of what
God has given us the spiritual gift to do. We teach by our actions: "look
to be served," while the Bible teaches us that we should look to serve. If
artists would follow the counsel that the Lord has given about giving and
serving, we would find that our desire for a fully satisfying pleasure from
the motive "look to be served" cannot be found. That satisfying pleasure
we seek to know can only be realized fully through the act of giving and
releasing, not through pretentiously giving all the while seeking, hoping
to receive praise, money, compliment, recognition, or status. A singer
might be singing a message of giving with his mouth; "Help your brother
in his need. You've enough that you can bleed," while his actions are
singing a message of seeking: "Respect me, honor me. I am an artist."
This is not loving. Artists, we are not loving others when we give this
way; we are loving ourselves. We are not seeking the edification of the
body with this grace of talent; we are seeking our own fleshly edification
(I Corinthians 13:5).

I return to Paul:

If I speak with the tongues of men and of angels, but do not
have love, I have become a noisy gong or a clanging cymbal.
And if I have the gift of prophecy, and know all mysteries

and all knowledge; and if I have all faith, so as to remove mountains, but do not have love, I am nothing. And if I give all my possessions to feed the poor, and if I deliver my body to be burned, but do not have love, it profits me nothing (I Corinthians 13:1-3).

He says it profits him nothing. The poor may gain some food in the meal Paul buys for them, which is good for them, but for Paul's account, he has gained nothing. No profit for Paul. The audience may profit from an artist's gig, but if there is no love for them from the artist, there is no profit for the artist. The artist can walk out with loads in merchandise sales, yet never profit.

Paul seems to be saying that in whatever we do, there is a seeking of an eternal profit that we should be after. I want my artwork to work for me in a way that gives me reward in heaven, not merely temporary reward that is consumed while on earth. Earth's rewards will all perish with the artwork in the day of fire. But, there is a work in and through an artwork that can bear everlasting fruit, which will be proven in the fire.

...each one's work will become manifest, for the Day will disclose it, because it will be revealed by fire, and the fire will test what sort of work each one has done. If the work that anyone has built on the foundation survives, he will receive a reward. If anyone's work is burned up, he will suffer loss... (I Corinthians 3:13-15a).

There is so much work to be done by the artists in the body to nurture the health of the body of Christ. And remember artists, your individual health is directly affected by the condition of the body's corporate health (I Corinthians 12:26). When an artist thinks that he is able to stand alone, apart from the body, acting as if he is special or

sufficient in himself, he proves that he does not understand his place in or need for the body of Christ. "For the body is not one member, but many" (I Corinthians 12:14). An artist will not be as fruitful or as satisfied apart from the body as he would be by being the part of the body he was made to be.

THOSE WHO SEEM TO BE WEAKER ARE INDISPENSABLE

In I Corinthians 12:22 Paul says that "the parts of the body that seem to be weaker are indispensable" (ESV). Let's push on this a little. Artists are often viewed to be in this "weaker" category, especially when we apply the word "weaker" to one's economic influence or to how necessary their "labor in life" is for survival (i.e., we need water to live, we don't need a painting to live). We need to be careful that we don't understand "weaker" wrongly. We are all weaker than others are in some area of our physical and spiritual life. It would be an error to think that since we are strong in one area, then we are never the weak one that Paul is referring to. But this is not true. I might be strong in discipline, but weak in faith. You might be strong in faith, but weak in discipline. Then we are each the "weaker" one, are we not? And we are each the "stronger" one, which is one reason why those who "seem to be weaker are indispensible." I have seen many people who are weak in economic status be the ones who are strongest in faith (Jesus, John the Baptist, Elijah, David the shepherd boy, countless missionaries and martyrs).

James warns us not to judge how valuable a person is to the body by his appearance:

> For if a man wearing a gold ring and fine clothing comes
> into your assembly, and a poor man in shabby clothes also

comes in, and if you pay attention to the one who wears the fine clothing and say, "You sit here in a good place," while you say to the poor man, "You stand over there," or, "Sit down at my feet," have you not then made distinctions among yourselves and become judges with evil thoughts?" (James 2:2-4 ESV).

This is horrible body life. Where are we practicing such distinctions?

I want to start with the artists, as I am one of them. Where are we looking at others in the body as being "weaker" than we are, say, in regard to artistic articulation? Where do we begin to make distinctions or begin judging others in our hearts? It might sound like this: "Why was she singing today?" "I can't understand why the worship pastor lets him play in the band." It may be true that you have more talent and that they have less, but that kind of judging proves that you are weaker in grace and humility, and that they are stronger in the grace of serving (assuming they are not proud). So who is weaker? We both are. Who is damnably weaker (Hosea 6:6)? The one who proudly judges. Interesting isn't it? Who is using a spiritual gift for the edification of the body? The one who is serving. Do you see where the artistically weaker one is necessary for the body because you are not fit to lead others in the worship of God when you have a prideful attitude? And they are specifically necessary for your sanctification in the revealing and putting to death of your pride. Everyone is the "weaker" one, and everyone is necessary.

For those who might consider the artists to be the weaker ones, and just kind of pass over them, be careful. They are necessary for you. You may learn from them (although I really hesitate to mention these areas because we artists are not doing a very good job with these ourselves) patience, endurance, contentment, joy, the pleasures of simplicity, observant wisdom, graceful articulation, etc. Everyone in the

body is necessary because God has designed it that way. If we can grow in understanding how this is true, we will be growing in the knowledge of God, which can only be edifying.

There is a time for an artist to lead and testify. And there is also a time for the artist to be quiet, to listen and observe and rest and not get in the way as the other parts of the body serve as they are gifted by God to do. An actor cannot be both in front of the camera and behind the camera at the same time. The actor needs a cameraman to capture the shot. A cameraman needs an actor to shoot. It takes members to make a whole. Body life is a good design of God that keeps our boasting in check. So let's know our parts, artists, and play that part in the strength that the Spirit provides, all for the edification of the body, of which we are a member.

We all want gifts. There are gifts we are encouraged to desire ("desire earnestly spiritual gifts" I Corinthians 14:1b), and biblical motives for desiring them ("...since you are zealous of spiritual gifts, seek to abound for the edification of the church" I Corinthians 14:12). So artists, however the Lord has uniquely gifted you in deploying that spiritual gift He has given you, be faithful then in its cultivation because "There is an appointed time for everything. And there is a time for every event under heaven... A time to mourn, and a time to dance" (Ecclesiastes 3:1, 4b).

Mourners (poets, songwriters), prepare yourselves! Dancers, prepare yourselves! Be faithful to God, be disciplined, and enjoy the labors of your portion! For when the time comes to mourn and when the time comes to dance, how will the body most satisfyingly mourn and dance if you, one of its necessary members, are not prepared to serve them by leading them to God: the End of mourning and dancing?

The Church Service

Thus says the Lord: "Heaven is my throne and the earth is my footstool; what is the house that you would build for me, and what is the place of my rest? All these things my hand has made, and so all these things came to be," declares the Lord. "But this is the one to whom I will look: he who is humble and contrite in spirit and trembles at my word." (Isaiah 66:1-2 ESV)

We who are strong have an obligation to bear with the failings of the weak, and not to please ourselves. Let each of us please his neighbor for his good, to build him up. For Christ did not please himself, but as it is written, "The reproaches of those who reproached you fell on me."...May the God of endurance and encouragement grant you to live in such harmony with one another, in accord with Christ Jesus, that together you may with one voice glorify the God and Father of our Lord Jesus Christ. Therefore welcome one another as Christ has welcomed you, for the glory of God. (Romans 15:1...7 ESV)

Most everything I have tried to wrestle with so far has been from the perspective of what I see the Bible teaching me regarding how I should live my everyday life in the arts in the recognition, strength, and enjoyment of God, to the praise of God, so that my joy may be full.

God is interested in my joy (Psalm 81:16). I have a life that is immersed in music and other art forms by the direct design of God. A life, like your own, that is not a solo life, but rather, a part of all mankind. And even more specifically, a necessary part of the body of Christ, if we are indeed repentant and atoned for. Our necessity in the body is in no way on account of anything of our doing. Hear me, artists: We have no ground or reason to boast in being the part of the body that we are! We are an insufficient one of many. That part of the body of Christ is made up of artists is solely because of God's counsel and pleasure. And the counsel of God is the ground reason why anyone, even everyone, in the body of Christ is deemed necessary (I Corinthians 12:22). It is this way because of the will of God (I Corinthians 12).

When the body of Christ comes together to worship the Lord in one accord, meaning that all kinds of body parts with different designs and functions join together to worship God for who He is, the members of the body will individually see a view of God that can only be seen when worshiping together as a whole. We should not be so immature as to let our artistic preference issues distract us from the pleasures in God that are known through corporately worshiping together.

Consider a soccer match. It sure is easy for masses of people to set aside personal preferences in order to experience the joy of rooting on their team together, hoping to see a victory. I don't get all bent out of shape if I don't hear my preferred style of music being played over the field PA system at a soccer match. Likewise, a Country & Western theme over the PA does not distract me from focusing on the ball in play! I go to a soccer match because I desire to see soccer battled out live in the

field, and there is such a pleasure in joining with other lovers of soccer to help my team wrestle for a victory. I'll gladly, even unknowingly, set my individual music preferences aside in order to pursue the pleasures of a corporate victory.

Do we go to church with the desire to be victorious in seeing and worshiping God? Can we set aside our artistic preferences for the kind of worship and view of God that is only found when the body comes together? The opponent of the goal of truly worshiping God at church is not the other church members, but the devil and his own. The devil is very sly. He knows that he can easily subvert a victory if he can mis-direct the people. We've bought into his lie when we exercise little self-control over our personal preferences in corporate worship. Our lack of self-control will cost us a victory. We won't see God, and that makes us the loser.

NECESSARY DEMOLITION

In order to make any progress on the rub in the form/style/artistic preference of "worship time" in the church service, I think we first need to do some necessary demolition. We need to keep in mind what the goal of gathering together for a church service is: to worship God for who He is.

I think the only thing we can say with absolute certainty is that corporate worship should be about the "corporate" worshiping God. It is not to be about the "corporate" worshiping other men or styles or preferences of expression delivery. God alone is to be worshiped.

I don't pretend to be some kind of expert in church history. I only know that the Bible is clear that God alone is to be worshiped, and nothing and no one else should have our ultimate affections. Praise God that we don't have to be geniuses to know Him, we just have to

be repentant. We don't have to be the most polished singers for God to accept the praise of our lips, we just need to be humble, contrite in spirit and trembling at His word (Isaiah 66:2b). God is the end of the church service, the artistic expression of our worship is not the end. It's not even near the end! Once we get this order right, then I think we will begin to know the Lord's fuller blessing for our local body as He calls us towards a greater knowledge and enjoyment of Himself through the various lives and skills He has put in the local body. The porch hounds baying for their artistic preferences of worship need to be silenced so we can hear the invaluable whispers of God.

How does your local body, with all of its members, express its joy in God? Do they express their joy in God? Do they only express a measure of joy when the presentation of God suits their preference? If so, is this truly joy in God, or is this joy really a joy in a sonic preference?

The worship of God has nothing to do with our preferences. Furthermore, our worship of God is not conditional upon whether or not we are feeling jubilant. God is God, and He will be worshiped no matter how He decides to reveal Himself any given day. If not by us, then the rocks will cry out.

I doubt it was Abraham's preferential style of worship to hear the Lord say, "Take your son, your only son Isaac, whom you love, and go to the land of Moriah, and offer him there as a burnt offering on one of the mountains of which I shall tell you" (Genesis 22:2 ESV). Yet Abraham rose and worshiped God. I doubt it was Job's preference to hear the news that he had just lost all his children and possessions, and yet the first thing he did was worship God (Job 1:20). I doubt it was Shadrach's, Meshach's and Abednego's preference to hear Nebuchadnezzar threaten death if they would not bow to the idol, and yet they could worship God amongst all the noise from the various local musical instruments (Daniel 3). The author of Lamentations surely was not living the life he preferred, and yet he could worship God and say, "'The Lord is my portion,' says my soul,

'therefore I will hope in Him'" (Lamentations 3:24).

Our preferences are really not a factor in whether we should join in the worship of God or not, church service or otherwise. These saints had affections for God that would not be squelched by their affections for their preferences. God is worthy to be worshiped at all times because He is the Almighty Sovereign God! And we will enjoy genuine worship of God when our affections are tuned to receive what God is saying about Himself, rather than tuned to what we prefer to hear. He who has ears to hear will come to church ready to listen.

We do have a lot of history showing how certain generations have expressed their worship of God in the past that corresponded directly with or against the culture they found themselves in. Each culture's unique expression of genuine God-worship is the direct result of God exercising His boundless creativity. One way that God began to reveal His inexhaustibility was by placing man in various conditions with differing materials and differing languages and temperaments. And all of that in a continuum of time that builds on itself. God did not make clones, nor has He revealed all of His genius at once (Romans 16:25). God did not inspire all men to construct the same instruments ever known or yet to be known. He continues to inspire and reveal throughout our living history, which demonstrates just how grand He really is. It is God who began this expression of joy in God, joy in Himself, when He created man to be in His image, in many varieties and with many forms of expression. To express joy in God was not our idea (John 17).

"STYLE AND FORM" VS. "WHAT IS FROM FAITH"

I want to throw the hammer against this issue we make of "style and form" because what we should be looking at is "what is from faith."

God tells us in Hebrews 11:4, "By faith Abel offered to God a more acceptable sacrifice than Cain, through which he was commended as righteous, God commending him by accepting his gifts. And through his faith, though he died, he still speaks." Abel is still speaking this to us today: God accepts what is from faith. Do we hear Abel?

We are not to measure our style or expression of worship against another's style in an effort to find the "godliness" or the "godly rank" of our worship style. Cain was a worker of the ground, and his first fruit offering (his style or expression as God made him) God did not find as acceptable worship because it was not from faith. And Abel, a keeper of sheep, brought his firstborn from the flock (his style or expression as God made him) and God did find it as acceptable worship because it was offered in faith. Everyone's personal expression of worship will be a bit different because God has made us all different. But what will corporately bind our worship together is the common ground we all must have: a heart that offers in faith.

When we are tempted to measure where our personal form of worship ranks among others, we begin to follow the course of Cain where sin lies "crouching at the door. Its desire is for [us], but [we] must rule over it" (Genesis 4:7b). Sin will tempt us to judge another's form of worship in hopes of distracting us from worshiping God. How often we are suckered. Our proud flesh is so weak. Artists, we must rule over this temptation. But if we are so tempted to measure, then the only accurate appraisal will be found when we measure our form against the fullness of the expression of God. Then we will realize just how tiny our little "form of worship" preference actually is.

Our pride in "forms" will finally be silenced when we hear God call the roll and all of creation takes its turn in giving homage and praise to its Creator and Saviour. Let us not be like the indignant chief priests and scribes who could not discern the difference between the praise that God prepares and the praise that man prefers. Jesus says, "...have you never read,

'OUT OF THE MOUTH OF INFANTS AND NURSING BABIES YOU HAVE PREPARED PRAISE FOR YOURSELF'?" (Matthew 21:16). The form does not demonstrate the value of our worship, nor does it confirm the genuineness of the worshiper. The varying forms demonstrate the broadness of God, and all that is from faith He hears.

Looking for some kind of godliness rank in form or style focuses our attention on ourselves and what we bring to God, which means that we are in part worshiping us, and not God. Worshiping God is all about declaring how sufficient God is, how empty we are, and how beautifully satisfying He is for our insufficiency. So artists, let God be the decider as to what pleases Him in form and style according to how He has portioned the people in your church body, and let us attend to the condition of our hearts.

Thus says the Lord: "Heaven is my throne and the earth is my footstool; what is the house that you would build for me, and what is the place of my rest? All these things my hand has made, and so all these things came to be," declares the Lord. "BUT THIS IS THE ONE TO WHOM I WILL LOOK: HE WHO IS HUMBLE AND CONTRITE IN SPIRIT AND TREMBLES AT MY WORD" (Isaiah 66:1-2 ESV emphasis mine).

So again, we must start with God if we are going to understand anything rightly. God tells us to look at our hearts and His word, not the form or style of artistic expression in our worship of Him.

ABSTAINING IN FAITH

I want to send the hammer against another wall that Preference has

built. As the church gathers together to worship the Lord, each gathering may find good reason to abstain from a certain form of worship from another's culture if they cannot embrace that form or style in faith. If a body cannot embrace something in faith, that is good biblical reason to abstain from practicing it. They should not practice it and we should not judge them because "whatever is not from faith is sin" (Romans 14:23b).

Paul says:

> Who are [we] to pass judgment on the servant of another? It is before his own master that he stands or falls. And he will be upheld, for the Lord is able to make him stand. One person esteems one day as better than another, while another esteems all days alike. Each one should be fully convinced in his own mind. The one who observes the day, observes it in honor of the Lord. The one who eats, eats in honor of the Lord, since he gives thanks to God, while the one who abstains, abstains in honor of the Lord and gives thanks to God. For none of us lives to himself, and none of us dies to himself.... So then each of us will give an account of himself to God (Romans 14:4-7, 12 ESV).

It is before the Lord, not one another, that another man worships. Before God, each of us will give an account of our heart's worship (affection), not the melody or quality of our singing. Why for the sake of artistic style or preference do we so often engage in quarreling, or worse, cause our brother to sin as we encourage him to compromise his conscience when artistic style is of such a lesser pleasure than the pleasure of fellowship with God? Or is it? I fear this quarreling proves how misplaced our affections are when we prefer a certain style over joining with our brother in genuine worship of God. God, forgive us for our idolatry of style and our selfishness of preference.

The Church Service

THE CORPORATE DOES NOT REPLACE THE CLOSET

I was talking with a friend of mine, Richard Mailly, about this and we were pondering on how some of this "worship time" rub happens because we look to the corporate gathering at church to quench the need of our heart to worship God, as we neglect our closet worship. In the closet, and all throughout our day, we can be as preferential in style and form as we desire, and if it is from faith, we will enjoy some sweet fellowship with God. The closet worship and the corporate worship are not the same, and both are decidedly necessary.

To say, "I just can't worship God with the body unless worship time sounds like (insert whatever pleasing style the devil is using to hypnotize us away from embracing the full expression of God)," just makes plain how immature we are in our understanding of what the worship of God is and means. Jesus worshiped God both alone and with the brothers. He did not rely on the brother time for his personal worship desires to be satisfied, and for good reason. The brothers were not reliable (Luke 22:46). Jesus was fiercely after His personal time with God the Father.

Paul continues to say in Romans 14:

> I know and am persuaded in the Lord Jesus that nothing is unclean in itself, but it is unclean for anyone who thinks it unclean. For if your brother is grieved by what you eat, you are no longer walking in love. By what you eat, do not destroy the one for whom Christ died. So do not let what you regard as good be spoken of as evil. For the kingdom of God is not a matter of eating and drinking but of righteousness and peace and joy in the Holy Spirit. Whoever thus serves Christ is acceptable to God and approved by men. So then let us pursue what makes for peace and for mutual upbuilding. Do not for the sake of

food, destroy the work of God. Everything is indeed clean,
but it is wrong for anyone to make another stumble by what
he eats (v. 14-20 ESV).

Isn't this corporate talk? We are not to destroy the work of God
for the sake of music or art or dance or drama or presentation. Corporate
worship is about worshiping God, not worshiping what God made.
Remember, form does not have a heart, so it does not sin. Therefore form
is not even the issue. Obedience in faith is the issue (Romans 16:26), and
that comes from the heart. And yet we have made form the issue because
we find it easier to change the form than to change our heart.

All this quarreling about worship styles and forms provides the
evidence that we do not know that Romans 14 is even in the Bible. It
also convicts us that we may not be doing much of anything from faith,
but rather out of some kind of traditional law-keeping religiosity. Wake
up, Harms! We better check ourselves right now to see if we are today
engaging in our corporate worship time from faith. If not – we "worship"
in sin. So who are we, Cain or Abel?

When we rightly understand that it is God that we are to be after
in our corporate worship, rather than some artistic preference, only
then will our hearts be in a position to hear all that God is saying about
Himself as He demonstrates just how grand and deserving of our worship
He is as He displays His genius through all the many various peoples and
sounds (that may not be our preference at first) He has made. We must
start seeing everyone, no exceptions, as they are: a unique and necessary
creation of God. Only then can we truly worship more of God as we grow
in knowledge by embracing, in faith, more of what He has made.

We must pursue greater faith! The many generations and cultures
and their many flavors of expression testify to the grandness of the scope
of the creative genius of God. It is to God's credit that there are so many

different forms and expressions of genuine God-worship.

A FOOTING FROM WHICH TO GROW
IN THE WORSHIP OF GOD

So, let's start over now from a solid footing of faith, and try to articulate a direction for pursuing a corporate worship time that is solely about the worship of God, in faith, as we find it helpful, and even pleasurable in the Lord, to employ artistic means in the expression of the affection.

The church service is to be about worshiping God as brothers and sisters, all vessels of mercy alike, in one accord. It is not about being happy together for an hour in ignorant worship. "This people honors Me with their lips, but their heart is far away from Me. But in vain do they worship Me, teaching as doctrines the precepts of men" (Matthew 15:8-9). We do not want to be that kind of people, a people that can beautifully talk and sing about God and godliness with their lips, yet have no life or affection in their heart that produces or confirms or is acted upon by what the lips are saying about God. That people's heart is far from knowing God. A "spiritual-like" emotion that is felt when hearing a sound is not to be confused with a Holy Spirit empowerment or conviction that is birthed in the soul of a man when a truth of God is declared and understood. If a people's affection is not kindled when God Himself is the only theme sounded – then they do not know God! God is overwhelmingly cascading with majesty just as He is. He needs nothing to help Him be more attractive. I'll say it again:

> If our affections are not kindled when the name of God
> is the only theme sounded – then we do not know God
> as He is!

If we only knew God! The God who set the earth in motion with only a word from His mouth (Hebrews 11:3); the God who has no counselor (Romans 11:34); the God who rains down fire from heaven upon the wicked (Genesis 19:24); the God who provides rain for the just and unjust alike (Matthew 5:45); the God who can destroy His creation with water and then start over again (Genesis 6); the God who cannot be summoned (Job 9:19, Jeremiah 49:19), the God who does whatever He pleases (Psalm 135:6), the God who holds all things together, whether seen or unseen, by the word of His power (Colossians 1:17, Hebrews 1:3); the God who stands in furnaces with those who trust in Him alone (Daniel 3:28); the God who put death to death (Hebrews 2:14); the God who is the giver of life (Genesis 2:7); the God who has always been (John 1); the God who came to serve (Philippians 2) and has no need of being served (Psalm 50:12). One day, at the sheer mention of the name of Jesus, every knee will bow (Philippians 2:10). It will not matter that day in what style, or in what key, or whether there is an organ playing or not; when the name of Jesus Christ is pronounced, all will bow and worship!

Lead us to God, pastors and worship leaders and elders and choir! An entertaining placebo will not cure my sick soul. Worship leaders, you must lead us to God! He will hold you accountable for your gig (Matthew 18:6).

But how can one lead if he doesn't know the way himself? Worship leaders need to be worshiping God themselves (Sphere One) before they attempt to lead others (Sphere Two) to God. Worship leaders, lead us in worshiping God by worshiping God yourself, not just by pointing out directions to God. A good, shepherding leader is more than a road sign pointing in the general direction of the destination; he is a guide who takes you there by walking the path before you himself. Leaders, don't spin your wheels in fear or pride if the path of worship looks a little unfamiliar to you. Always defer to the Holy Spirit. He will lead

you or provide direction through someone else. Be willing to lead with humility. Even good guides will call upon a local scout at times for precise navigation. Leaders, be careful not to be proud guides, but effective guides. Get your people to the destination of fellowship with God. Jesus modeled for us so beautifully how to lead with humility while He held such complete authority.

Leaders of corporate worship, care for your own soul's worship (Sphere One) and the scent will be caught and the trail will be exposed. When the hounds find the scent of the game, the hunters will follow (Sphere Two). But a spook hound is not fit for the hunt. Don't be spook hound worship leaders, easily distracted by every tickling scent. Lead us to the Game that will satisfy our hunting soul. Find and follow the scent God is laying.

I do believe artistic talents are a beautiful, helpful and biblical means of leading or pointing a group of people towards the unifying goal of worshiping God. The Bible clearly gives examples of this with the Psalms. But artistic talents are only a means of leading in so far as they are able to help unify direction, emotion or expression. They are not a means of getting to the throne of God. Art has not been granted that power. Only the blood of Jesus possesses that kind of power. Let's make sure we understand and employ artistic means, then, in the way that they are helpful, but let's not be fooled or tempted to exchange the glory of the Creator for the glory of what He created (Romans 1).

In a theater of battle, where a drum and bugle corps would provide direction in the heat of battle, no fighting soldier would want to hear the corps perform some extracurricular piece that told them nothing about how and where to engage. The soldiers' lives are at stake, and bad leadership may lead them to their death. If artistic means are helpful in leading towards and not distracting from the goal of meeting God, worshiping God, then I want them, because I want the fellowship that

God desires to give. Hear me, though. It is not art that I need. I need God! I don't need a certain style of music in order to see God. Artistic expression is not the object, nor is it the lens that enables us to see God. Artistic expression is an emanation of the glory of God who is the object, and of Jesus who is the lens! Any pleasure that we have in God via the employment of artistic expression is only because Jesus has stepped in as the lens to bring into focus the Author of such pleasurable expression. Oh God, show us where our affections have not had You as their end, and where we've heinously replaced Jesus with our artistic means!

God uses artistic, aesthetically pleasurable means all the time in His creation to tell the masses about Himself. When He wants to remind us that He will not send the rains again in such volume as to destroy the whole earth, He paints a rainbow in the sky (Genesis 9). When we need a reminder that the solar system does have order and is kept by His word, He sends a fascinating eclipse or comet right on schedule for all the science lovers to be awestruck by His punctuality (Job 38). Or to keep us in suspense and in our place, He will spew molten lava into the air, or shake the earth and sea to remind us that He is not to be bound.

What is tough, though, is that because we are so diverse in cultures and tastes and flavors (which is God's design), and at the same time so incredibly selfish, desiring only to eat what we want, we often come to that corporate worship service with an attitude of "feed me" and "feed me that vanilla I am used to. AND ANOTHER SCOOP OF VANILLA... please!" More of God will not be known through calls for more vanilla. If we do not slay our selfish attitudes, we will never feast on some of the "manna that our fathers never knew about" (Deuteronomy 8:16). Manna is still from God. It is just the bread of a place foreign to us. Variations in style and form of worship can still be from God, they may just be from a place that is foreign to us. Have you eaten the bread of angels lately?

Let's look at Deuteronomy 8:16 from the perspective of a worship

service. "In the wilderness He fed you manna which your fathers did not know, that He might humble you and that He might test you, to do good for you in the end." God humbles us to test us to do good for us. He may humble us by showing us that our style preference is not the most pleasing style on earth to everyone else's ears. But, as it turns out, they have the same Creator as we do. The poor and the rich alike are pinched off the same lump of clay. "Whoever mocks the poor insults his Maker" (Proverbs 17:5a). God tests us to prove to us what the desire of our heart actually is. Is our heart's desire to grow in the knowledge of God and worship Him, or to tell of and pacify self? All this humbling does us good in the end when we learn our place. Each of us is only a piece of a whole that's been created by God, so let's pursue the whole of God as we observe the individual pieces He made. If God made a man and ordained that a certain sound comes from that man's God-fearing heart, then let God be God. We would do well to listen. We may learn something about God. We may better understand and enjoy the greater body. We may even enjoy the bread of angels if we would stop grumbling when we are not served what we crave.

SHOULD WE SEEK A SOUND OR A BLESSING?

There is this deceptive notion that we all embrace to some degree, which I fear makes us miss out on what the Holy Spirit would have for us of God. We tend to assume that our music worship time should sound a certain way before we take stock of whom the Lord has put together in our local flock. We tend to look for a sound before we look for the blessing of God.

What if God didn't give your flock the ability to play a piano and a bass, but rather a fife and drum, or an accordion and a banjo, or some other initially unfamiliar Sunday morning mix? Do you first

think that this instrumentation won't do and that you must go and secure the "necessary" instrumentalists? Maybe even to the degree that you are willing to overlook the state of the musicians' own hearts for the sake of a certain sound? Would you give the responsibility of leading the people in the worship of God to someone who does not know or worship God himself? The Lord "does not take pleasure in the legs of a man. The Lord favors those who fear Him…" (Psalm 147:10b-11a). God doesn't say that He favors a certain sound or style, He's made them all. He favors those who fear Him.

I can hear the objector cry that God is excellent and deserves nothing but our absolute best. And I answer:

Yes. He is excellent!

And yes, God is deserving of our very best!

God is deserving for sure, but do we know what God demands and delights in?

God could care less about our very best where our very best is not from faith. He says of Eliab to Samuel, "Do not look at his appearance or at the height of his stature, because I have rejected him; for God sees not as man sees, for man looks at the outward appearance, but the Lord looks at the heart" (I Samuel 16:7). We need to be careful not to think as men think. That is really tough, being a man.

This issue of excellence is really an issue of faithfulness with what we have been given. Excellence is not about style selection. Excellence is an issue of faithfulness on the part of the leader as he works to discern what will be most helpful, and not distracting, for his people. Excellence is an issue of faithfulness on the part of the servant (musician, poet, etc.) as he will have to give account to his Master on how he employed what

was entrusted to him for the edification of the body. Excellence is an issue of faithfulness on the part of the worshiping heart in the pew not to entertain his pride by thinking that God has granted godliness more or less upon certain musical forms of expressions, but to rather employ humility, slay the grumbler inside, set the affections soley on God, and consider all other personal distractions as necessary afflictions that work for his greater sanctification! Regarding excellence, let's, each one of us, apply excellence in personally being faithful with our portion in the body and see if our affections don't fall more excellently into place.

Maybe we should first ask the Lord who the person is who has His blessing in leading the corporate worship time, and then listen for the sound that the Lord would compose? Since God put the body together as He desired, He should know best what the greatest blessing would be for that local flock. Remember, preference does not equal blessing.

We are so tempted to try to reproduce a sound that I'm afraid we often forfeit the tailored blessings the Lord would have for us when we presumptuously think we need to sound or look like what's going on in the next county. The Lord is not shallow in grace or creativity. He knit your local body together just as He desired (I Corinthians 12:18), which may not be as your flesh desires, but will prove to be, if you yield, the means that you experience the fullness of God's blessing for your flock. See whom He brings to your fold. Don't fall into the trap of thinking you need to sound popular. You will only be frustrated. In fact, if you find that you are currently frustrated, check your heels, they may be ensnared in this trap already.

WHAT IS IMPOSSIBLE WITH MAN
IS POSSIBLE WITH GOD.

My conclusion for what the church service should look like

is really not so tough. It should show God is sufficient (which He is), show we are in need of Him (which we are), and show that He is full of lovingkindness for those who fear Him (which He is) – so we enjoy and praise Him for who He is. The implementation is just really hard to swallow because it exposes our sins of selfishness, arrogance, ignorance, idolatry, and laziness. But thank God that "the things impossible with men are possible with God" (Luke 18:27). God is able to give life to our dead hearts.

For starters, we corporately need a serious dose of humility. We are all children who don't know the joys of sharing toys, and in fact forget that the toys were given to us in the first place by our Father. They are His. Music is His idea. Poetry is His idea. Sculpting is His idea. The body of Christ would do well to share their affection expressions of genuine God-worship with each other so that we can all better grow in the knowledge of God through observing what God is revealing about Himself as He cut man in so many variations.

Depending on the size and depth of the corporate, the leader must discern what will best lead that body of people together in worshiping God. If a worship leader leads in a certain direction or style to appease the people, I believe he misleads. His appeasing motive is rooted in the fear of men. To appease means to bring quiet, or pacify, or give in to demands. An appeaser in this sense is not a good leader. The worship leader, submitting to the Holy Spirit, must lead with the motive of serving the people. Serving them well by leading them to God.

Serving the body by serving them what is helpful is different than appeasing the body by giving them what they want. Any particular style of worship can be used. The style does not sin. It's the motive for using a style that may or may not produce sin. The issue, as always, is the motive (affection), which comes from the heart. One and the same style could be employed either from a motive of appeasement or a motive of service. The leader might serve the body well at times to lead the people into new

territory to taste other grain. While at other times, he serves them well by feeding them in the pasture of familiarity, as it keeps the body regular.

It is true that certain styles or methods are familiar to certain groups of people and are probably less distracting than other styles or methods. But do we want to know the fullness of God's glory, or just the fullness of us – "the main part of God's glory," so we think? We are so proud. Pride runs very deep. This is like saying that one race of people pleases the Lord over another race. God made all races and has chosen His own from each tribe so that His purpose in election would stand (Romans 9-11). In fact, even the Jewish "style" was and is partially set aside for a season so that this Gentile "style" can come into the vine, and then all "styles" will be a part of the worshiping family where no one can boast in any style over another. Our boasting will only be in the mercy of God calling us out of darkness and giving us life through Christ. The various styles in the body are to the boast of the coverage of the cross of Christ. Would we dare muzzle Christ's boast?

There are necessary seasons for more sub-culture specific expressions of worship, but we all need to learn how to set aside differences of personal preference for the unique pleasure of unified corporate worship like we hear about in Revelation 19:5-7,

> And a voice came from the throne saying, "Give praise to our God, all you His bond-servants, you who fear Him, the small and the great." And I heard, as it were, the voice of a great multitude and as the sound of many waters and as the sound of mighty peals of thunder saying, "Hallelujah! For the Lord our God, the Almighty, reigns. Let us rejoice and be glad and give the glory to Him, for the marriage of the Lamb has come and His bride has made herself ready."

The grandness of great multitudes, sounding as mighty waters and mighty peals of thunder will never be experienced coming from the mouth of one individual and his few unique buddies. There is both a time for sub-culture specificity and a time for chief-culture uniformity. Let's be faithful in both the closet and the corporate so we can know the pleasure of more fully worshiping God.

So, the church service.... I suggest we humble ourselves before God, and pray that He would lead us into as full and wide and deep and high of corporate worship times as He would permit this side of heaven for our local flock, so that we may experience the grandness of the glory of our God! As it turns out, God is God over South Korea and North Korea and Iraq and Afghanistan and South Dakota and Arizona and Ecuador and Ireland and Russia and the swamp and the igloo and the desert and the rainforest and the sea and the plain and the mountain and the beach and the forest and the sky and the atmosphere and space and heaven and hell and downtown and country and hood and burb and cathedral and underground church and world preacher and suffering martyr. We haven't begun to physically experience the variety of the styles of God. We should pray for our corporate worship services as Jesus taught us: God our Father, "Your will be done on earth as it is in heaven" (Matthew 6:10).

And I think there is a word of caution to embrace here. Let's not make the mistake of trading one fetter for another. We don't want to get distracted away from God by trying to be all styles. Again, style is not the issue. Faithfulness is the issue. Let's faithfully be who God has made us to be. We are not God. We cannot be everybody. But through God's grace we can be a better body. A better family that worships God for each of its members, as no one is unnecessary for the health of the local fold.

All Thy works shall give thanks to Thee, O Lord, and Thy
godly ones shall bless Thee. They shall speak of the glory

of Thy kingdom, and talk of Thy power; to make known to the sons of men Thy mighty acts, and the glory of the majesty of Thy kingdom. Thy kingdom is an everlasting kingdom, and Thy dominion endures throughout all generations (Psalm 145:10-13).

God's dominion endures throughout the styles of all generations. Glory be to God!

Oh the depth of the riches both of the wisdom and knowledge of God! How unsearchable are His judgments and unfathomable His ways! For who has known the mind of the Lord, or who has been His counselor? Or who has first given to Him that it might be paid back to him again? For from Him and through Him and to Him are all things. To Him be the glory forever. Amen (Romans 11:33-36).

Artists,

May the God of endurance and encouragement grant [us] to live in such harmony with one another, in accord with Christ Jesus, that together [we] may with one voice glorify the God and Father of our Lord Jesus Christ. Therefore welcome one another as Christ has welcomed you, for the glory of God (Romans 15:5-7 ESV).

A Final Charge

You have an Author, artist. He made you precisely as He desired. You are particularly made, with all your strengths and weaknesses, such that your greatest pleasures will be found, secured, and enjoyed when you pursue your artistic pleasures with God as the culmination and termination of all that you find enjoyable in the arts. Fellowship with the Author of all that is pleasing should not be squandered.

Artists, do not cheat yourself by settling for lesser pleasures. Do not be bound by erroneous traditions of men. Never be a slave to pride. Fear no man or market. Rather, bind your heart to the Word of God. It is sure. It is nourishing. It is liberating. It is the wisdom of God. Faithfulness to the Word frees! Faithlessness fetters.

The earth is the Lord's, and all that it contains! (Psalm 24:1). Your themes and mediums, then, seem to be endless. If God is for you, who can stand against you? (Romans 8:31). You have no good reason to be enslaved by the fear of men. God works for those who wait for Him! (Isaiah 64:4). Your strength is found through faithfulness to God.

So then: that you might enjoy the fellowship with God that is to be had, uniquely, and that we might enjoy the glory of God that is to be displayed in you, His creature, be what you are in Christ! Be a God-fearing, Christ-enjoying, Holy Spirit-seeking, Body-edifying, humble, bold, generous, above reproach, zealous for truth, persevering artist. It is God who made you artistic. Enjoy Him, then, in all that is pleasurable.

An Artist's Creed

For from Him and through Him and to Him are all things.
To Him be the glory forever. Amen. (Romans 11:36)

God was pleased to make man, and God made man with creative capacities. Apart from God, man would not be, nor would man have any artistic, creative ability. Therefore, to engage in any artistic expression of man as being apart from God is to both dishonor God, the Author of man and of artistic expression, and to deny ourselves the full pleasures that God has intended for our enjoyment in art, culminating in our enjoyment in Him, through Jesus Christ.

So with God's help and to the glory of Jesus Christ alone, as I engage with art,

I RESOLVE:

I. TO GROW in the knowledge, love, and enjoyment of God as I embrace God's skillful, aesthetic emanation of what God knows, loves, and enjoys of Himself.

(Genesis - Revelation)

II. TO PURSUE eyes that see as God sees as I am
presented with all that He has put to image in what He
created.

(Romans 1, I Samuel 16:7)

III. TO BOAST only in Christ in my artistic labor since
all things were created through Him and for Him, and in
Christ all things hold together.

(Colossians 1:15-17, I Corinthians 4:7)

IV. TO UNDERSTAND how, and to acknowledge that,
my standing before God is exclusively dependant and
grounded in Christ's work on the cross, and is in no way
earned by any worthy artistic labor I engage in.

(Colossians 1:18-23, Romans 8, Ephesians 1-2:10)

V. TO PUT my hope for satisfaction and provision in
God alone through the work of Christ, and never rest my
hope on art, audience, or self.

(Deuteronomy 8:3, 17-20, Philippians 4:19, Romans 8:18, 31-39, Psalm 107:9,

Matthew 5:6, Psalm 40:4)

VI. TO PURSUE the joys of faithful obedience as a
bondservant of Christ in all that He has called me to and
charged me with in the arts.

(Galatians 1:10, Isaiah 66:2, I Peter 1:22)

VII. TO TAKE PLEASURE in art for the sake of enjoying
God; the Giver of art for my enjoyment.

(I Timothy 6:17, Ecclesiastes 2:24-25)

An Artist's Creed

VIII. TO LABOR to artistically articulate the kind of beauty that will continue to satisfy even after my effort at the tangible representation of that beauty has long been consumed or destroyed.

(I Timothy 6:6-7, I Corinthians 3:13, James 5:2-3, II Peter 3:10-12)

IX. TO LABOR in the arts in such a way as to lay up as much treasure in heaven as the Holy Spirit enables and my faculties allow.

(Matthew 6:19-21, Ecclesiastes 11:1, II Corinthians 9:6)

X. TO SEEK the edification of others through my artistic labors.

(Ephesians 4:29, Jude 1:17-23)

XI. TO NOT BED with the creeds of sterility, mediocrity or spineless-complaisancy as they all trade the grandest joys for the quick and temporal.

(Revelation 3:15-19, I Thessalonians 2:2)

XII. TO NOT DEFILE myself as I study, with much discipline, the "literature and language" of the arts.

(Daniel 1:3-8, Psalm 1:3-4, Proverbs 21:12)

XIII. TO DISCIPLINE my body and mind to fully develop the skills with which God has endowed me, and that in the strength that He gives.

(Exodus 36:1, I Corinthians 15:10, Colossians 1:29, Proverbs 13:18)

XIV. TO PRIZE humility, as humility is more valuable and more beautiful than the most aesthetically pleasing work held in the hand of pride.

(1 Peter 5:5, Philippians 2:3, Proverbs 22:4, Daniel 4:37)

XV. TO SEEK the full pleasures to be had in art by engaging art through engaging God.

(Romans 11:36, Ecclesiastes 2:24-25, 1 Timothy 6:17-19, Job 38:1-2)

Jason Harms

FOR ONGOING WRESTLING ON THESE THEMES VISIT:

THE GAIUS PROJECT

THEGAIUSPROJECT.ORG

Confession

I must tell you (Sphere Two) that wrestling through these themes on paper was a joy! The greatest pleasure was in the fellowship I had with God (Sphere One) working through the Bible, working on the clarification of the thoughts of my mind, the groanings of my soul, and the affections of my heart to see if they are biblical. Because where my affections are not biblical, they will harm me on the one hand and deny me pleasures on the other. "Search me, O God, and know my heart; try me and know my anxious thoughts and see if there be any hurtful way in me, and lead me in the everlasting way" (Psalm 139:23-24).

With that said, I do not feel for a moment that I now have life in the arts all figured out. In all humility, the more you grow, the more you realize how much you have yet to learn. But I do feel, with great confidence, that if I pursue a trajectory of starting at God in my enjoyment of artistic pleasures, or if I push on them hard enough until I end up at God, I will not be disappointed with His portion for me in the arts.

I'm not saying that there must forever be this big math process rendering in my mind as I try to solve the art equation with God being the sum before I can simply enjoy anything of artistic beauty. There will probably be seasons of re-calibration or re-tooling to work through, but it will be worth it. It has been worth it. As my mind becomes transformed and sees more the way God sees, it should be more simply natural (or

rather supernatural) when viewing anything, to see God as the beginning, means, and end of all the things He has given us for our enjoyment. And as my mind becomes renewed, I will better discern where I am actually gratifying the desires of my flesh in my "pleasures," rather than enjoying what God has given me for my enjoyment in Him. "Do not be conformed to this world, but be transformed by the renewal of your mind, that by testing you may discern what is the will of God, what is good and acceptable and perfect" (Romans 12:2).

I want to know more of God because God is so beautiful! I do feel His pleasure, His fellowship, when I engage life from a heart of faith. And even more, I feel His intimate pleasure when I faithfully embrace life as He uniquely designed and enabled me to engage it.

I want my soul to know true, satisfying, and lasting fruitfulness. I don't want to be the old man whose fruit is all laid up in his barns and banks, and yet is starving for something to satisfy his soul. I don't want to be the artist who appeases admirers and thinks that he is feeding himself as he dines on their momentary praise. Instead, I want to know the joys and contentment of the little child who is so confident in the love, provision, and security of his father that he can freely play and enjoy his days. And as that child matures and works along side his steady-handed father, the boy learns that dad wasn't chiefly after the fruit of the tree as he planted, tended, and protected his orchards at such great cost. No, there was another fruit of a lasting kind in the soul that dad fed on as he faithfully and thoroughly enjoyed the temporal fruit of the tree. I want to enjoy this soul fruit, this sweet fellowship with God, my Father, when farming the orchards of art.

> So then, you will know them by their fruits. Not everyone who says to Me "Lord, Lord," will enter the kingdom of heaven; but *he who does the will of My Father* who is in heaven. Many will say to Me on that day, "Lord, Lord,

Confession

did we not prophesy in Your name, and in Your name cast
out demons, and in Your name perform many miracles?"
And then I will declare to them, "I never knew you; depart
from Me, you who practice lawlessness." *Therefore everyone
who hears these words of Mine, and acts upon them, may be
compared to a wise man*, who built his house on the rock.
And the rain descended, and the floods came, and the winds
blew, and burst against that house; and yet it did not fall,
for it had been founded upon the rock. *And everyone who
hears these words of Mine and does not act upon them, will be
like a foolish man*, who built his house upon the sand. And
the rain descended, and the floods came, and the winds
blew, and burst against that house; and it fell, and great was
its fall (Matthew 7:20-27 italics mine).

So now I have heard...

Pray for me that I would act upon these words of the Word, Jesus
Christ: the image of the invisible God.

...the one who looks into the perfect law, the law of liberty,
and perseveres, being no hearer who forgets but a doer who
acts, he will be blessed in his doing (James 1:25).

Jason Harms

ARTISTS,

ENJOY YOUR AUTHOR AS HE SO BEAUTIFULLY, SKILLFULLY, AND

BENEVOLENTLY GIVES YOU PLEASURES TO ENJOY TO LEAD YOU TO

THE CULMINATION OF

ALL PLEASURES,

NAMELY,

YOUR ENJOYMENT

OF

GOD

HIMSELF.

Cover Art

Adrian Johnston painted the piece I am using for the cover art. I have been so blessed to hear of God's mercy demonstrated in Adrian's life. And it's been a great pleasure to wrestle along with Adrian towards a greater knowledge and enjoyment of our Maker.

I felt that this painting articulated many of the emotions, truths and realities that artists often find themselves working through as they fight for their faith, desiring to be found pleasurably faithful with their lot and portion. Most of the time we need to get with the author of a work if we are going to squeeze out of the artwork all that is to be had. We must apply patience and listen. So I have asked Adrian to tell us (Sphere Two) about his wrestlings with the Lord (Sphere One) as expressed outwardly through this painting titled *Provision For The Cost*.

PROVISION FOR THE COST
ADRIAN JOHNSTON

In this painting I see a broken man in absolute need of his God. A man hemmed in, pushed to the edges, alone by a brook on the border of Israel's inheritance. He is trapped by God's word, yet sustained by it. We see a man whose journey is mapped out by the duration of God's provision for him in every place. He sees the long days from sunrise to

the darkness of night as he waits...the distance of his lips to the ravens which bring his food, and the place of desolation in which He is promised sustenance, while the word of the Lord works to fulfillment. Does he fret, or consider where this road of faith will lead? Does he forage for food, or does he simply wait by the dwindling brook in the time between the dawn and twilight ravens?

I painted this in the spring of 2004, in a small city in southwest China. In the end of 2002, I had begged leave of God from my employment in America. My heart was on trial before Abraham's faith, and like Jacob, I begged His provision for the months of preparation before He provided an open door to "Go." I was hasty, and after an exhausting first semester of teaching in China, I spent the winter break begging him for the provision of time to paint and study language and travel. He blessed me richly in all I asked of him, and though not without struggles and mistakes, many paintings and relationships were the fruit of that season.

"I want to do your will at any cost." I was awed to read of a martyr who once prayed like this. Elijah experiences the cost: estranged from his king and people; his land suffering from drought for seven years because of the word of faith that he spoke; the bitter rebuke of a bereaved widow; the feeling of being forsaken in the wilderness by Horeb. We are taught to pray to a God who hears, honors, and answers prayer. We are taught to desire God's will above all. But not often do we say, "At any cost..." - the prayer of those who prize God Himself above all other things. Nonetheless, Elijah's cleaving to God's will is testimony to us of God's intimate understanding of what Elijah needed, whether provided by raven, widow, angel, or voice of revelation. Remember when Elijah awoke in the wilderness, forlorn and exhausted, and there by him a cruse of water, and bread, and the angel who says, "Arise, eat, for the journey is too great for you." Merciful God! He knows! It is because the cost is so great that God marks our journey with heavenly provisions to sustain body, soul, and spirit, and to bring us home.

Cover Art

There are so many of God's direct and specific words to Elijah, and God's direct and specific provision for his bodily needs. For example, in I Kings 17, Elijah, by the word of the Lord, has told Ahab that there will be no rain on the land until he says so. The Lord tells Elijah to go east to a brook, where he dwells until the water dries, according to the prayer he prayed: "It will not rain." And during this time, God commands ravens to provide for him bread and flesh, morning and evening. (How strange, the Lord God, who through angels gave the laws of cleanliness to Moses, would command a carrion bird to carry flesh to His servant! What God makes clean, let us not call unclean!) When his water is depleted, it follows that through a widow in Zarephath the Lord chooses to sustain Elijah. I cannot imagine that Elijah did not feel burdensome to her, but the substance of this relationship is one of unfailing provision for both Elijah and the widow's family, even to the end of the famine, though it is fraught with sickness and death. But the relationship culminates in a way that hearkens forward to Jesus' word in John 11, concerning the death of Lazarus. The widow sees her son raised, and glorifies God.

IS THERE A COST FOR GOD'S PROVISION?

Jesus commands His disciples: "Count the cost." Does this mean that we must earn our standing with him? No. Does it mean that He tallies our mistakes against us? No. What brings us to friendship with God through Christ is free because it was earned already by what Jesus did, and it is true that we cannot add to it by sacrifice. There is nothing we can choose to forsake that will merit us salvation or the peace that comes from friendship with God. If the price of faith demanded the sacrifice of any thing we could give, it would not be grace, but would render instead an increasingly weighty burden of sin. But after we receive that free gift through faith in Jesus, the yoke of slavery to sin is broken in the flood of

joy that washes away the enemy and leaves the Son. Then the high price we saw Jesus demonstrate on the cross becomes the windowpane through which we see a greater place of joy. Because Jesus knew His Father, and knew that He was the Son, He prized the free gift most highly--let what He called sweet become our sweetness. Elijah, who was "very jealous for the Lord God of hosts" (I Kings 19:10), chose to desire God's will being done and obeyed throughout all the consequences of his obedience.

The widow of Zarephath spoke: "Now I know that you are a man of God and that the word in your mouth is truth." What if she had said, "Despite all the difficulties attached to your choices, I know that God made you an artist, and I can see that what you create is a true reflection of His glory!" Are you willing that what you hold true be true indeed? But what if the proof of truth through your life costs you your artwork, your tools, your instrument, your manuscript, your computer and all its conveniences and organization, or your body parts and their working functions, or your reputation, or your life, or the life of a loved one? Is it worth it? God's word through Jesus is securely planted, and has been proved through the trials when nothing is more precious to us than God Himself, and Him having His way. We release all these things willfully, and surrender our possessorship to His management. The light of life floods in, and we become who we are. He may exact the price of all we thought was ours, but not without the display of His glory for an everlasting testimony. And this is the painting, the song, the poem; the architecture that will last.

We trust that He sees us with merciful eyes, and will hold us true to Him, for His own name's sake. He does not bruise spitefully, or forgetfully, or randomly, but in order to replenish and heal. Look how our bodies send blood to a wound that knits itself into a scab, in order to heal damaged flesh. We expect that when we are hurt, our bodies heal involuntarily, given the right conditions. Death however, is not natural for us, but remains awful. Therefore, our Lord, who wept before Lazarus'

tomb, demonstrates that He is the matrix of the pattern of all true nature, and says, "I will raise them up at the last day." Death is temporary; healing is eternal. He does not bruise except that it should follow its natural course: to mend. He was wounded that we may be healed. And He Himself is the word of truth in our mouths, faithful though we may be faithless. "By the fruit of the lips is a man satisfied" (Proverbs 18:20).

Dear artists, this is for us: who struggle with the source of our life and work, and the final validation of the worth of our life's work; who struggle for means to eat and for our reputation; who struggle to provide for our loved ones; who struggle to stay true. And because the cost is so high, this is for those who find that our provision for the journey is Jesus. Who has strength and faith to recognize that nothing about us is our own? That all ought to be offered openhandedly back to God from whence it came? Better the wounds that lead to life than the stagnancy of sin that bears only death. The cost of knowing Christ is high, but the provision is sure! "Did I not tell you that if you believed you would see the glory of God?" "Lazarus, come forth!" (John 11:40,43).

Adrian Johnston

Notes

INTRODUCTION

1. *Jesus, Priceless Treasure* by Johann Franck, 1618-1677. Text from: *The Handbook To The Lutheran Hymnal* (St. Louis, MO: Concordia Publishing House, 1942), 248-249.

THE CREATION OF THE WORLD AS A MODEL FOR ARTISTS

1. John Piper, *Desiring God: Meditations of a Christian Hedonist* (Sisters, OR: Multnomah Books, 1996 ed.), 44.

2. John Piper, *God's Passion For His Glory: Living The Vision Of Jonathan Edwards* with the complete text of *The End For Which God Created The World* by Jonathan Edwards, (Wheaton, IL: Crossway Books, 1998), 170.

3. John Piper, *God's Passion For His Glory: Living The Vision Of Jonathan Edwards* with the complete text of *The End For Which God Created The World* by Jonathan Edwards, (Wheaton, IL: Crossway Books, 1998), v.

4. St. Augustine of Hippo, *Confessions,* (Nashville, TN: Thomas Nelson Publishers, 1999), 207-208.

5. Charles H. Spurgeon, *The Treasury of David,* Three volume set, (Peabody, MA: Hendrickson Publishers), vol. 1, part 2, p.122.

BOLDNESS

1. John Bunyan, *The Pilgrim's Progress* (Uhrichsville, OH: Barbour Books, 1988), Faithful, 77.

2. Charles H. Spurgeon, *Morning and Evening*, (Scotland, Great Britain: Christian Focus Publications Ltd.) December 19, Morning.

3. Arthur T. Pierson, *George Müller Of Bristol and His Witness to a Prayer-hearing God*, Appendix E: Reasons Which Led Mr. Müller to Establish an Orphan House, (New York, NY: Fleming H. Revell Co., 12th printing), 399.

4. Charles H. Spurgeon, *Morning and Evening*, (Scotland, Great Britain: Christian Focus Publications Ltd.) June 30, Evening.

Acknowledgments

I would like to thank God for His grace to me through His Son, through the Holy Spirit, through the Bible, and through so many people in this wrestling. In the body, no one is unnecessary, and so it proves difficult to name everyone who has played a part in the honing of this work. Many have no idea that they played, or how they played, into it. Yet, they have been a grace to me from God. To my wife, my children, my greater family, my comrades in music, my church, my pastors, my small groups, my fellow artists, my friends, fellow seekers of the truth, those who have lived, wrestled, and died before me and fed me through their accounts, those who pushed back, those who edited, those who supported: Thank you all for being fellow workers with the truth!

And to Carol Steinbach, you have evidenced that your affections for Christ and for playing your part in the body are greater than your affections for the gain of this world. You have generously served us all with your editing. "...you are acting faithfully in whatever you accomplish for the brethren..." (III John 5). Thank you.

"The grace of our Lord Jesus Christ be with you" (I Thessalonians 5:28).

One's a dance,
The other wrestles.
Same advance;
Different vessels.

The Affections of the Heart in Art and *The Land of the Fear of Men*
are two expressions of the same labor. The advance is to know and enjoy
the fullest pleasures in artistic expression as God has created and intended
the human soul to take delight in expressing his heart artistically, to the
aim and end of his enjoyment in the Author of such pleasures, namely,
God Himself.

ONE'S A DANCE,
THE OTHER WRESTLES.
SAME ADVANCE;
DIFFERENT VESSELS.

The Affections of the Heart in Art and *The Land of the Fear of Men*
are two expressions of the same labor. The advance is to know and enjoy
the fullest pleasures in artistic expression as God has created and intended
the human soul to take delight in expressing his heart artistically, to the
aim and end of his enjoyment in the Author of such pleasures, namely,
God Himself.

Jason Harms - voice/guitar

John Raymond - trumpet/flugelhorn

Jason French - piano/organ/rhodes

Jesse Harms - bass

Steve Goold - drums/congas

with special guest - Christopher Fashun - vibraphone

Engineers: Christian Richter, Ben Van Zee

Fresh ears: Christopher Fashun

Recorded at Pachyderm Studio, June 23-26, 2008

Catering by the beloved wives and children.

Produced by all parties involved.

All songs (except jesus, priceless treasure) written by Jason Harms.

Copyright © Blue Hat Music (bmi), arr. only on jesus, priceless treasure.

Paintings by: Adrian Johnston - kmov.org

We thank the Lord for the many Fellow Workers who

joined us in this recording. May the body be edified.

jasonharms.com / thegaiusproject.org / kmov.org

Mercy, Now, as Root and Core

A storm that drives one in for cover
May in time be blessed a lover.
Not as beautiful in face,
Or tender, nor possessing grace,
But an escort to the throne
Where mercy, now, her depths make known.

"Oh cursed wind!" I'd first proclaim,
Not knowing wind to bear the name
Of pilot, navigator, guide,
Each title acc'rately applied
While beaching me on humbled shore
Where self is less and Christ is more.

Brought to the refuge of your cleft,
Here I look 'round at nothing left
And see how pride lies deathly still
When shown the limit of its will.
I cannot boast or roar again,
Save, in this cleft that's hemmed me in.

What blinding light breaks through the rear!
This cleft's a door whisp'ring, "Come near,
And watch God's light illuminate
Where eyes of flesh could not make straight."
Each trial sung in earthly score
Hears mercy, now, as root and core.

The One Who Wields

Should the axe begin to boast
O'er the one who charts its aim?
Or the arrow dare to claim the most
Glory o'er the game?

No, there is a hand
Behind a tool
Working all that he plans.
Don't play the fool.
No, the one who wields will glory claim.
A tool not in hand knows no fame.

Can a jar boast of its glaze?
Should the canvas swell with pride,
Or the brush lay claim to beauty praised
As if he the oils applied?

No, there is a hand
Behind a tool
Working all that he plans.
Don't play the fool.
No, the one who wields will glory claim.
A tool not in hand knows no fame.

Sure, a sev'rance comes with pain,
But limbs are never lopped in vain.
Look 'round the garden while you cry
And trust the Pruner's shaping eye.

Cry my brothers for your soul,
Surrender pride to Calvary's knoll.
Cry my sisters, bend your knees,
And plead for ballast 'neath your seas.
Cry my fathers, lead the way
Away from errors of yesterday.
Cry my mothers, put on grace;
To follow's never second place.
But cry to God! He gave us tears
To float to Him unknowns and fears.
A tear, in faith, will prism be,
To color what you could not see.

Cry My Brothers

Cry my brothers, and heal your soul.
A crying man's no less the whole.
Cry my sisters, but choose your tear
And weep with truth, but not with fear.
But cry to God and weep 'longside
A soul that's tempted, troubled, tried.
A tear diffuses, or, makes way
For light to bend her color ray.

Despairing tears will comfort not,
They bleed the well and breed the rot.
But let a tear in Mercy's bed
And Hope will fill what water's shed.

Cry my fathers for your sons.
A boy is as with whom he runs.
Cry my mothers for your girls
To know their beauty's more than curls.
But cry to God and weep 'longside
A soul that's tempted, troubled, tried.
A tear diffuses, or, makes way
For light to bend her color ray.

If I Don't Cry, A Rock Will Cry Out!

If I don't cry, a rock will cry out.
Praise will happen whether' not you hear this man shout!
But, if I don't howl, then let it be heard,
"Foul!" from the creature, every boulder and bird.

Cry out! Cry out! Brother won't you?
Are you not affected when the Lord rides through?
Cry out! Cry out! Sister, what say?
Will the pebble beat your lips to Jesus today?

If I won't yell, well, what's there to fear?
"Hell's not a heater that you dare stand near.
If you won't wail, brother, angels still say,
'Hail to the Holy, Holy, Holy this day!'"

If you don't groan, still it should be known:
Man does not determine when the Lord's on His throne.
If you won't weep, then of you 'twill be said:
"The field stone's wiser than the rock in his head."

Well Said, Rockwell!

Father. Father. Father. Praise Father.
Praise Jesus. Praise You Father!
Father. Father. Father. Praise Father.
Praise Jesus. Praise You Father!

Jesus said we should feed the poor,
And when we pray, we're to close our door.
We should share with the needy, see!
With those less fortunate than we...maybe...?...

Father. Father...oh... Praise You Father!

Satisfied
is the hide
with a roof over head
to keep the snow at bay.
A warm, dry bed
providing rest from a day's
hard labor.
You do yourself no favor,
if you labor
for the latest nik, another nak,
you buy with a broken back.
See the problem with a misplaced
pace?
Won't satisfy.

Oh, what joyful bliss
flows from my Maker's hand.
This I will often miss
while I gaze on goods of the current land.

Satisfied
is the hide
with a roof over head
to keep the snow at bay.
A warm, dry bed
providing rest from a day's
hard labor.

Satisfied

Satisfied
is the soul
who can put his trust whole
in his Maker,
rather than his belly's craving for the baker's
pastry.
Sure won't be tasty,
come morning,
when that sugar's made its home
'neath the dome
round the waist. See
the problem with a misplaced
taste?
Won't satisfy.

Oh, what joyful bliss
flows from my Maker's hand.
This I will often miss
while I gaze on goods of the current land.

Satisfied
is the soul
who can put his trust whole
in his Maker,
rather than his belly's craving for the baker's
pastry.

Yet Will I Exult in the Lord

Though the fig tree should not blossom,
And there be no fruit on the vine;
Though the olive fails to yield,
And the fields produce no harvest, no harvest;
Though the flock be cut off from the fold,
And there be no cattle in the stall...

Yet will I exult in the Lord!
I will rejoice in the God of my salvation.
Yet will I exult in the Lord.
I will rejoice in the God of my salvation!

The Lord God, He is my strength,
And He makes my feet to be like the hinds'.
The Lord God, He is my strength,
And He leads me to walk the elevations.
So though the flocks be cut off from the fold,
And there be no cattle in the stall...

Yet will I exult in the Lord!
I will rejoice in the God of my salvation.
Yet will I exult in the Lord.
I will rejoice in the God of my salvation!

Habakkuk / Jason Harms

Man Will Find His Knee

Man's found a way that he can navigate the sea.
Man's found a way to comb the honey from the bee.
Man's found a way to live in outer space.
Man's found a way to make the horses race.
So why's it so hard for a man to find his knee?

A man will find time to slice one off the tee.
A man will find time to shine his Hummers, three.
A man will find time to dine his girl,
Treat her to the fair and the tilt-a-whirl.
So why's it so hard to find the time to find his knee?

There will be a day when God Himself decrees:
"Render every man according to his deeds.
Death and Hell for the wicked one,
All of Me if you loved my Son."
Yes, there will be a day when every man will find his knee.

The Land of the Fear of Men

The Land of the Fear of Men
She lies near the Devil's den
In hollows foul
With praises' howl.

We'll travel her now and then,
In hopes to secure a friend.
But all are slaves
Or sunk in graves -
The Land of the Fear of Men.

When fears and anxieties
Form clouds that canopy,
Forfeiting Light's true guide,
We follow our compass, Pride.

The Land of the Fear of Men
Is haunting at every bend.
In oaks of grey
The nooses sway.

Her hills form a prowler's pen
Ensnaring the singing wren,
Where praises made
Disguise the blade -
The Land of the Fear of Men.

Satan, I defy thee;
Death, I now decry thee;
Fear, I bid thee cease.
World, thou shalt not harm me
Nor thy threats alarm me
While I sing of peace.
God's great power guards every hour;
Earth and all its depths adore Him,
Silent now before Him.

Hence, all fear and sadness!
For the Lord of gladness,
Jesus, enters in.
Those who love the Father,
Though the storms may gather,
Still have peace within.
Yea, whate'er I here must bear,
Still in Thee lies purest pleasure,
Jesus, priceless treasure!

w. Johann Franck (1655) / m. Johann Crueger (1649) / arr. Jason Harms

Jesus, Priceless Treasure

Jesus, priceless treasure,
Source of purest pleasure,
Truest friend to me.
Ah, how long in anguish
Shall my spirit languish,
Thirsting, Lord, for Thee?
Thine I am, Oh, spotless Lamb!
I will suffer naught to hide Thee,
Naught I ask beside Thee.

In Thine arms I rest me;
Foes who would molest me
Cannot reach me here.
Though the earth be shaking,
Every heart be quaking,
Jesus calms my fear.
Lightnings flash and thunders crash;
Yet, though sin and hell assail me,
Jesus will not fail me.

THE LAND OF THE FEAR OF MEN

THE LAND OF THE FEAR OF MEN

The Devil's pride cost him much. And in his pride he attempts to lure as many men away from God as he can by massaging the pride in their hearts. It seems that his bait has always sounded this theme:

You can and should be like God (Genesis 3).

To awaken our pride, he sets forth a measure of glory to lure us all to the misery of his den. In this land, the Devil brews up Glamour Geyser from which flows Wheedle River to the west supplying Lake Persuade, and Wile River to the east supplying Lake Entice, both emptying eventually into the Sea of Pomposity.

Distinctions Divide separates the land into two main personalities to which the Devil plays. The pride of man manifests itself a bit differently in the countries of Complaisance and Approval than in Affirmation and Status, yet the fear of men is common soil to them all.

he Land of the Fear of Men is a land of affections. It is a land unhindered by geography. It is a land that our heart either seeks out or flees from. It is a land where Faith does not dwell. The Fear of Men is rarely a fear that is frightening - a fear that causes us to run from men. On the contrary, this strange fear seems to motivate us towards men. It is a type of revering fear where the affections of our heart seek their satisfaction in the approval of others. This is a toilsome, unfruitful land.

There is, however, a kind of revering fear that should be the affection of our heart: "Behold, the fear of the LORD, that is wisdom, and to turn away from evil is understanding" (Job 28:28).

We all live in or near The Land of the Fear of Men, and yet we rarely discern its dangers according to their peril. Her promises are actually fetters, though they appear to be benevolent. We must discern the fear of men for the enslaving affection that it is or we will find ourselves putting on its fetters, thinking we are adding to our armor. Not so. There is no armor in The Land of the Fear of Men, there are only chains.

So friend, turn not down her paths looking for camaraderie, for all are slaves or sunk in graves in The Land of the Fear of Men. You will find, however, the satisfaction that you seek in this life flowing from the hand of your Maker. His narrow paths are sure, true, and abundantly fruitful! Your greatest pleasures in all things pleasurable will be enjoyed when your affections are stayed on the fear of the Lord, not the fear of men.

"O fear the LORD, you His saints;
For to those who fear Him there is no want."
(Psalm 34:9)

THESE SONGS ARE THE ARTISTIC EXPRESSIONS
OF VARIOUS THEMES
CONTENDED WITH
IN

THE AFFECTIONS OF THE HEART IN ART

THE RECORDING CAN BE FOUND THROUGH

JASONHARMS.COM

THE LAND OF THE FEAR OF MEN

JOHN RAYMOND / JASON FRENCH / JESSE HARMS / STEVE GOOLD

JASON HARMS QUINTET

Printed in the United States
215683BV00001B/7/P